I AM BECAUSE WE ARE

PHOTOGRAPHS BY KRISTEN ASHBURN

FOREWORD BY MADONNA

pH powerHouse Books Brooklyn, NY

TO ALL THOSE LOST TO THE AIDS PANDEMIC IN SOUTHERN AFRICA,
AND TO THE MILLIONS OF CHILDREN LEFT BEHIND.

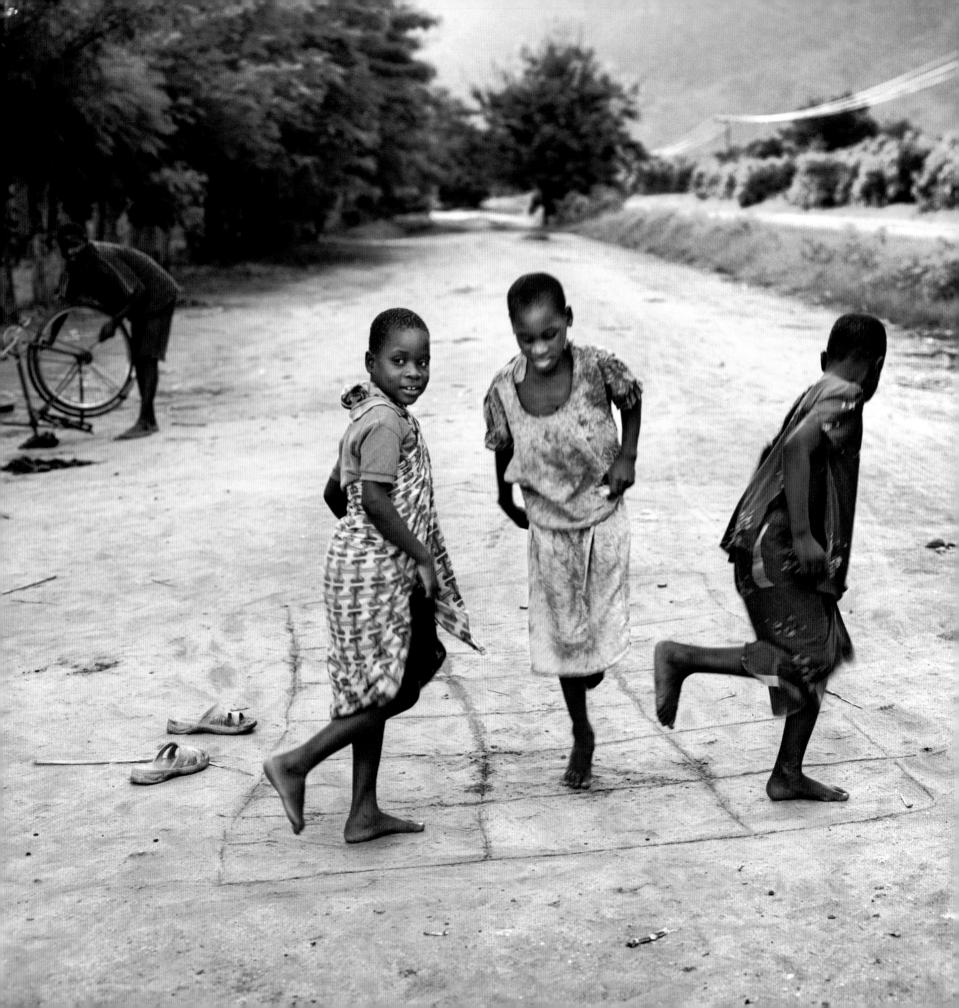

FOREWORD

Mercy, a beautiful African girl from rural Malawi, was the first person to teach me the meaning of Ubuntu. At thirteen, Mercy is the leader of her household. With fragile determination, she cares for her five younger siblings by gathering firewood and water, cooking their one daily meal, and earning the family's few monthly dollars.

She is not alone. There are over 1 million children in Malawi who have been orphaned by AIDS and the numbers are growing. But the number of people who want to help, who want to get involved and be a part of the solution, is growing too. That is why this book is so important to me.

Ubuntu is a traditional African philosophy that means *I am because we are.* It was Nelson Mandela's founding principle for the new South Africa. Desmond Tutu describes Ubuntu as *the proper self-assurance that comes from knowing that we belong to a greater whole and are diminished when others are humiliated or diminished, when others are tortured or oppressed.* As my friend Bill Clinton defines it, *Ubuntu means that what we have in common is more important than our interesting differences.*

For me, Ubuntu means that we are all interconnected—that each of us has a responsibility to care for others at least as much as we care for ourselves.

As you read the following pages and look at the breathtaking photography of Kristen Ashburn, I hope that you too will be inspired by the paradox of beauty and tragedy that exists today in Malawi, and in many other countries in Africa.

I have been moved to tears by the ravaging effects of HIV/AIDS, malaria, and poverty, and by the pain I have seen etched into the faces of so many vulnerable children who are wise beyond their years. But I have also been moved to laughter and joy by the inner strength shared by these beautiful people who stand together in utter defiance of their hardships.

Most of all, I have been moved to action. I feel a deep sense of responsibility to do something meaningful for the countless Mercys of the world.

I am grateful to Kristen Ashburn for her remarkable ability to capture the truth. I can only hope that you are so taken by her photos that you will join me in my journey to awaken the spirit of Ubuntu in the world.

Love,
Madonna

ABOUT I AM BECAUSE WE ARE

Malawi is a country of 13 million people. More than a million are orphans.

I Am Because We Are is a documentary film exploring the lives of children who have endured unimaginable suffering. Looking into their hearts and minds, the film follows several stories that provide an unflinching view of life at the center of the global AIDS crisis. Directed by Nathan Rissman and written and produced by Madonna, it explores all sides of the pandemic, from governmental responsibility to traditional practices that contribute to the spread of HIV.

I Am Because We Are includes interviews with such prominent international leaders and scholars as President Bill Clinton, Archbishop Desmond Tutu, Professor Jeffrey Sachs, and Dr. Paul Farmer.

Narrated by Madonna, the film challenges preconceived ideas about Africa, the crisis at large, and our own ability to effect change. Ultimately viewers come to understand that this is not just a story about orphans in Malawi, but about global responsibility and human interconnectedness.

This book of photographs by Kristen Ashburn contains images and brief biographies of several children depicted in the film. It also contains her images documenting the AIDS pandemic throughout southern Africa between 2001 and 2007.

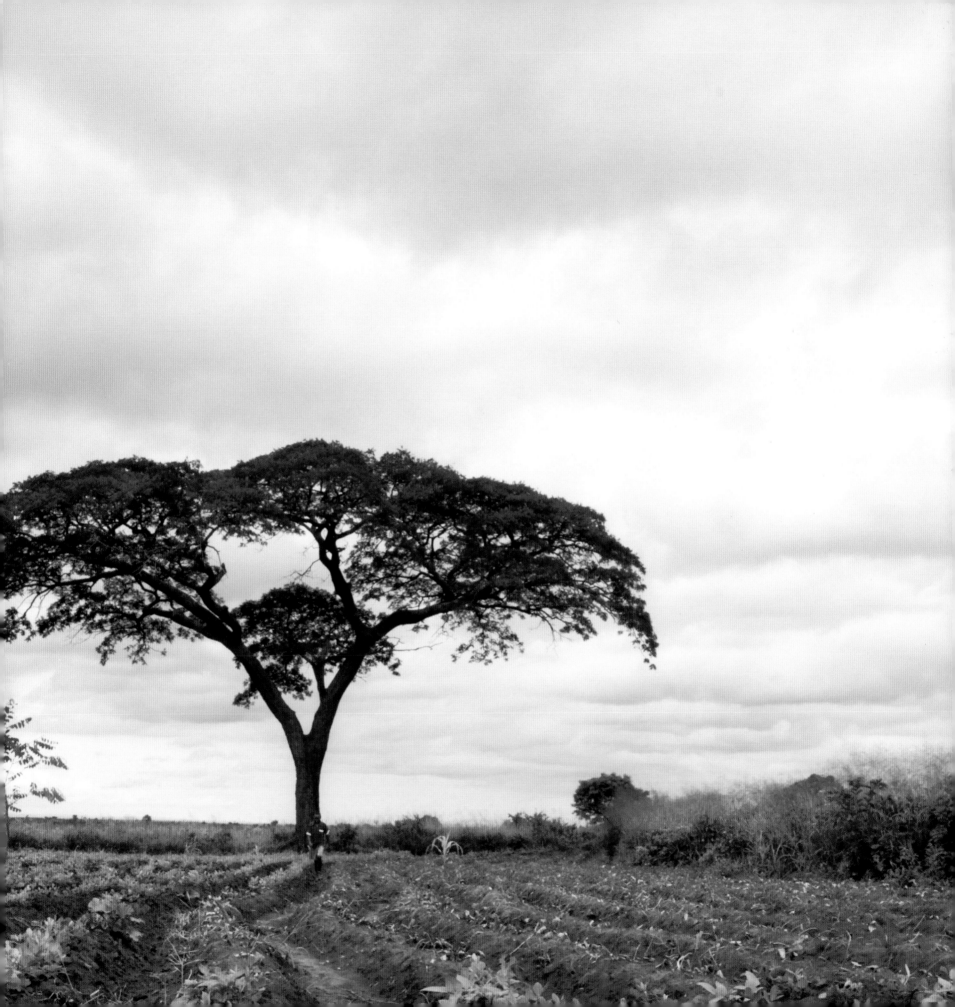

THE CHILDREN

MALAWI'S ORPHANED AND VULNERABLE

FANIZO

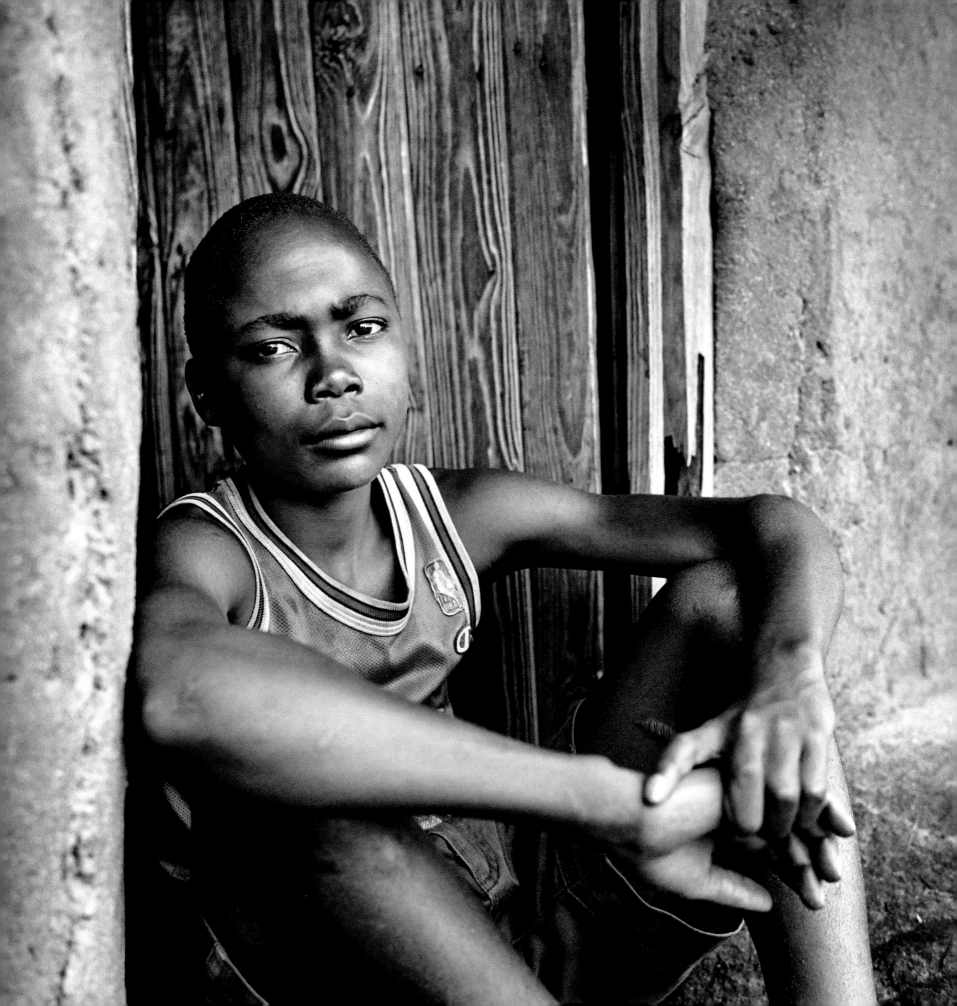

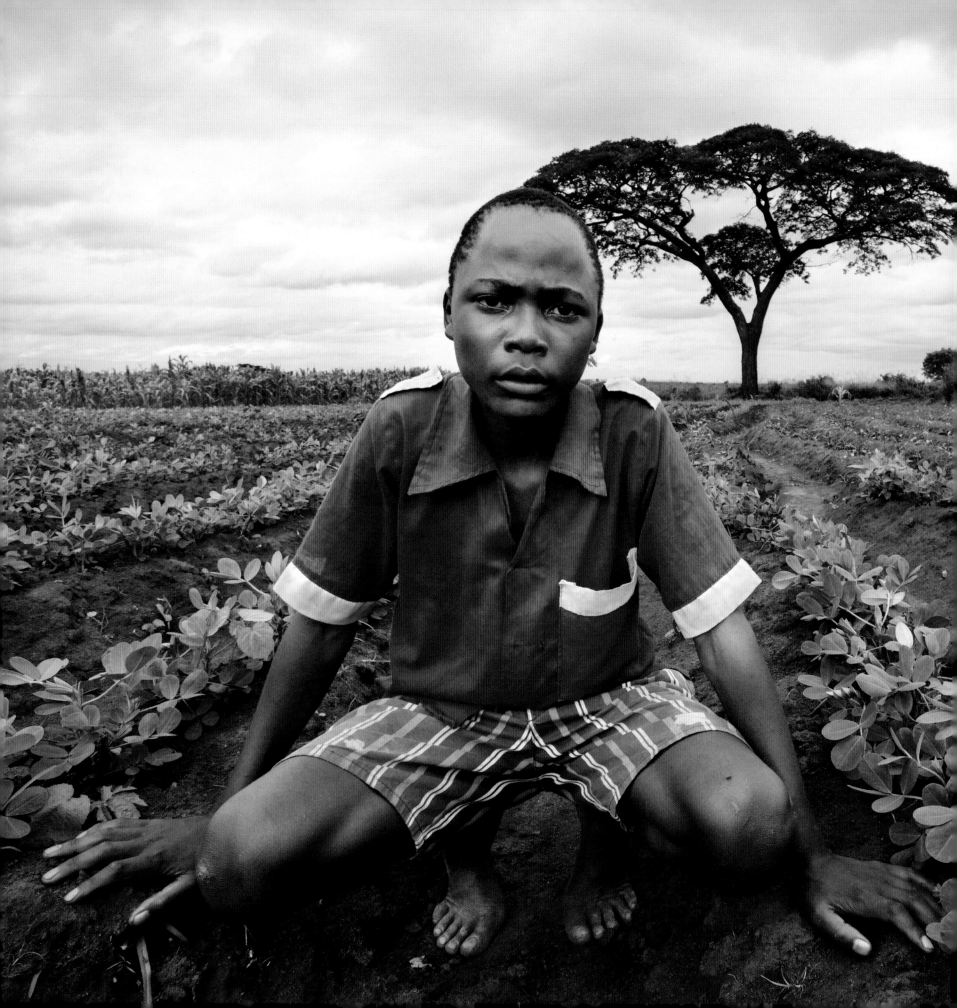

My name is Fanizo.
I am an orphan.

Often I think about not having
a mother or a father.

I feel sad when my friends tell
me the good things their parents
are doing for them.

I miss the love of my mother.

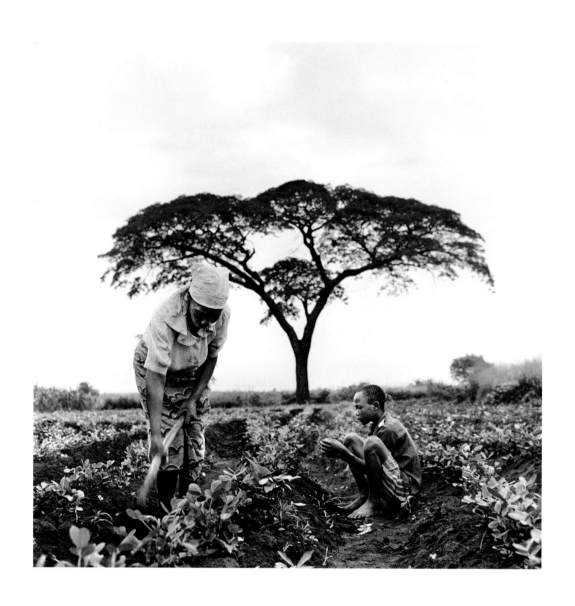

Fanizo lives in Khande Village. He is fourteen years old. After the death of his mother, he was taken in by his grandmother Rebecca, who is a subsistence farmer. Fanizo was a top student at his village schoolhouse, but lacking the money to attend secondary school, he had no choice but to join his grandmother in the fields.

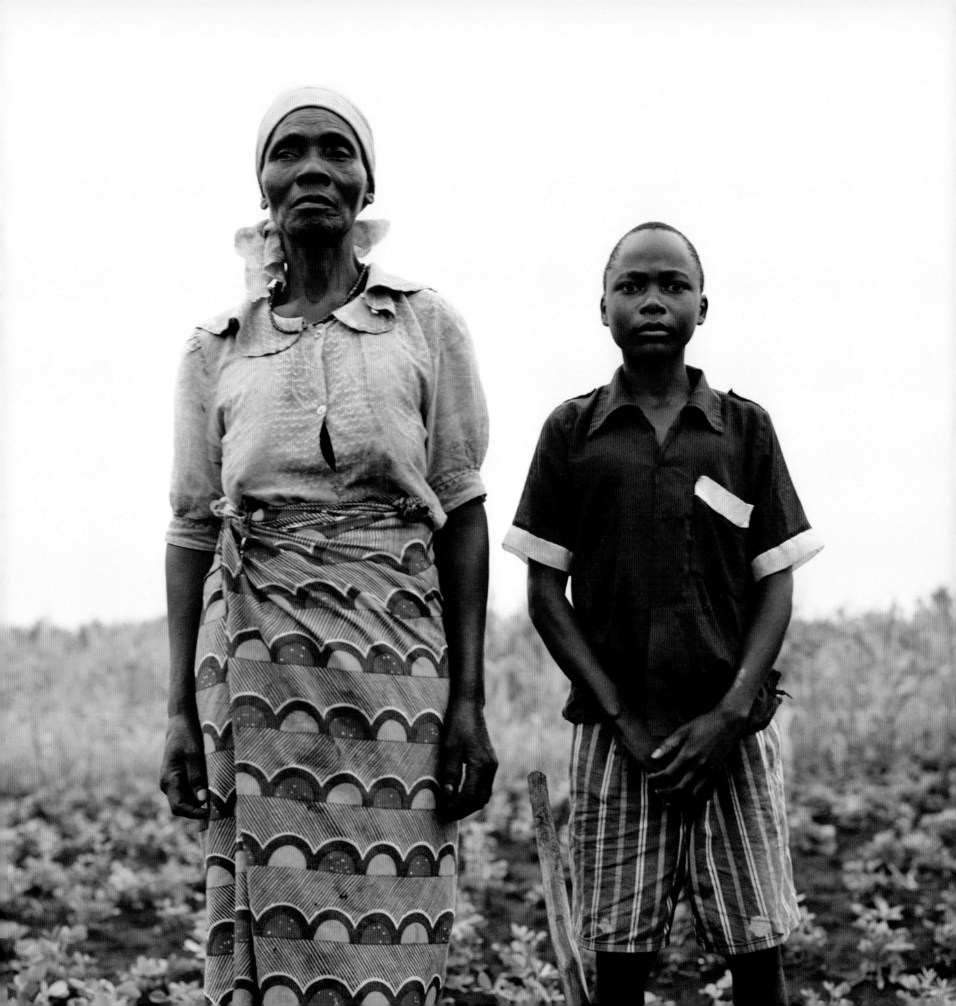

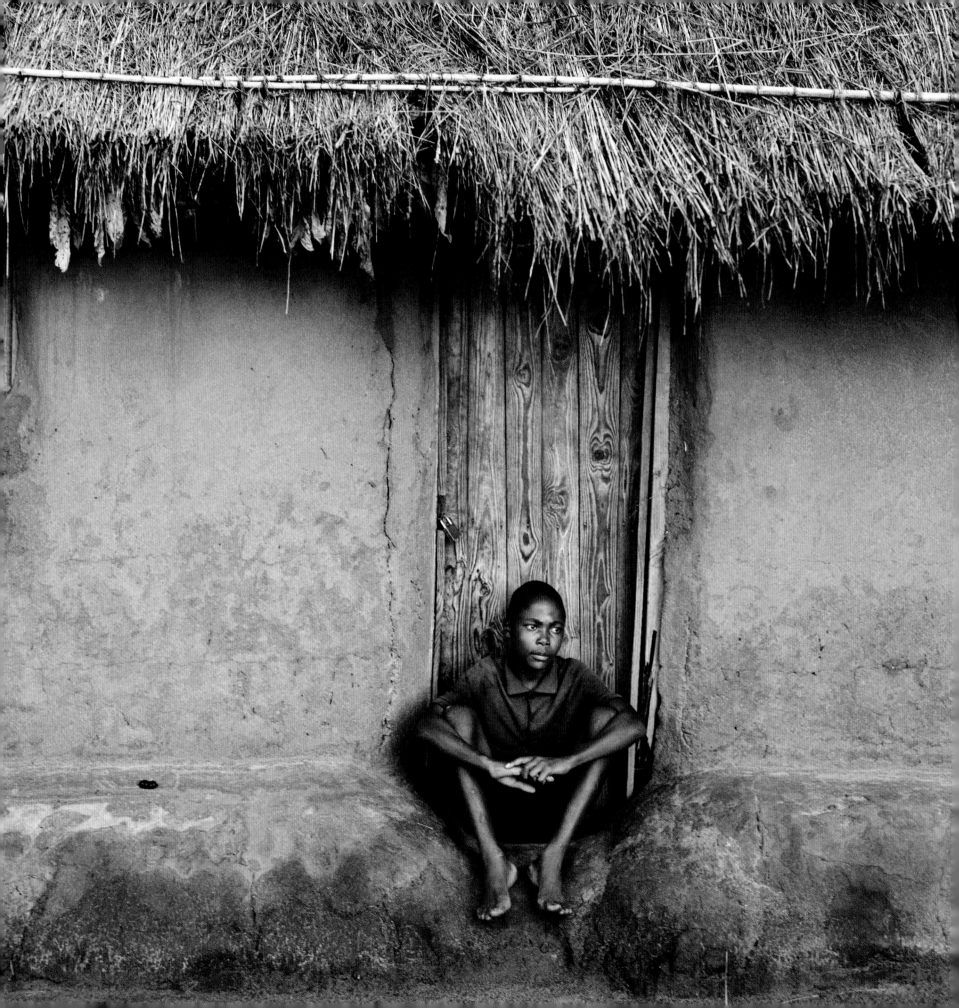

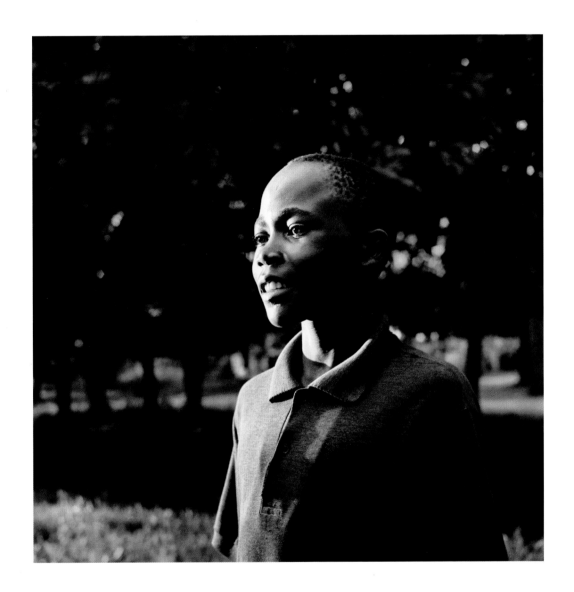

With assistance from Raising Malawi, Fanizo is now studying at Kamuzu Academy, one of the most prestigious schools in Malawi. He plans to become a doctor in order to help the people of his village.

Nothing is going to stop me just because I'm an orphan.

I will help by being an example to other orphans, showing that being an orphan hasn't stopped me from achieving my goals, and this will help my friends to try hard, and to be as I am.

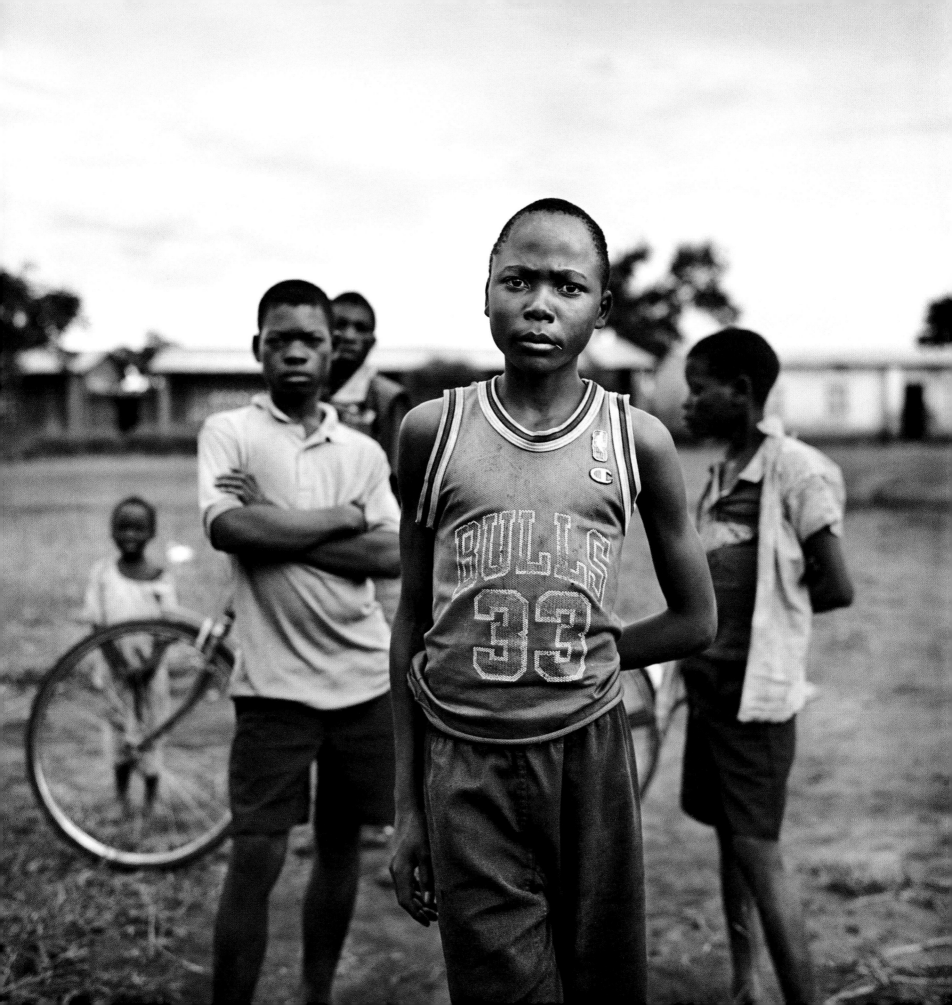

JOYCE

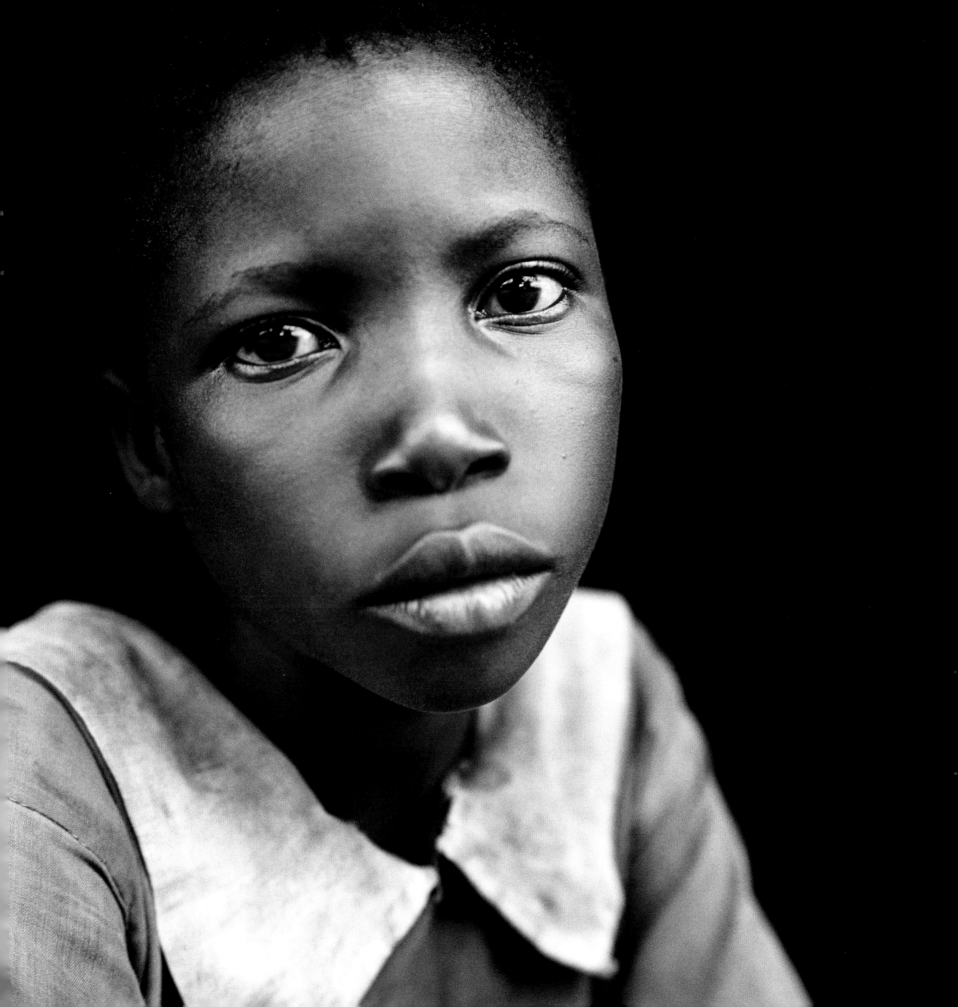

When my mother was sick she stopped working in the fields. I was the one taking care of her. We were left here suffering, suffering on the wet floor.

When the rain was falling, our house was leaking and we were freezing; even the door wouldn't close. We thought we would be attacked. We were afraid. We had no matches, no lamp oil. We were going to the neighbors to beg.

When my father got sick, my mother and I couldn't go visit him because my mother was sick as well. Even up to the point when he died, we still could not visit him because of my mother being ill.

When I see my orphan friends being sad, I also get sad. When an orphan goes begging, one of us goes to chat with them to make them laugh and feel a little bit better.

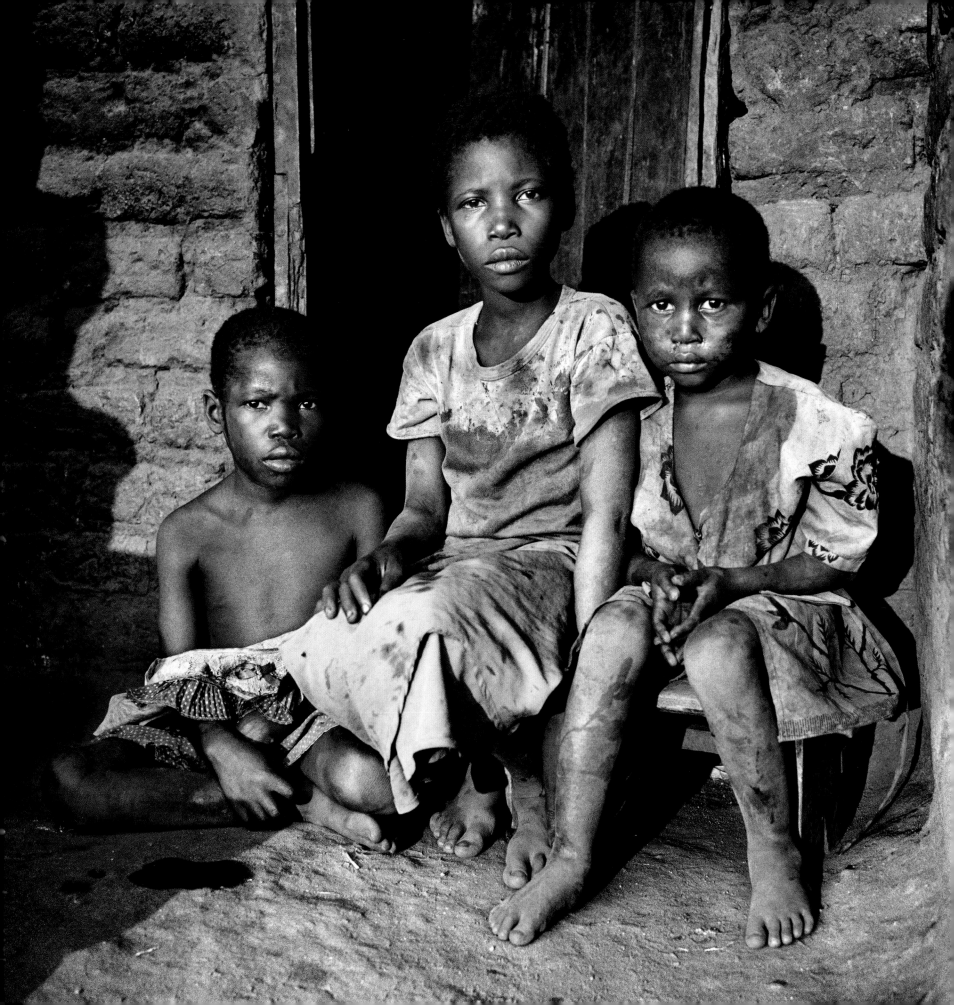

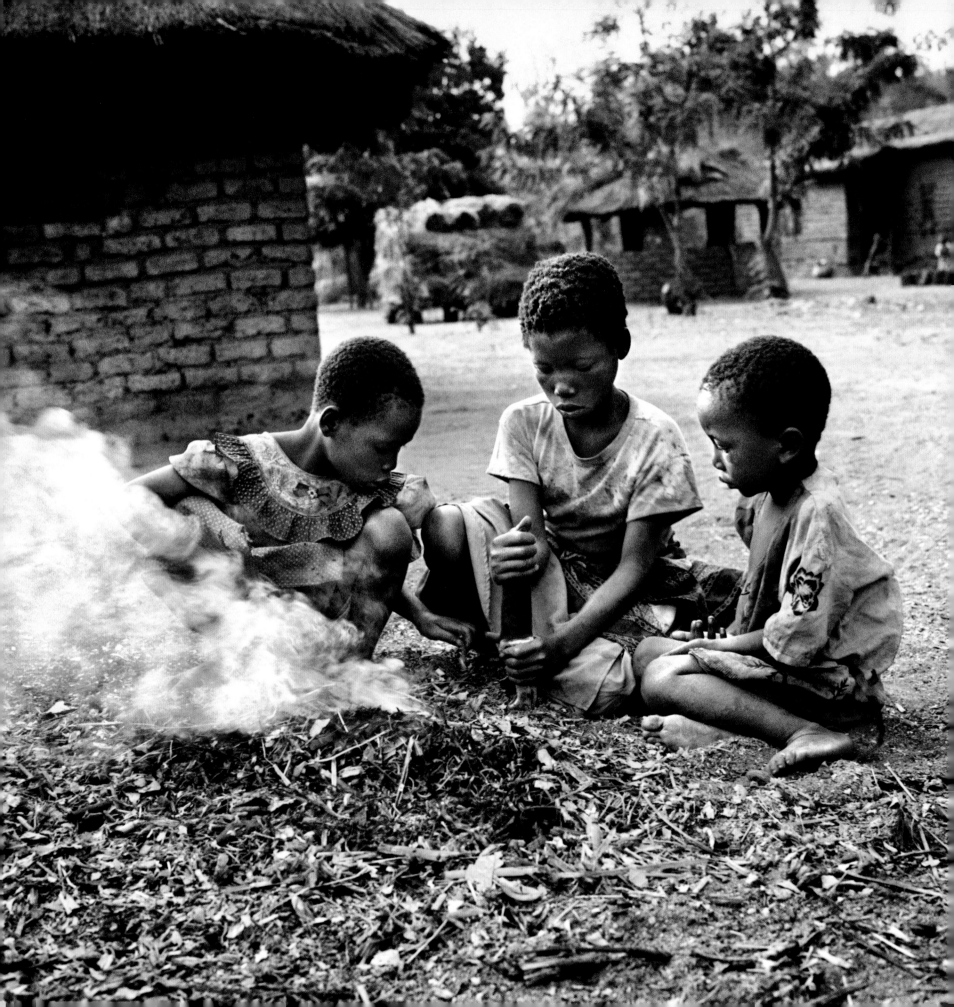

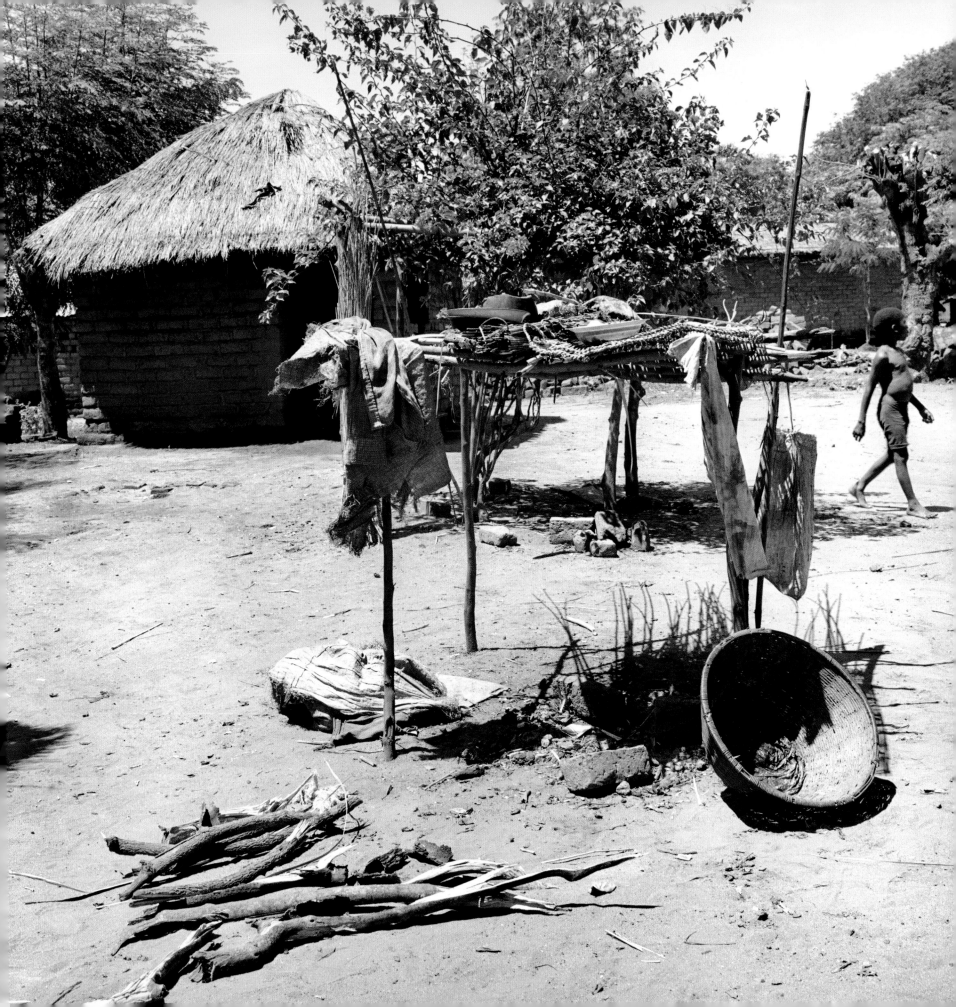

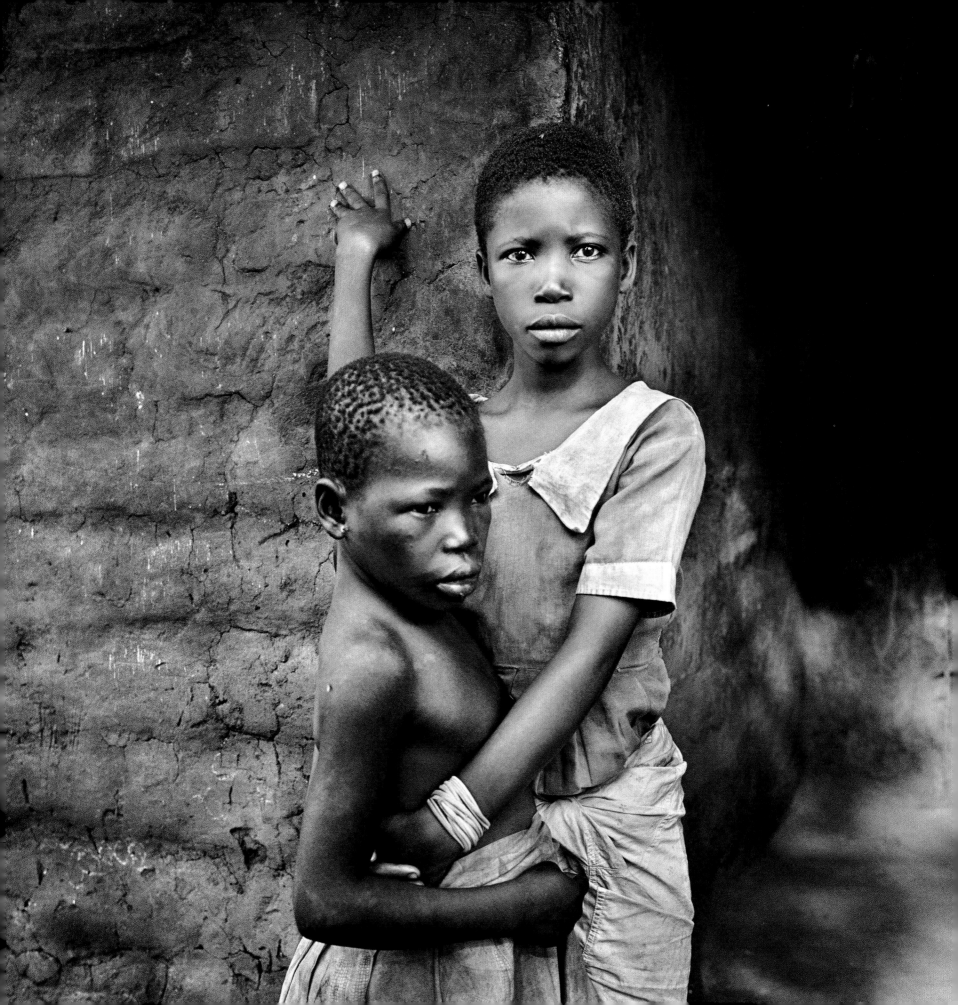

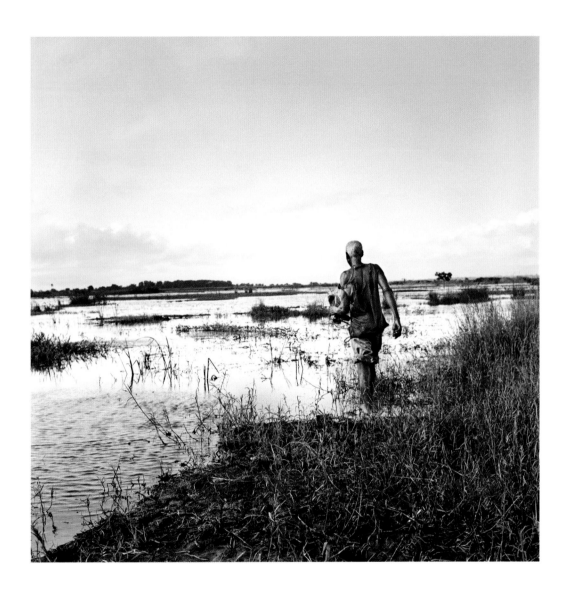

Joyce is twelve years old. While her mother battled AIDS, she was responsible for caring for her and two younger siblings. After her mother died in 2006, the children went to live with their grandparents. Joyce's grandfather tries his best to provide for them by fishing every day, but there are many days that the family is lucky to eat one meal.

WEZI

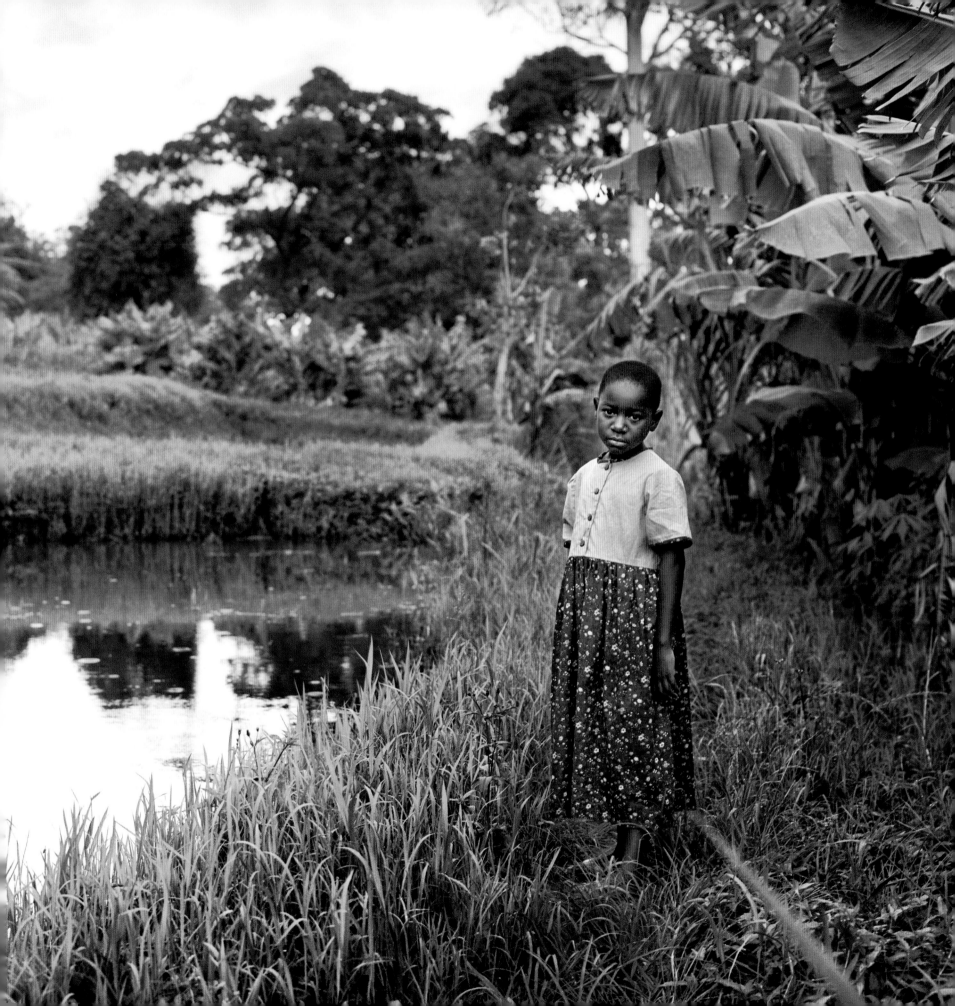

My name is Wezi.
I'm nine years old.
My mother is dead.

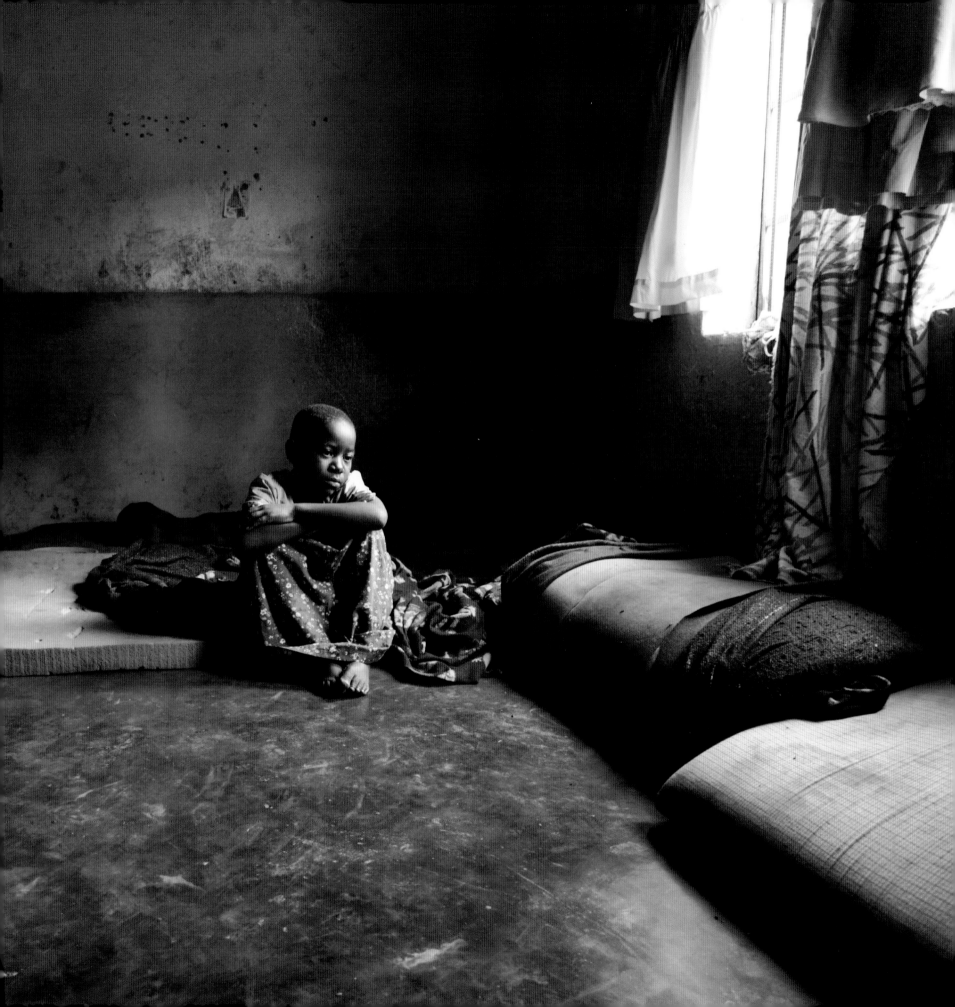

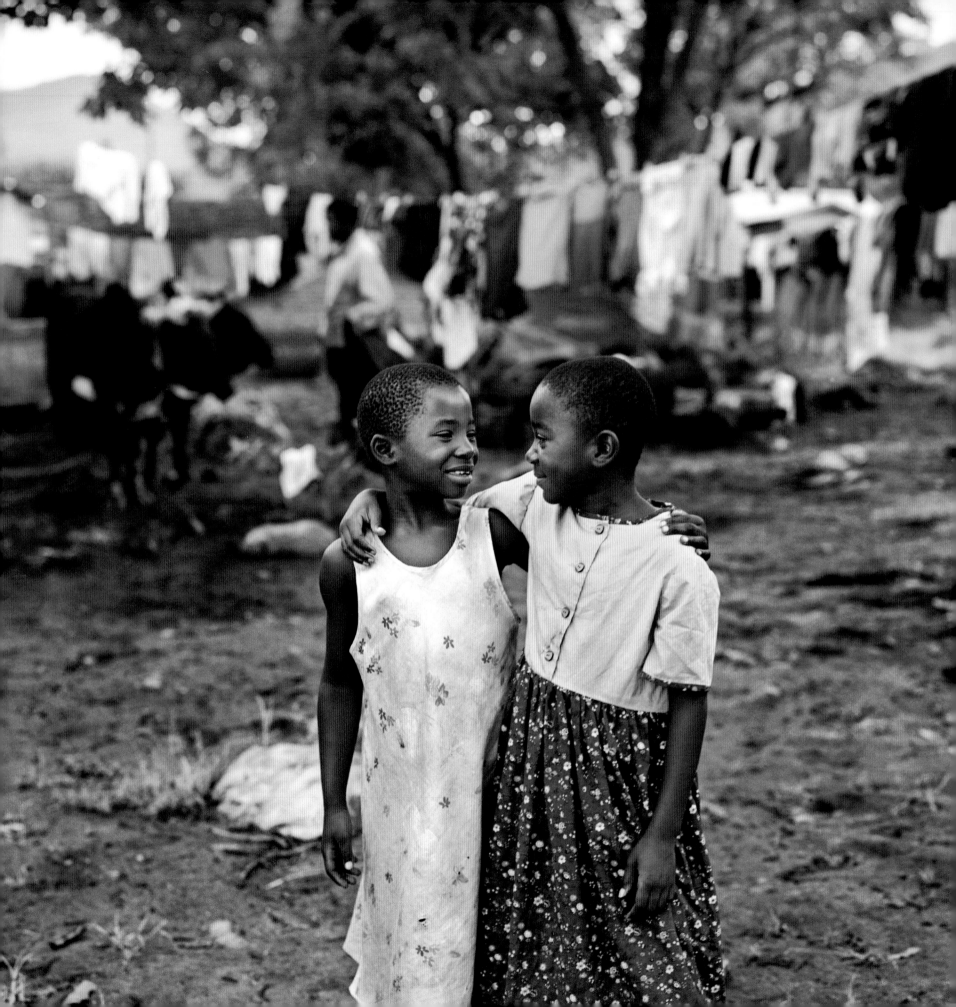

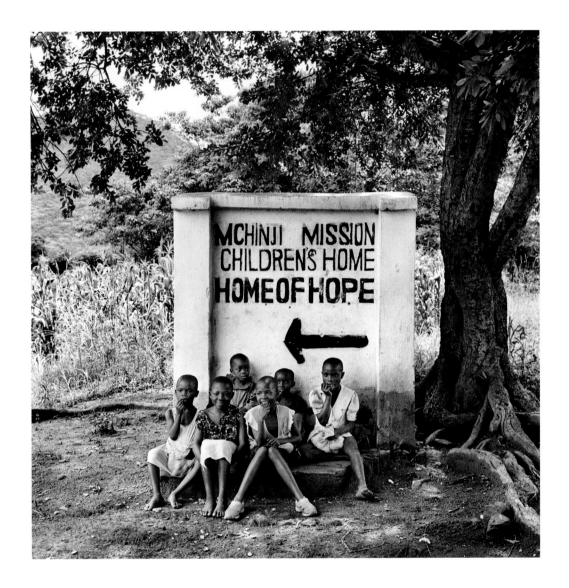

Wezi is one of five hundred orphans living at the Home of Hope orphanage in Mchinji. She is HIV positive and the last surviving child in her family. Unaware of her disease, she simply knows that she takes a pill each morning. Although Wezi's grandmother is too frail to take care of her, she does manage to travel to the hospital each month to ensure that Wezi receives her medicine. Wezi is frequently sick, but never complains. Along with her best friend Janet, she eagerly helps to care for the youngest children at the orphanage.

What makes me happy is that the child has a lot of interest in taking the medicine. She does not forget. Sometimes even I can forget about the medicine. The child reminds me.

—Wezi's grandmother

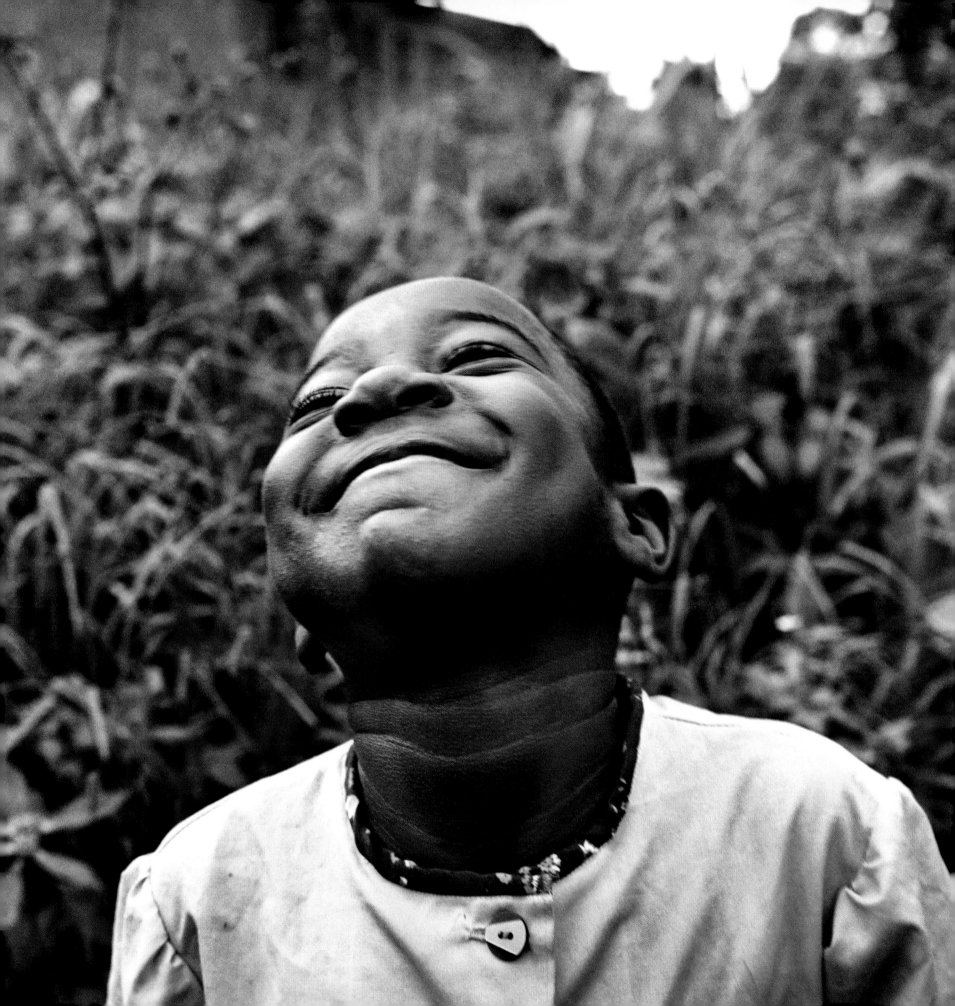

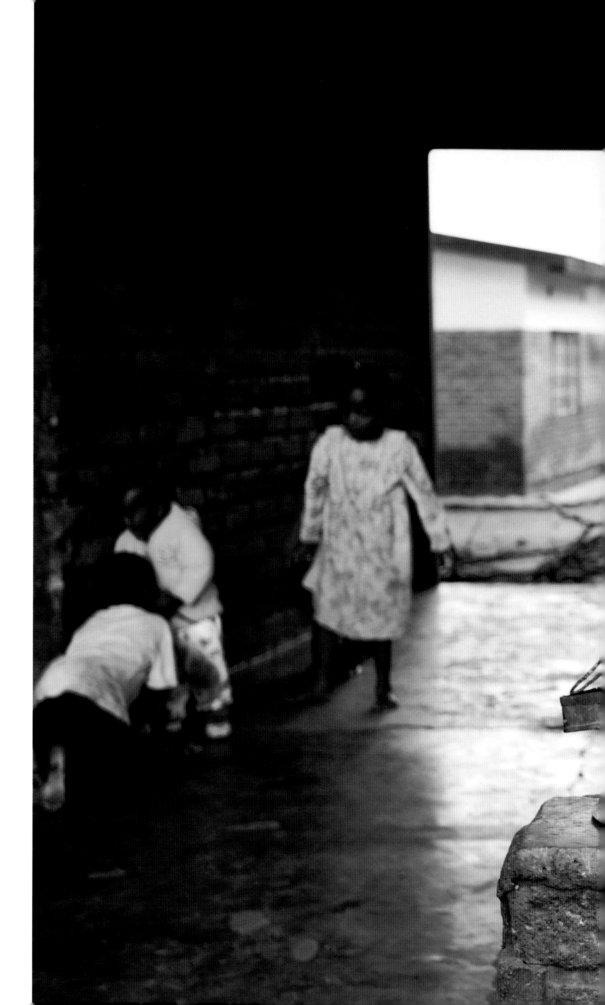

When I first met Wezi she was responsible for looking after three infants. I realized at this moment the reality, or rather the insanity, of children looking after children.

Wezi is one of five hundred orphans at Home of Hope. The orphanage is crowded and dirty.

The entire time I spent there I only met two adults. It felt like a small city run by kids.

—Madonna

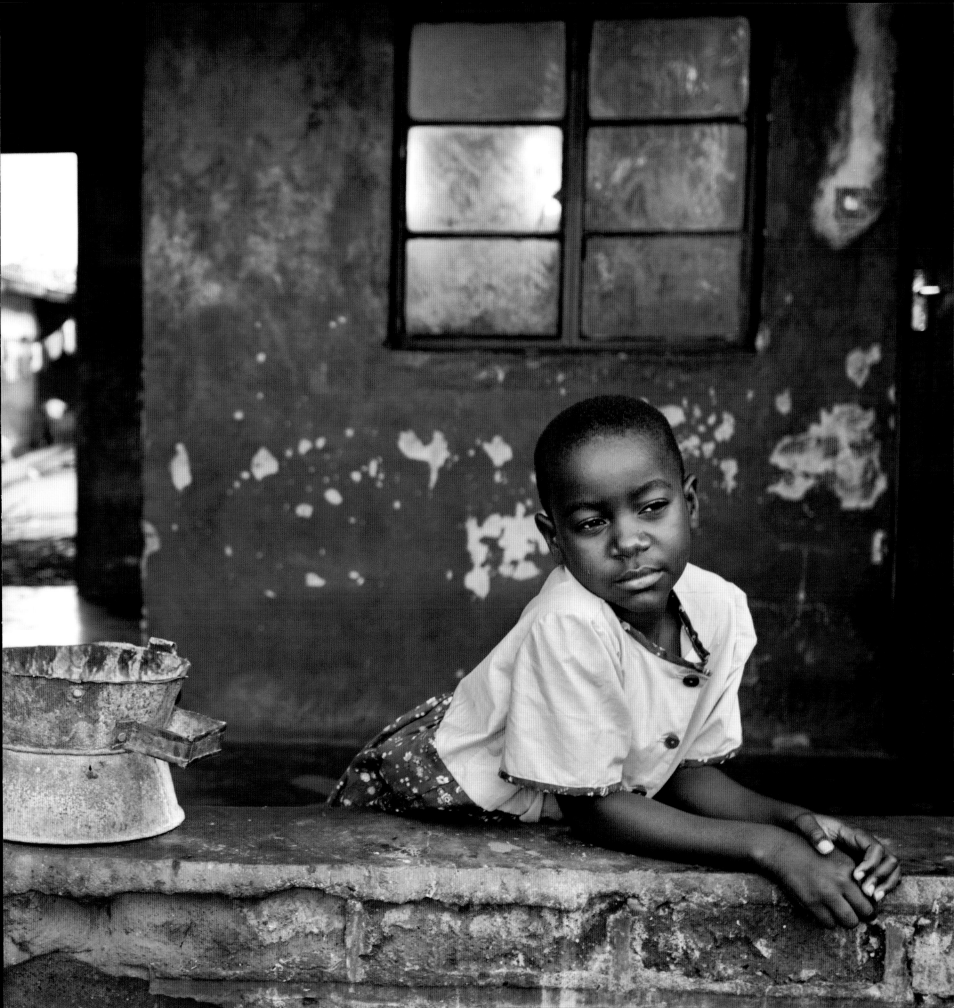

LUKA

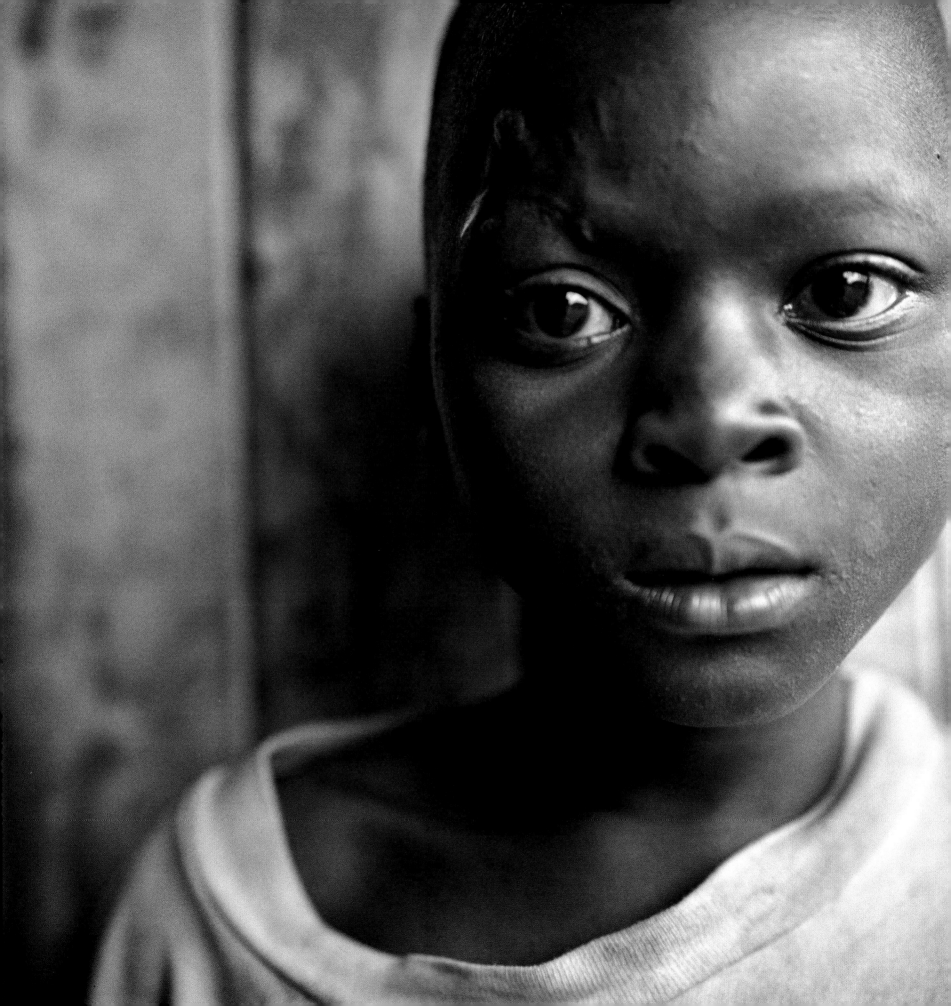

I was sent to go buy paraffin. I was given the money and told I could keep the change. I never got to buy anything because these people started chasing me. They grabbed my arm and dragged me into this field.

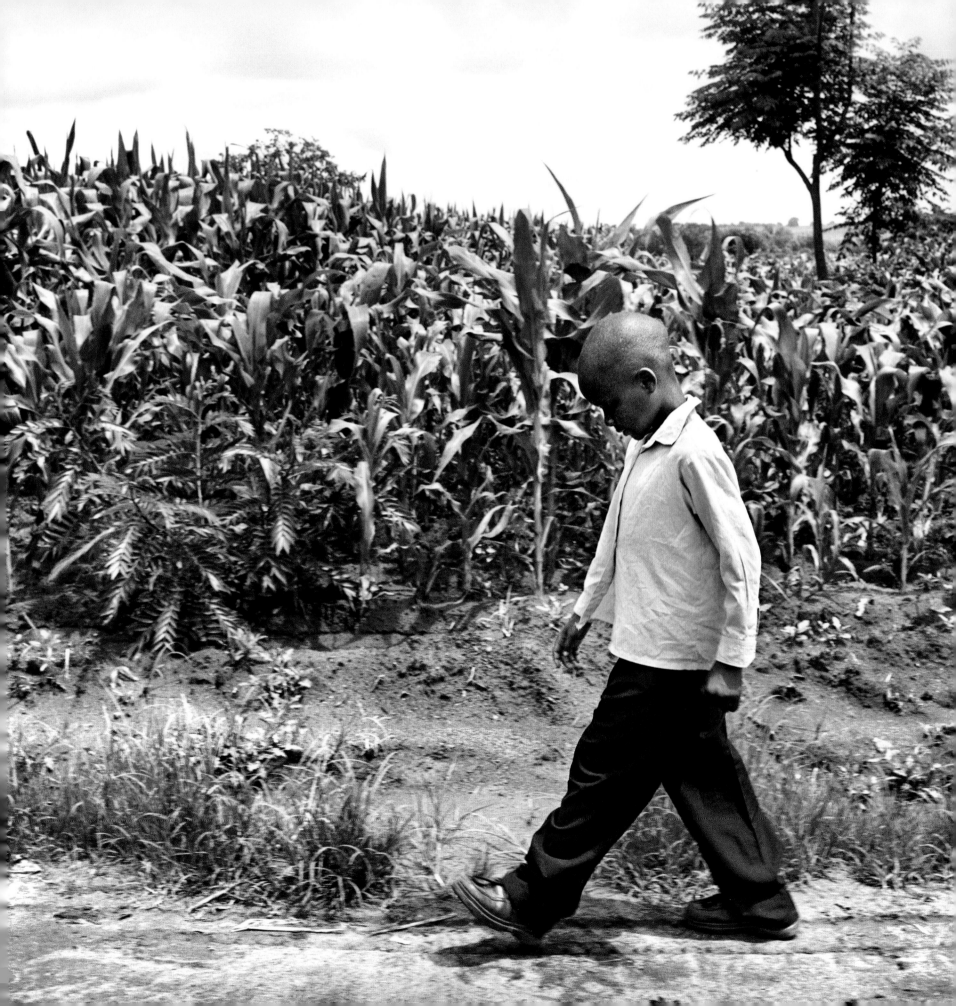

At the age of seven, Luka was brutally attacked and castrated by men motivated by witchcraft. The attack left him maimed for life. With the help of Raising Malawi he has since received numerous operations that have allowed him to lead a normal life.

Now nine, Luka attends a private school along with his older brother. He and his family previously lived in a one-room house so dilapidated that when it rained the mud floors flooded, forcing the family to sleep in one corner. They have since been relocated to a house on the outskirts of Lilongwe with proper floors and doors. Luka's attackers were never apprehended.

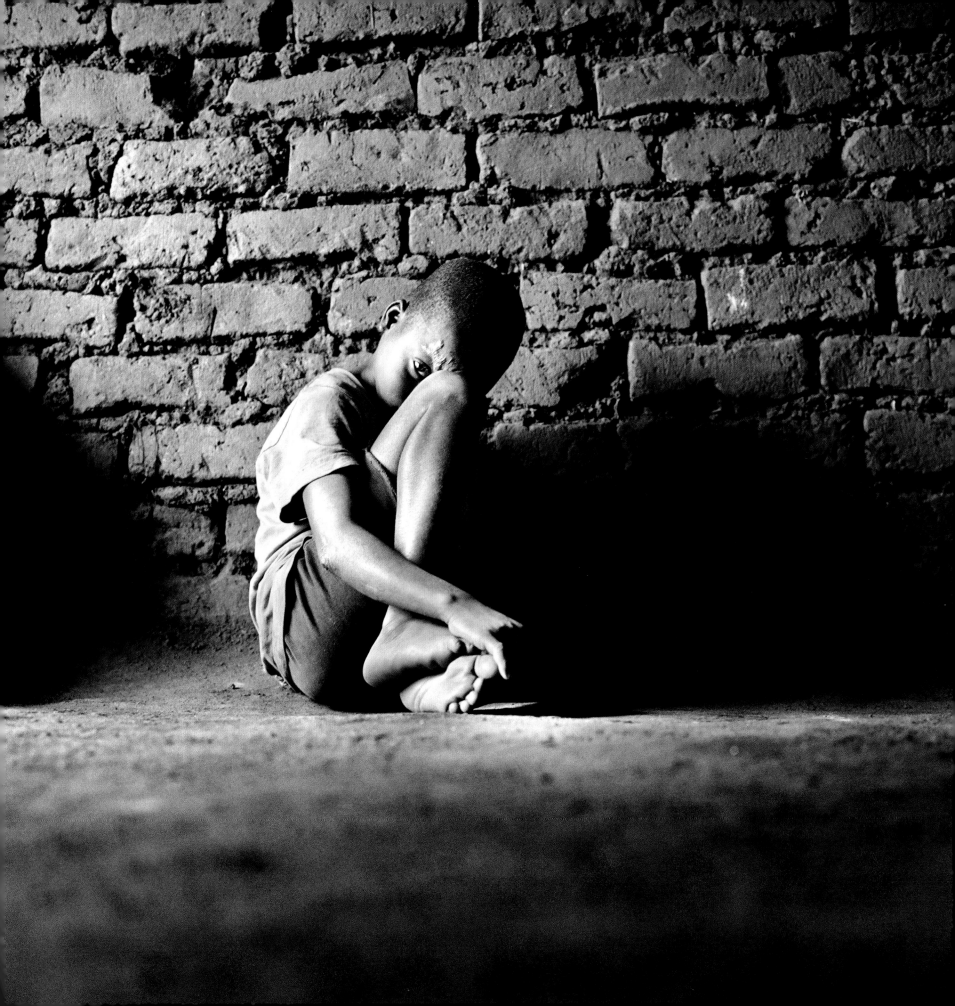

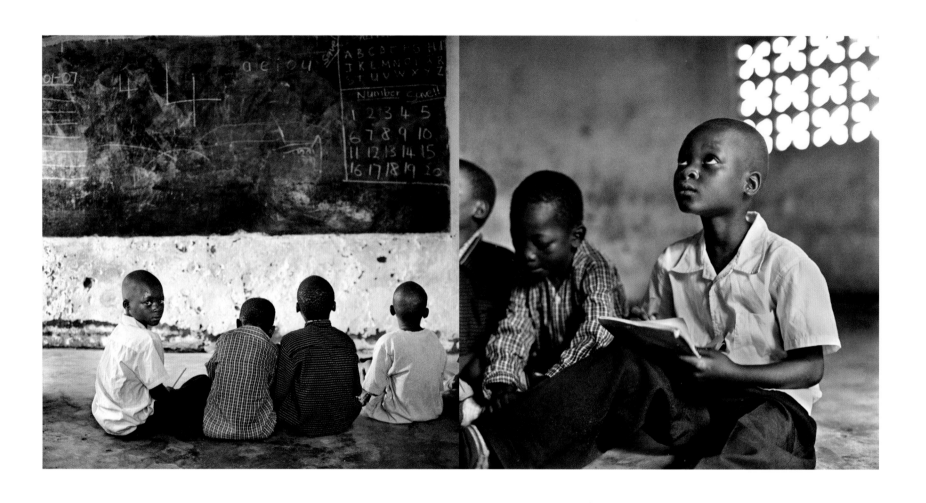

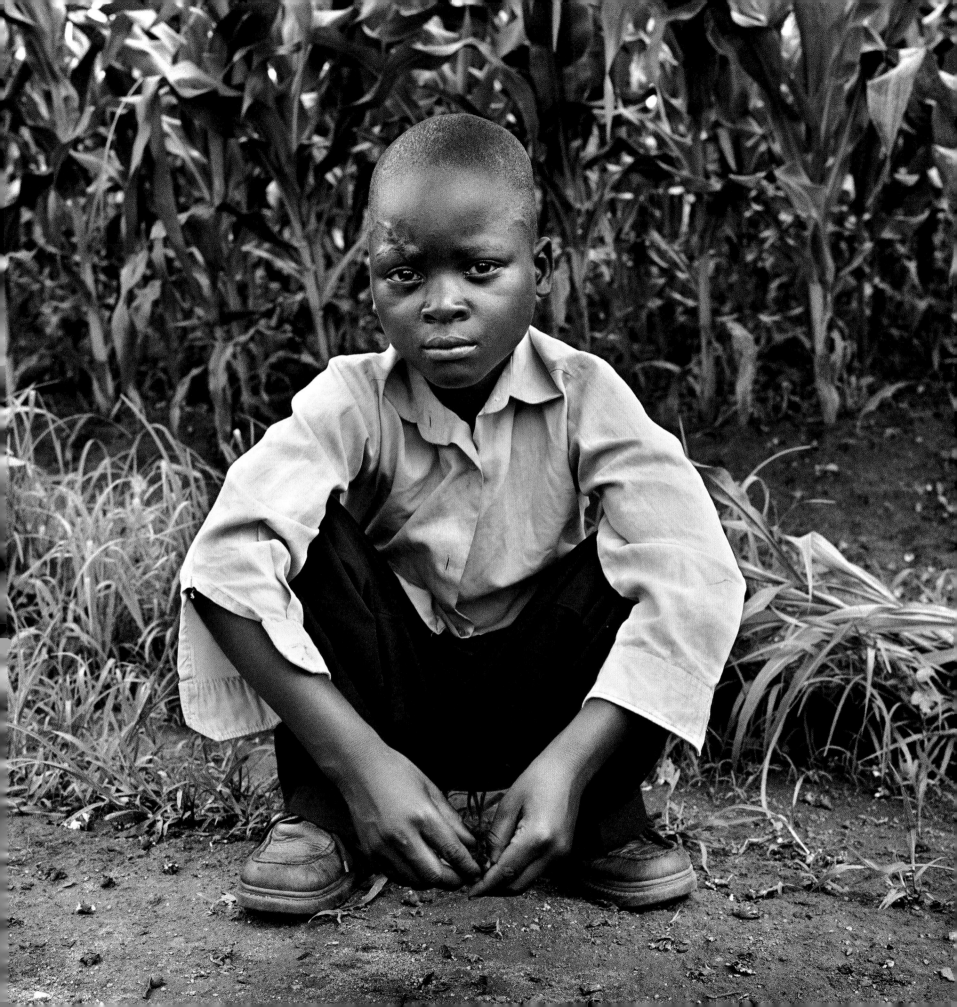

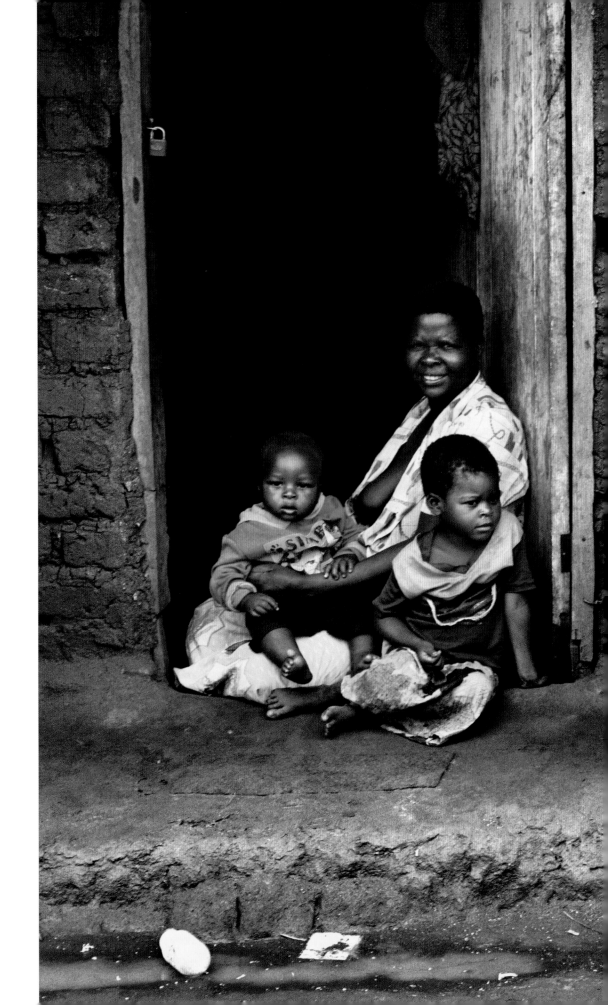

It's been a year since Luka's attack.

The first thing we had to do was find Luka proper medical attention, not easy in the outskirts of Lilongwe. We found a pediatrician that would operate on him. Unfortunately it was a six-hour drive. When we arrived, the hospital was closing. But the doctor was kind enough to stay open to do the procedure.

After a series of operations, Luka has been able to function like other little boys. I have seen him kicking a football around and laughing with his friends. I know I haven't solved all of his problems. But at least it's a start.

—Madonna

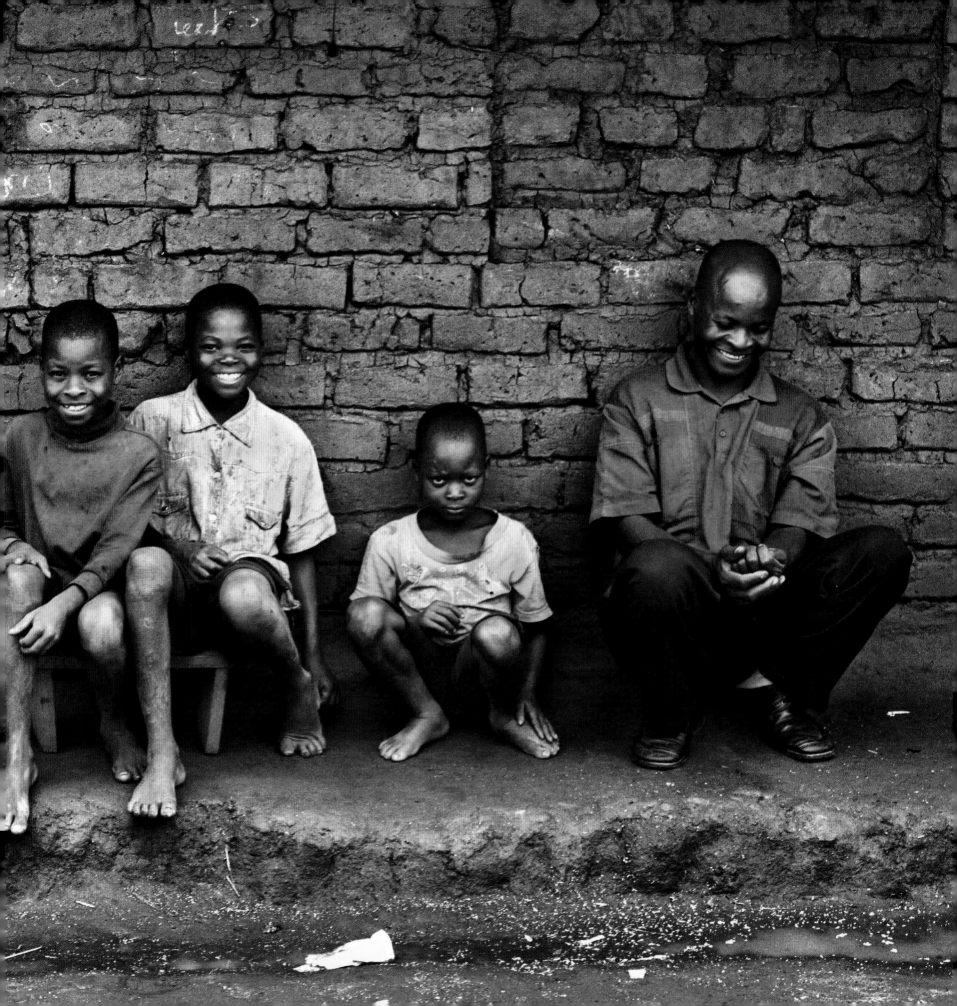

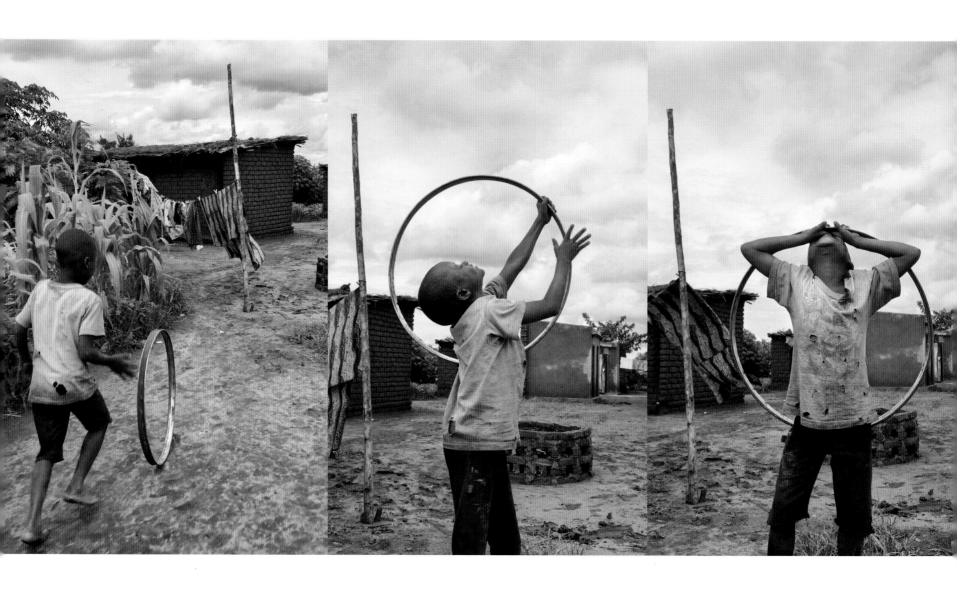

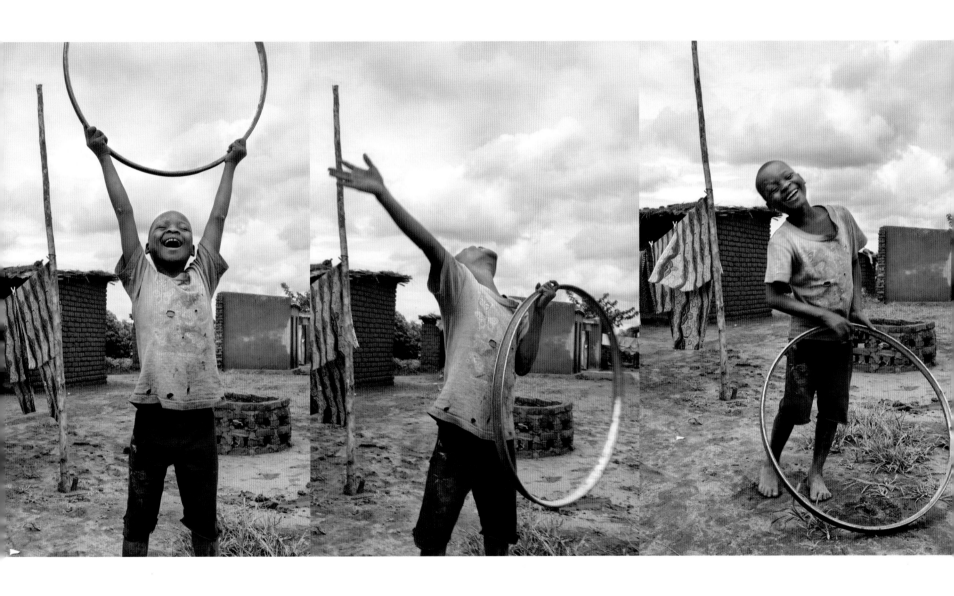

FRED

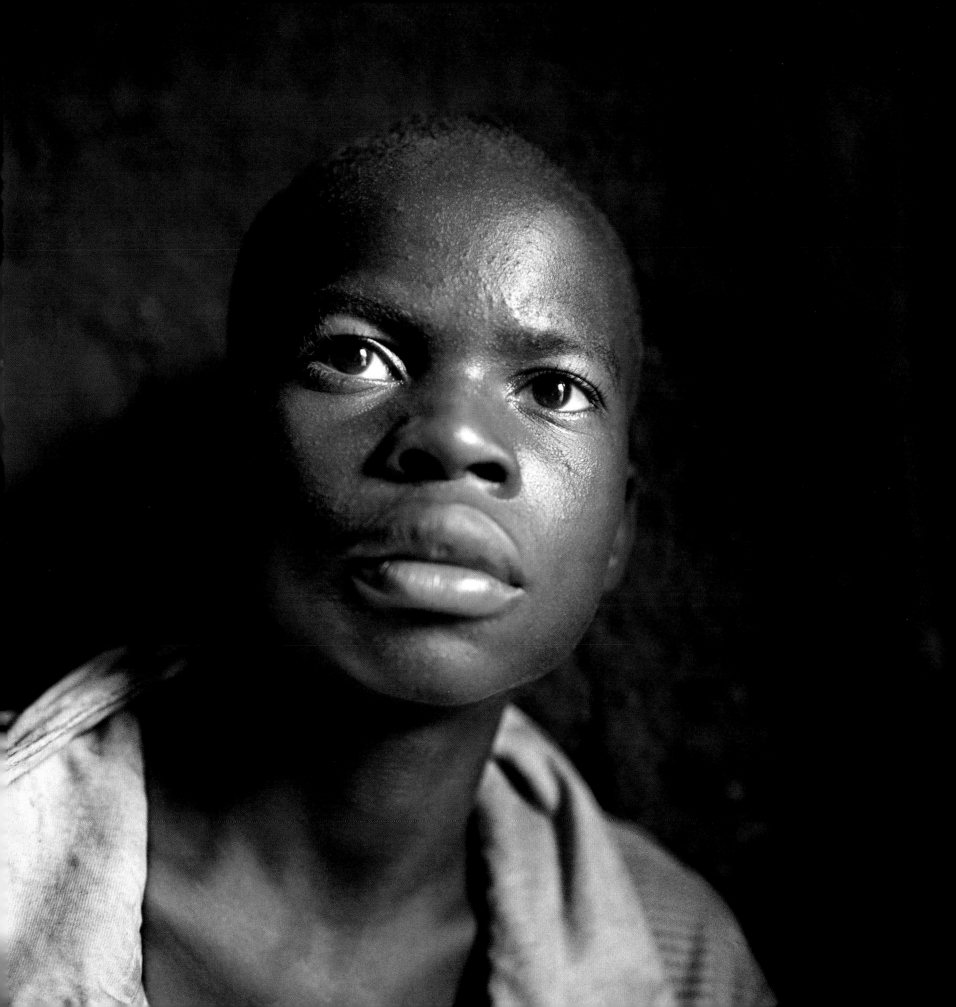

My name is Fred. This is our house.

My father's name is Mr. Fred Forty.

My mother passed away. She was very sick.
No one chooses to lose their parents.

I would have been happy if she lived to an
age when I could have taken care of her.
She only suffered for us and never had the
chance to enjoy the fruit of her labor.

The future? The way I see it?

I can't see anything because right now
I have too many problems.

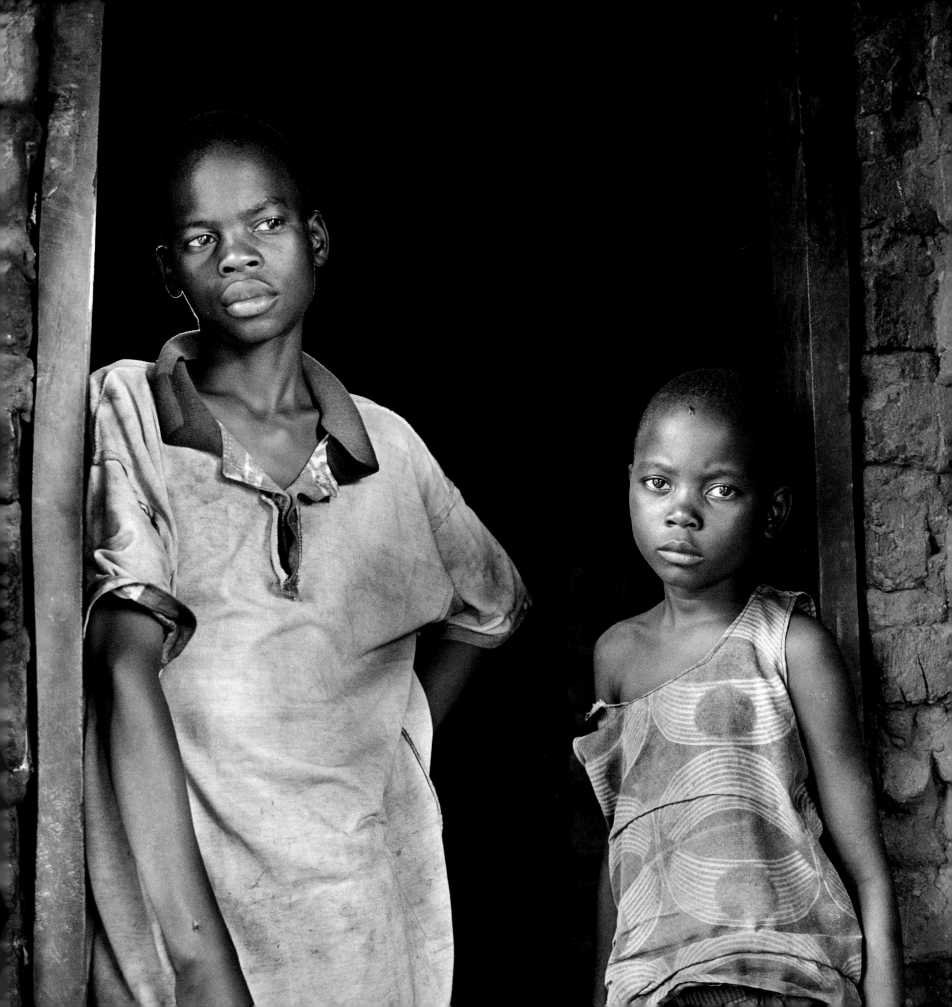

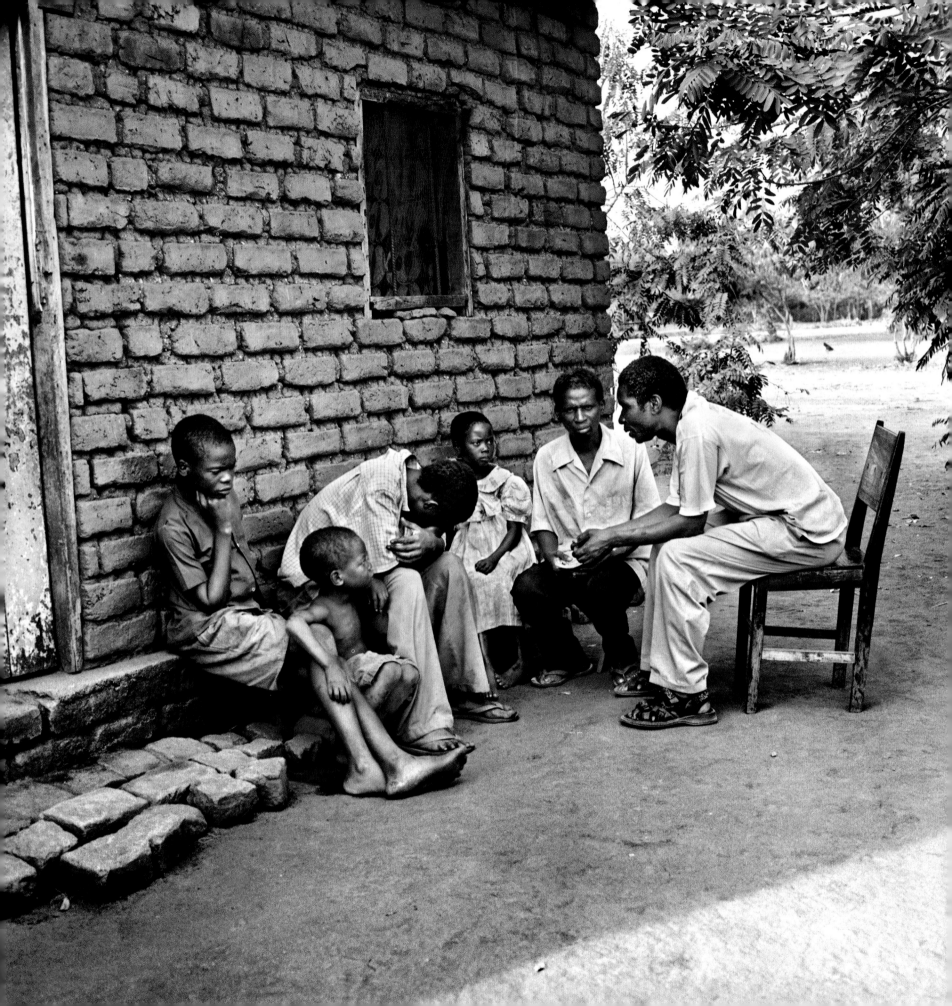

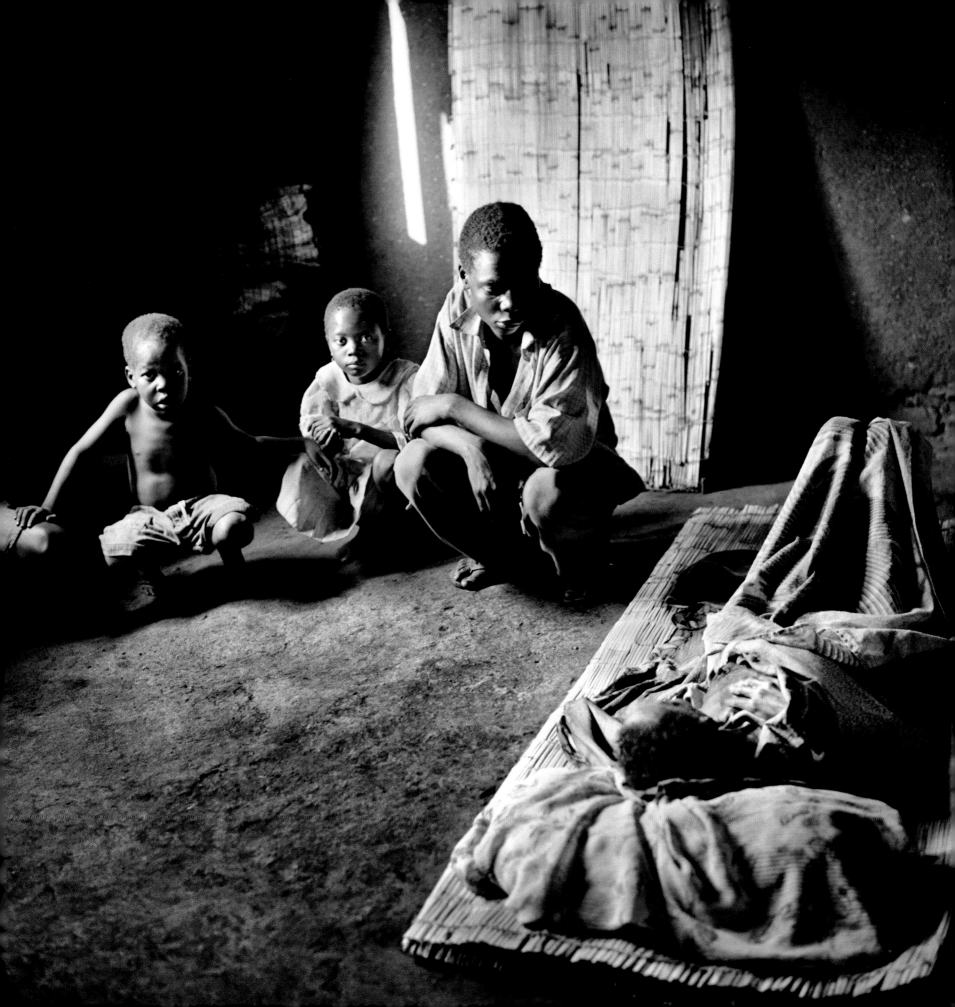

Fred is fourteen years old. His mother died in 2006, and his father is HIV positive. One of five children, Fred lives in Nsanje district in southern Malawi, one of the areas hardest hit by the AIDS pandemic. His father, a tailor, is sometimes unable to provide enough food to feed the children, forcing Fred's older brother, Frank, to leave school. Having witnessed their mother's death, the boys are now confronted with their father's uncertain future. With the help of Raising Malawi, both Fred and Frank have been able to continue their studies.

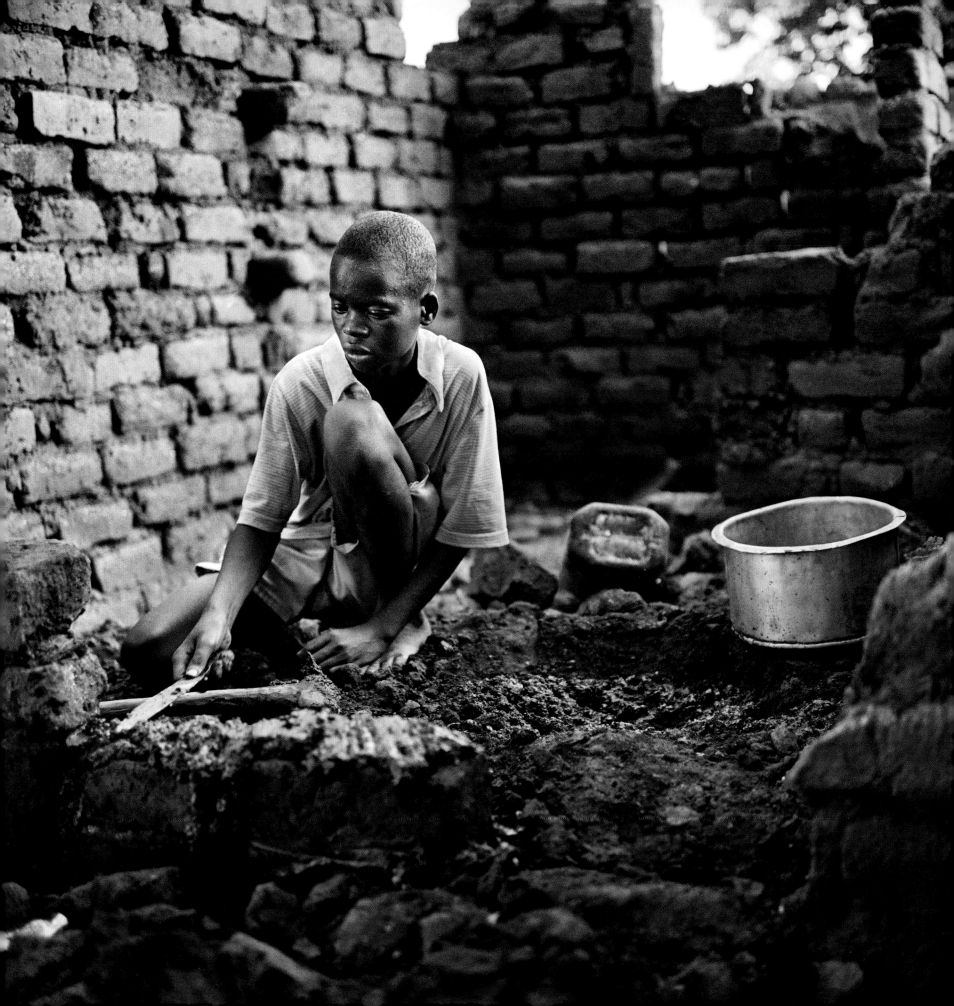

MABVUTO

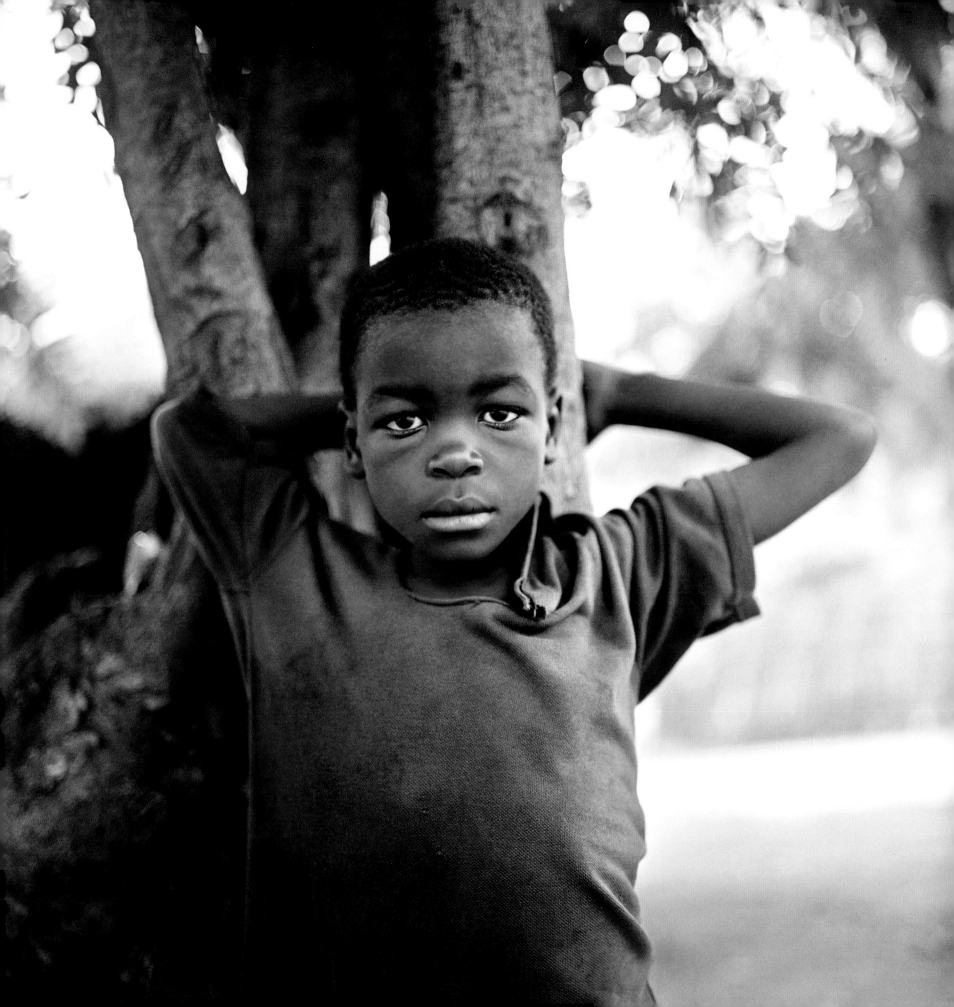

My future is gone.

I have failed to do what I wanted to do.

I wanted to look after my child. He is only eight. I wish he could grow up, finish his school, and be well educated. I often think about how I am going to die sometime soon and how my son is going to suffer.

—Mabvuto's mother

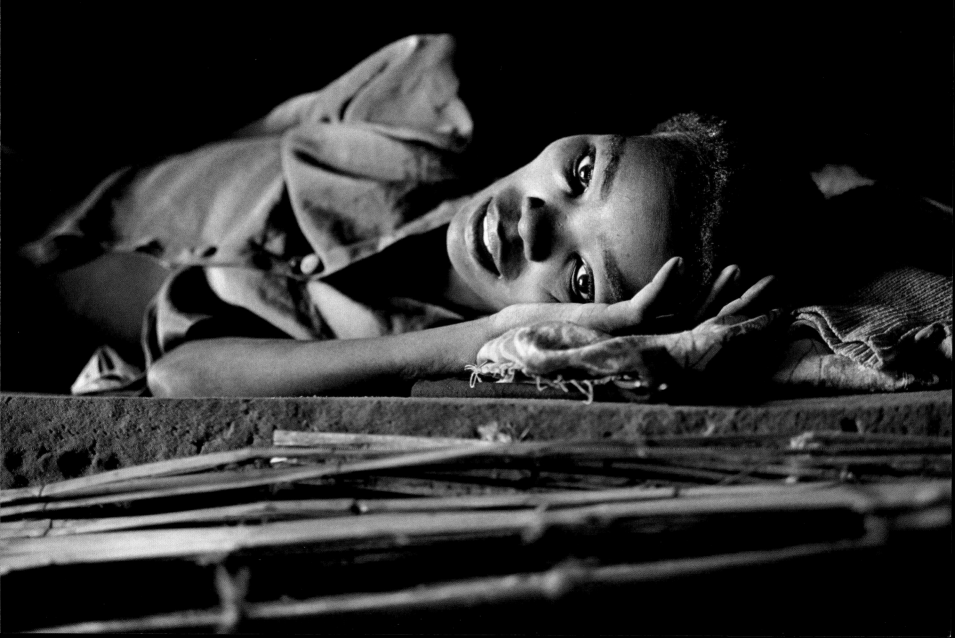

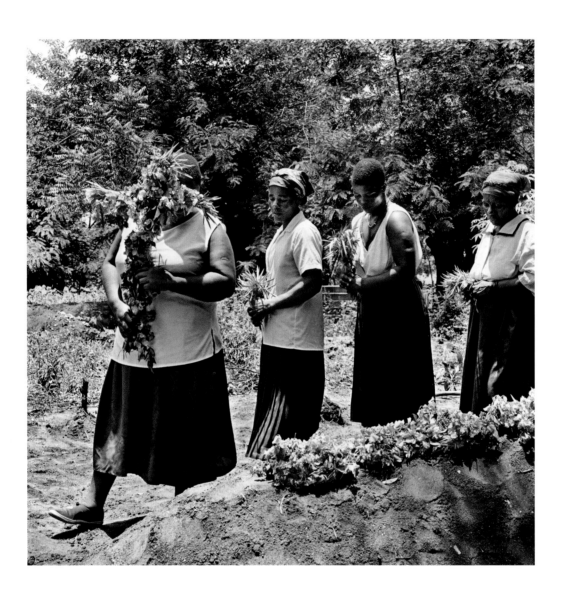

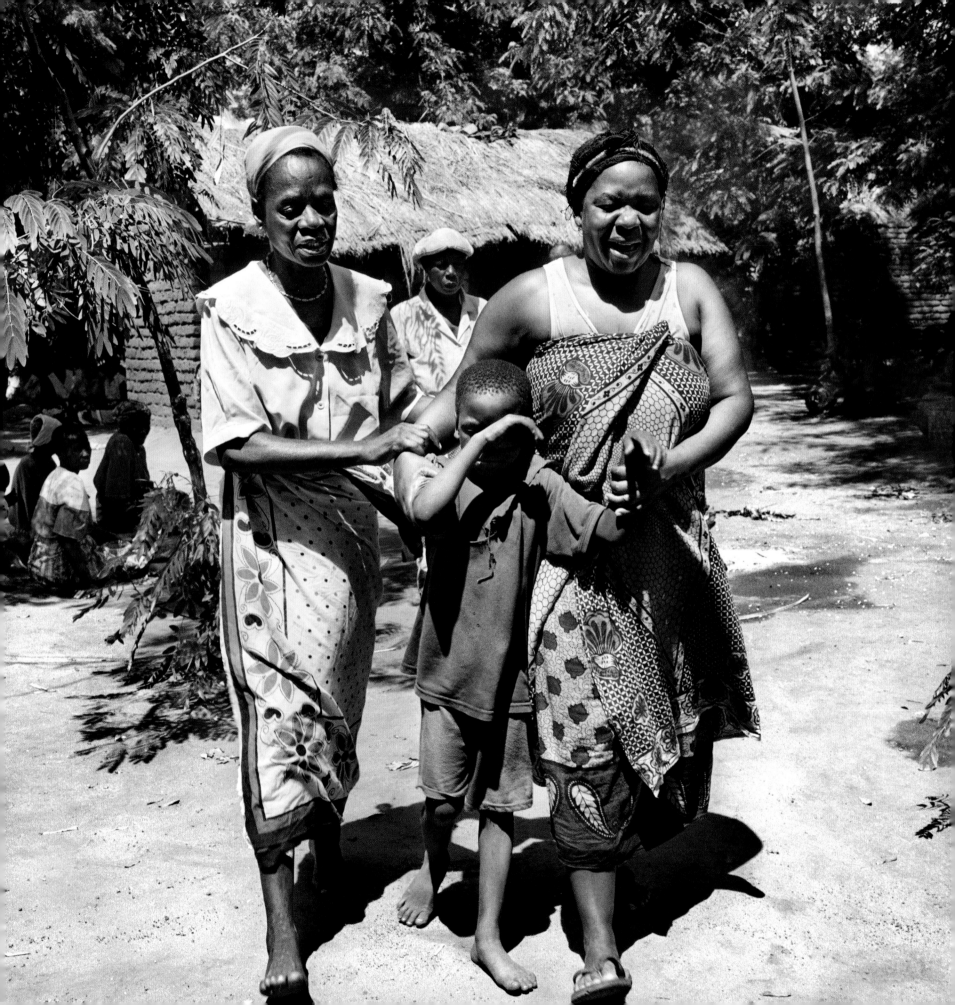

During the filming of *I Am Because We Are*, Mabvuto's mother Flora died of AIDS. He has since been taken in by a distant uncle he barely knew. The emotional burden children face in losing a parent is something that Mabvuto shares with millions of children throughout Africa. His future is still unclear, but for the moment, the sponsorship he receives from Raising Malawi has allowed him to continue attending school regularly.

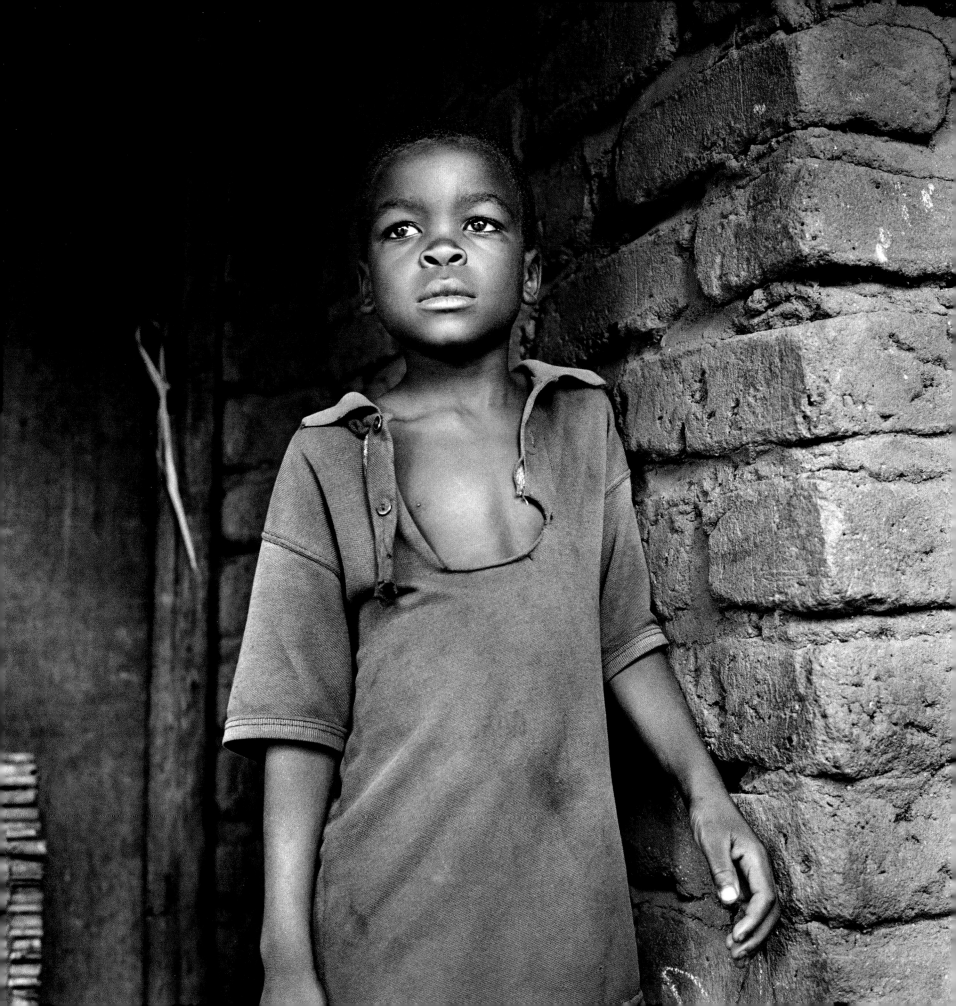

MERCY

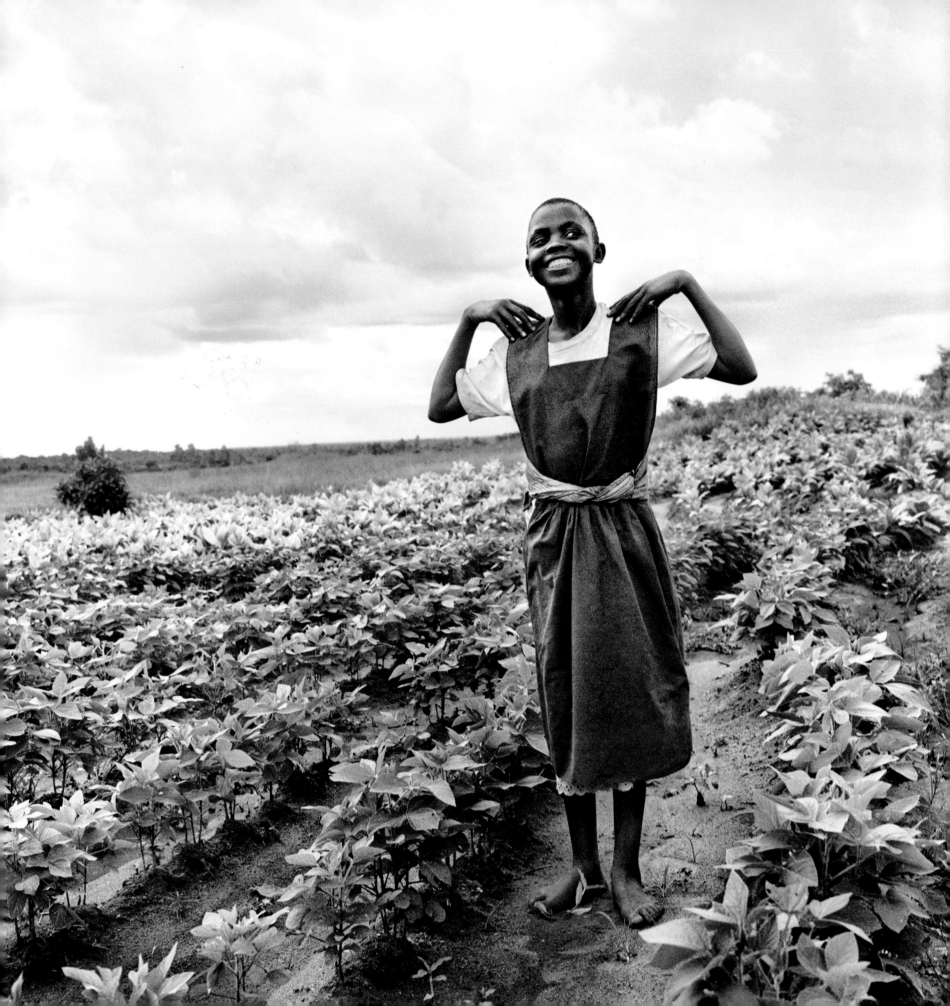

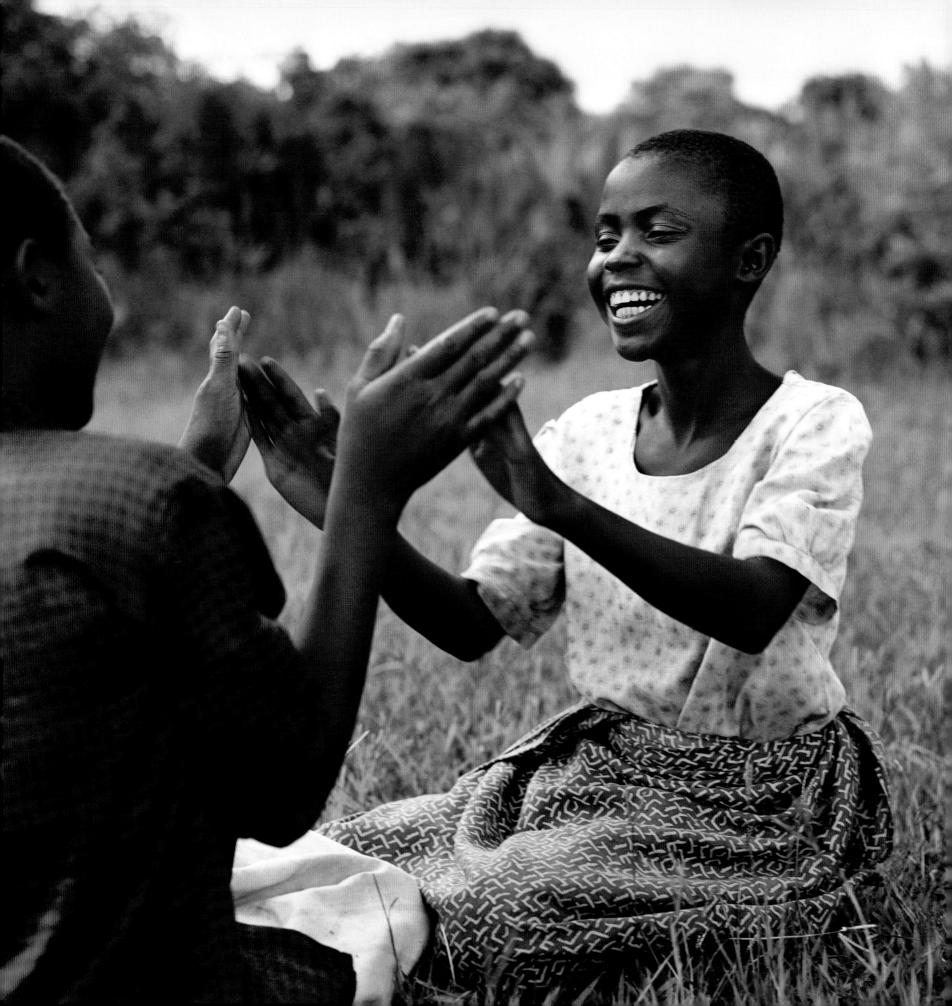

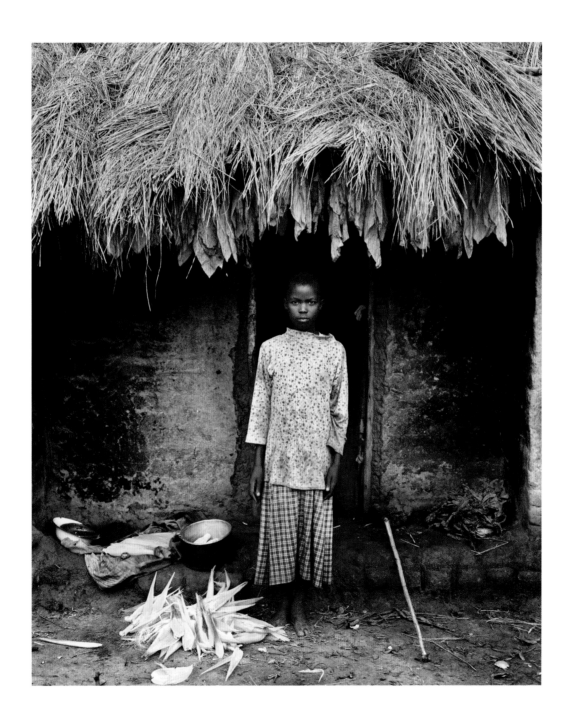

Mercy is thirteen years old. Orphaned at a very young age, she and her younger brother were taken in by their grandmother, a subsistence farmer in a small village near Lilongwe. As the oldest girl in the family, she works in the fields, cooks, and does chores—all of which leaves little time for her studies.

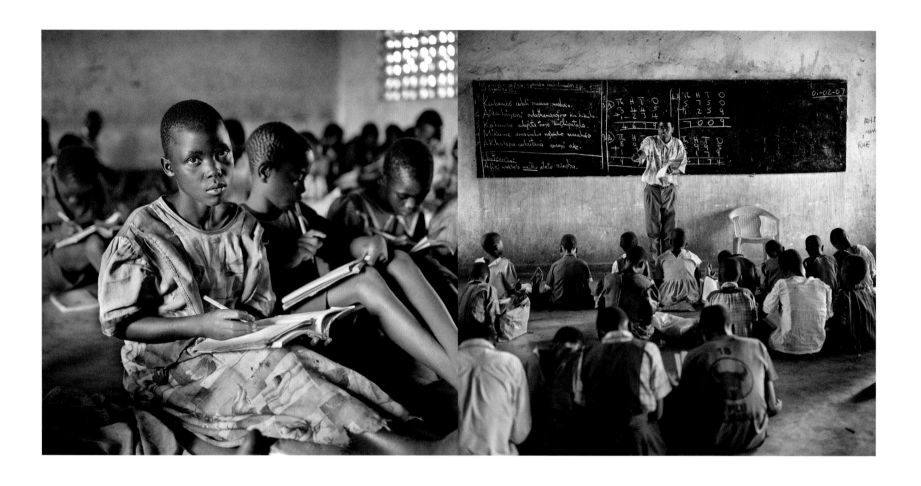

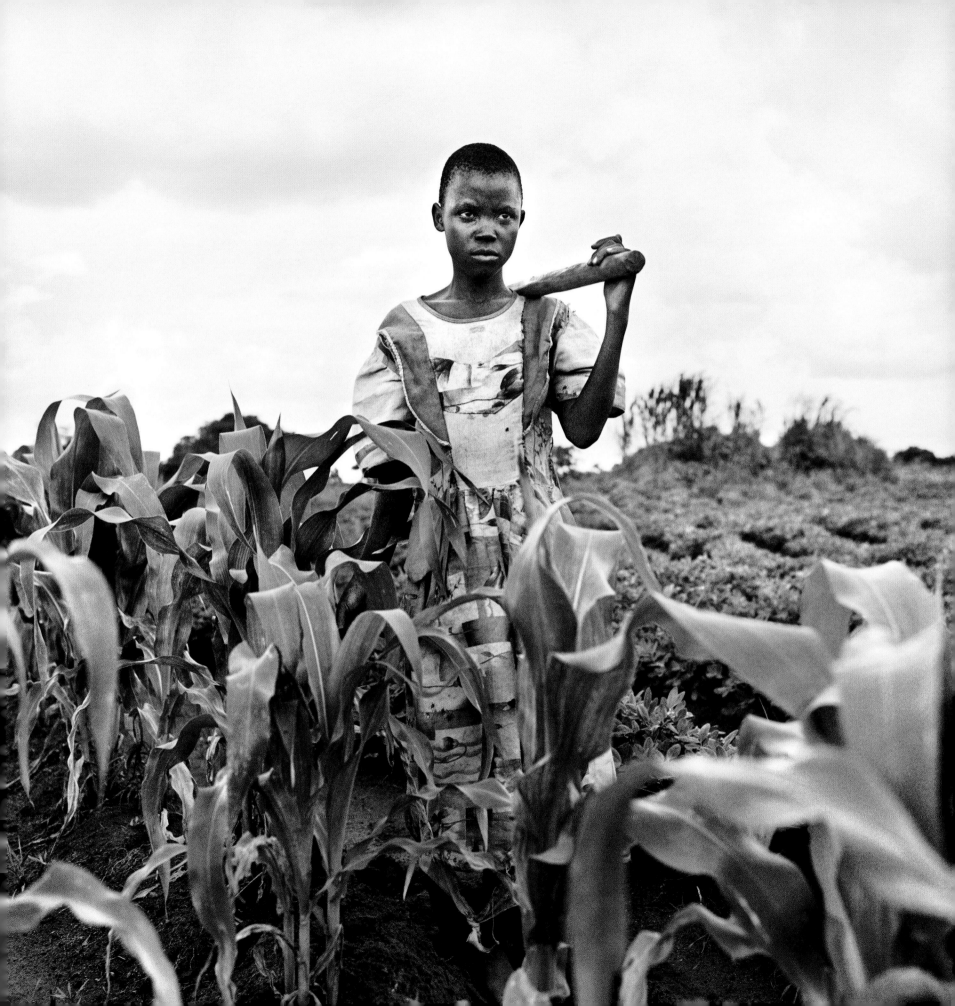

Recognizing Mercy's potential, Raising Malawi has sponsored her attendance at an all-girls boarding school. By receiving a higher education, Mercy hopes to avoid the fate of many other girls in her village.

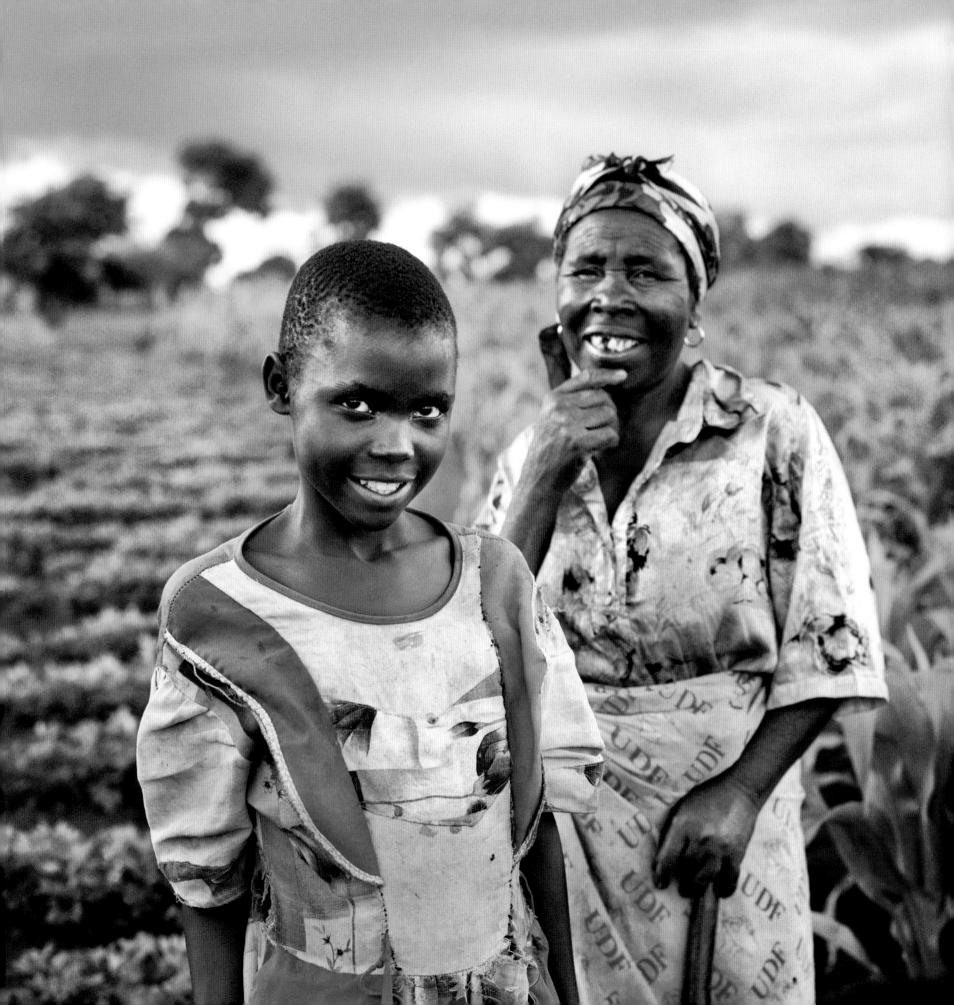

SINODE

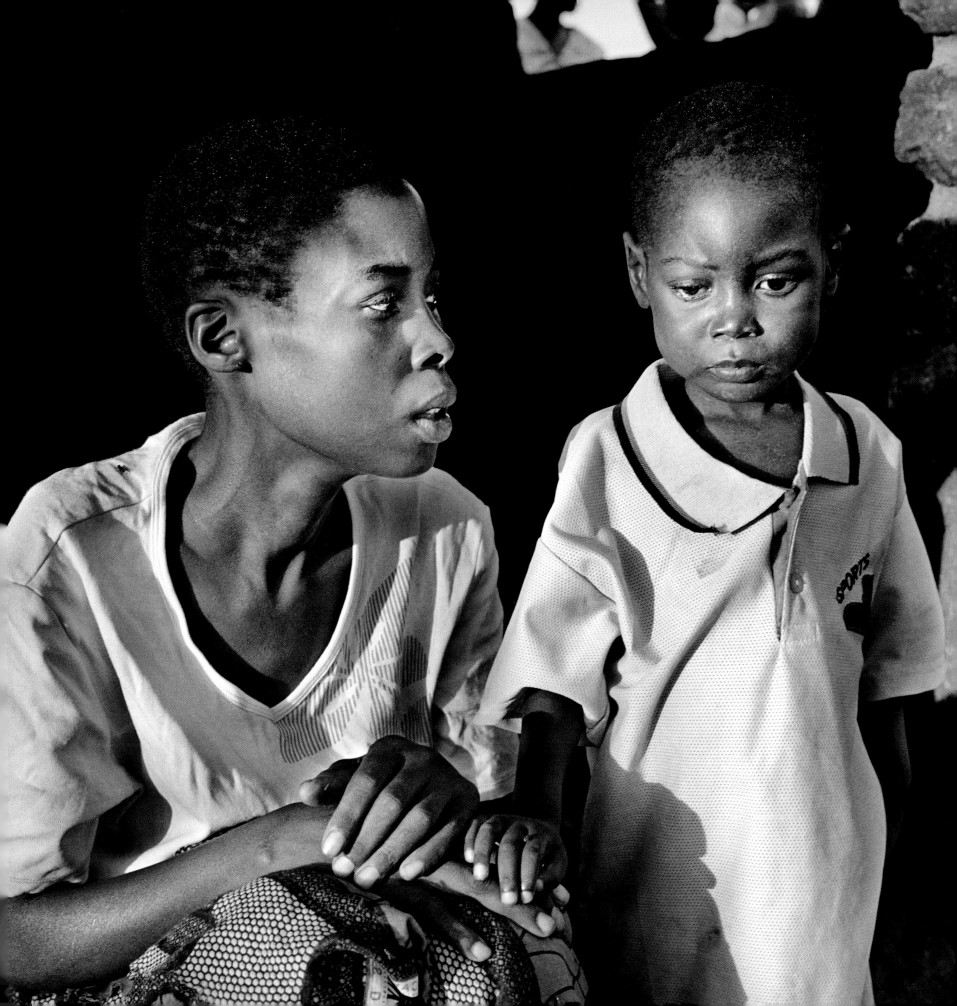

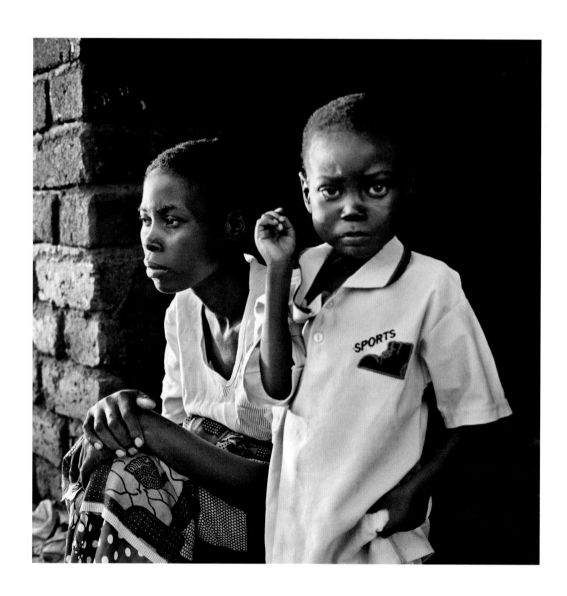

Sinode is six years old. Both he and his mother, Edith, were diagnosed HIV positive in January 2007. Living in rural Malawi, they were cut off from basic medical attention. A trip to a nearby hospital required a three-hour bicycle journey.

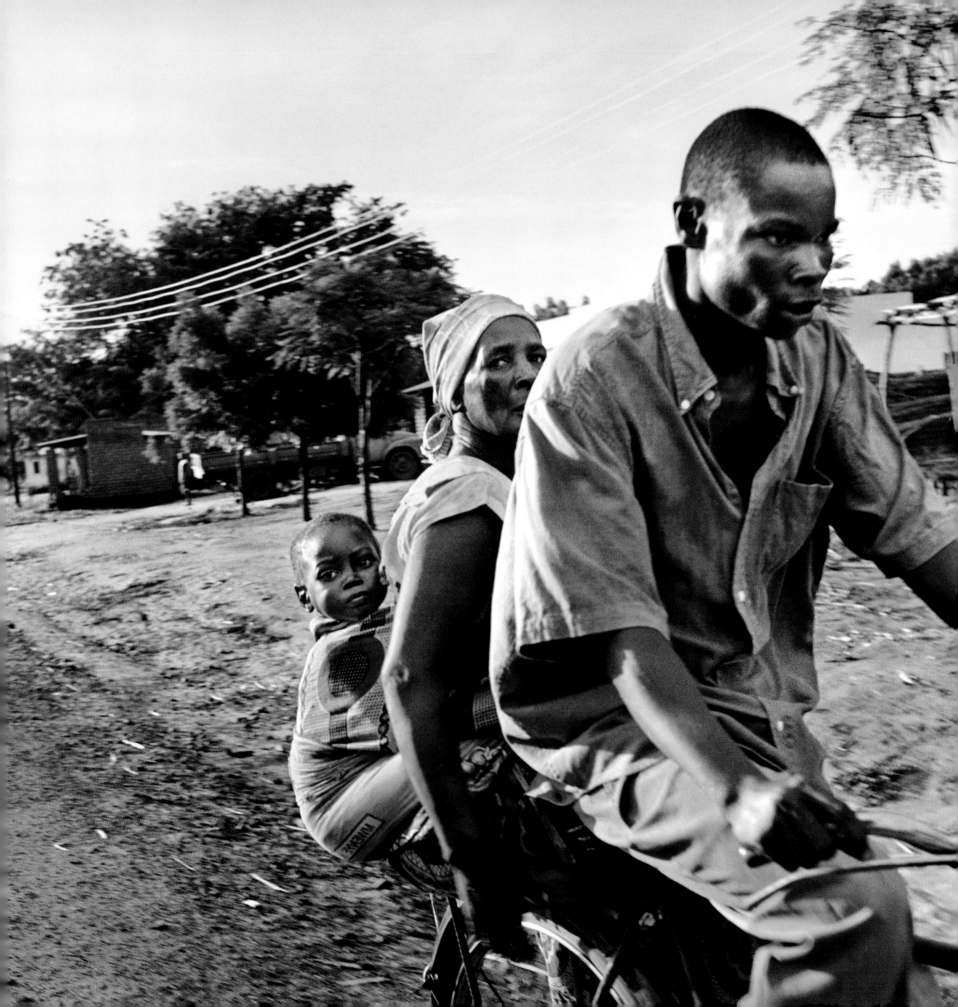

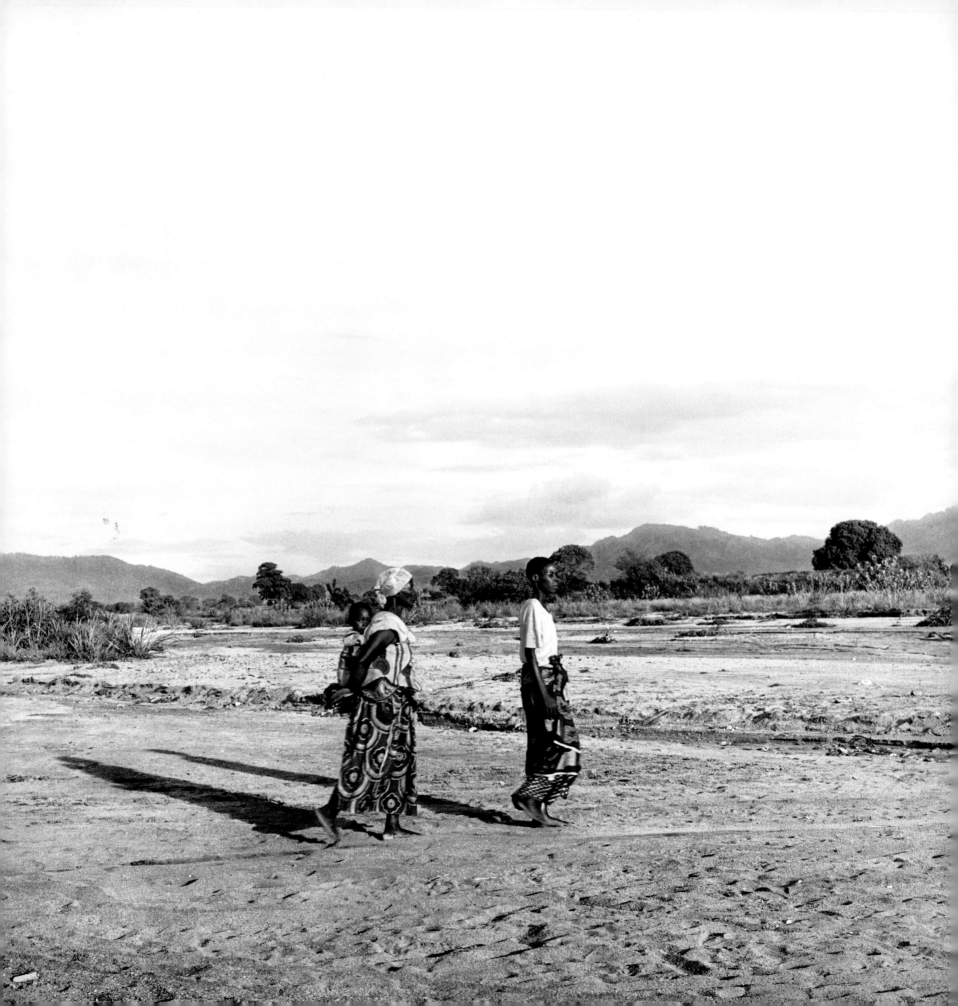

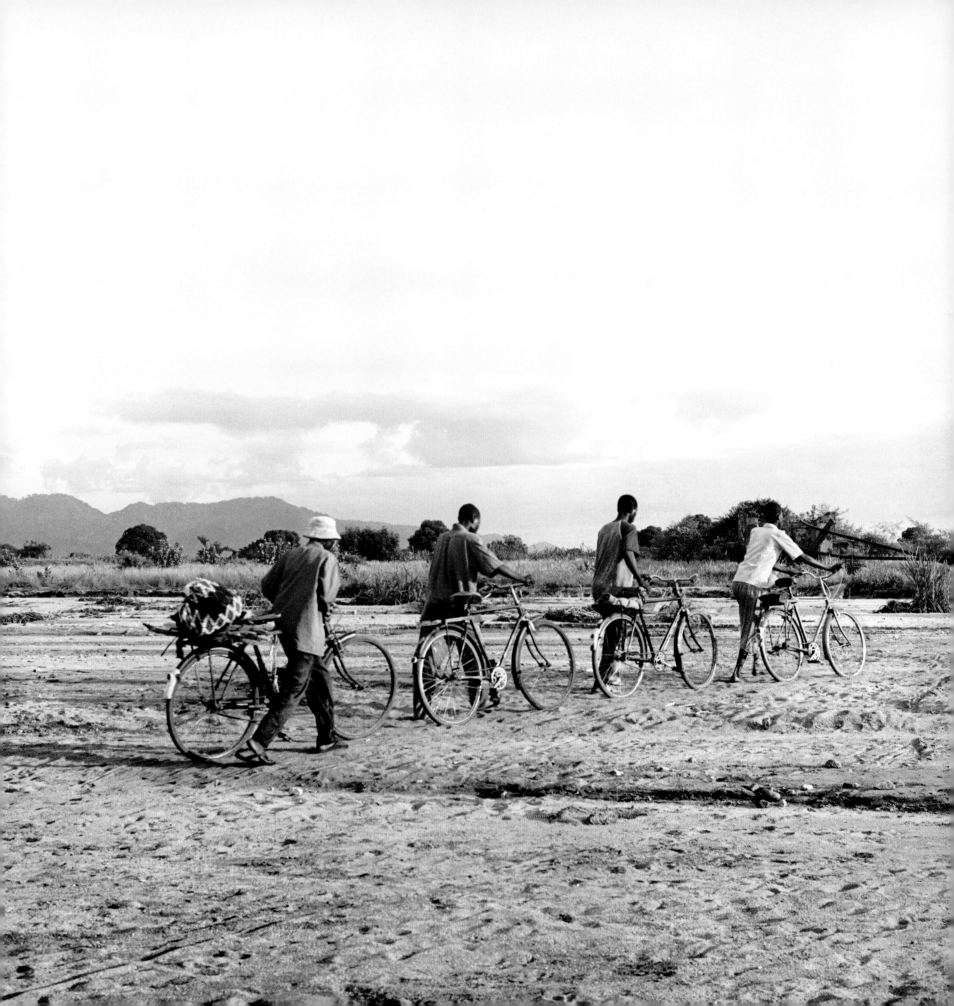

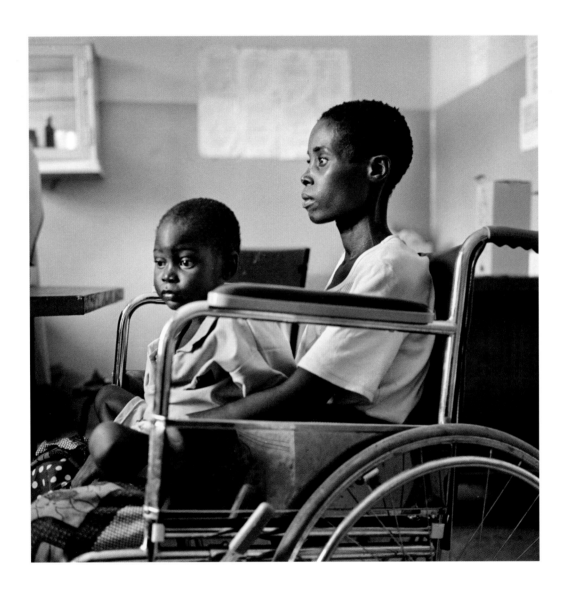

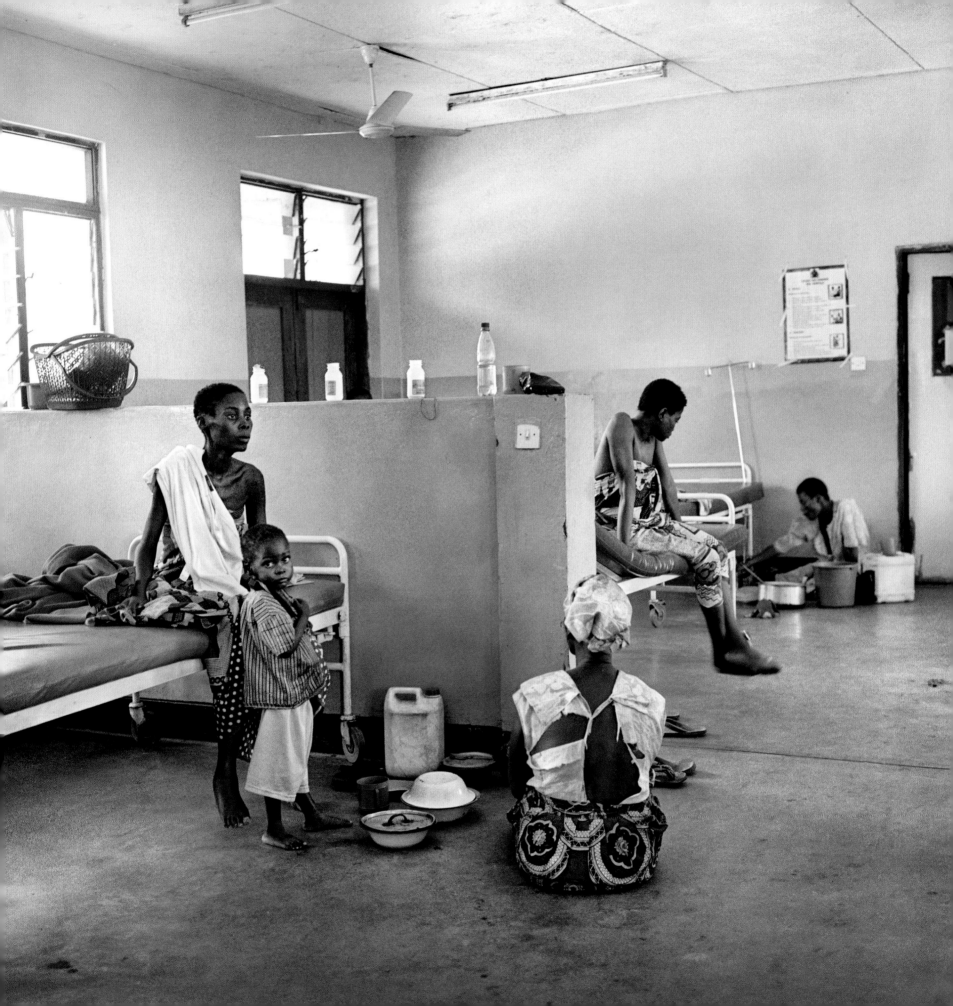

During the filming of *I Am Because We Are*, Sinode's mother Edith died. Sinode is now in the care of his grandmother who, with the assistance of Raising Malawi, has been able to provide him with life-saving ARV drugs.

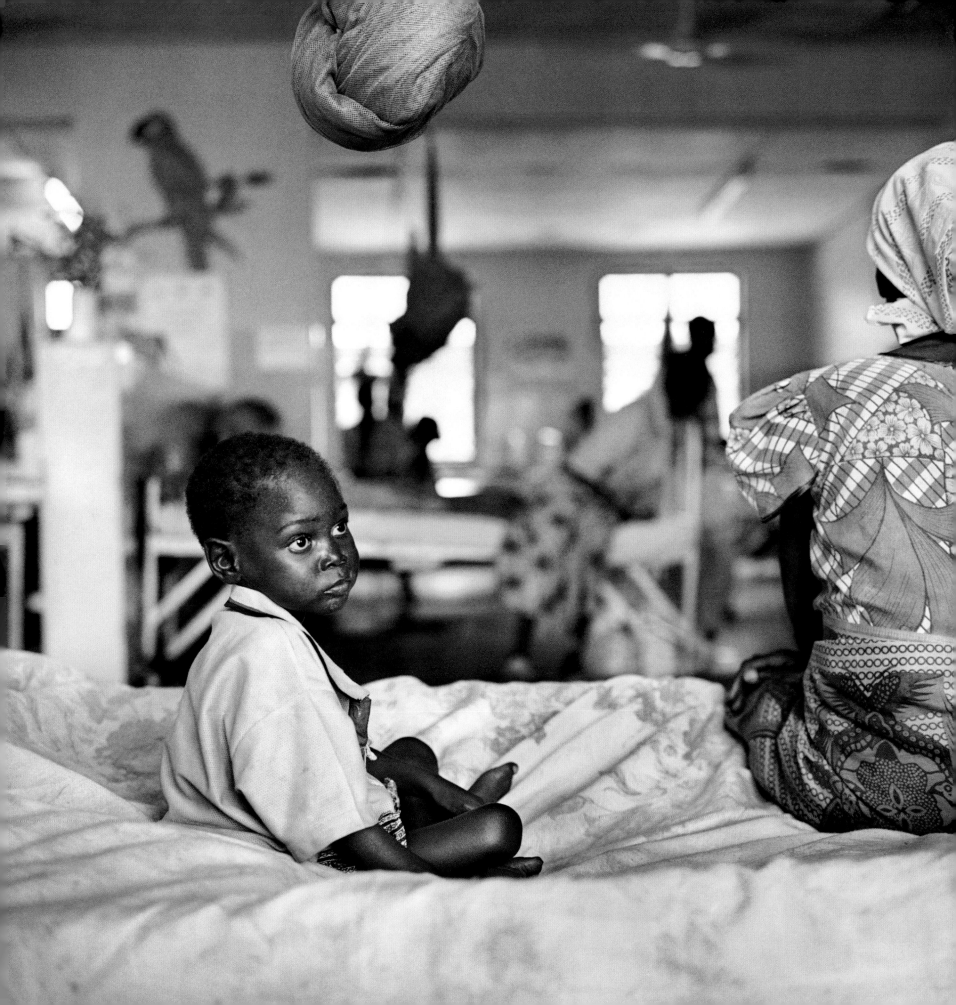

THE CRISIS

AIDS IN SOUTHERN AFRICA

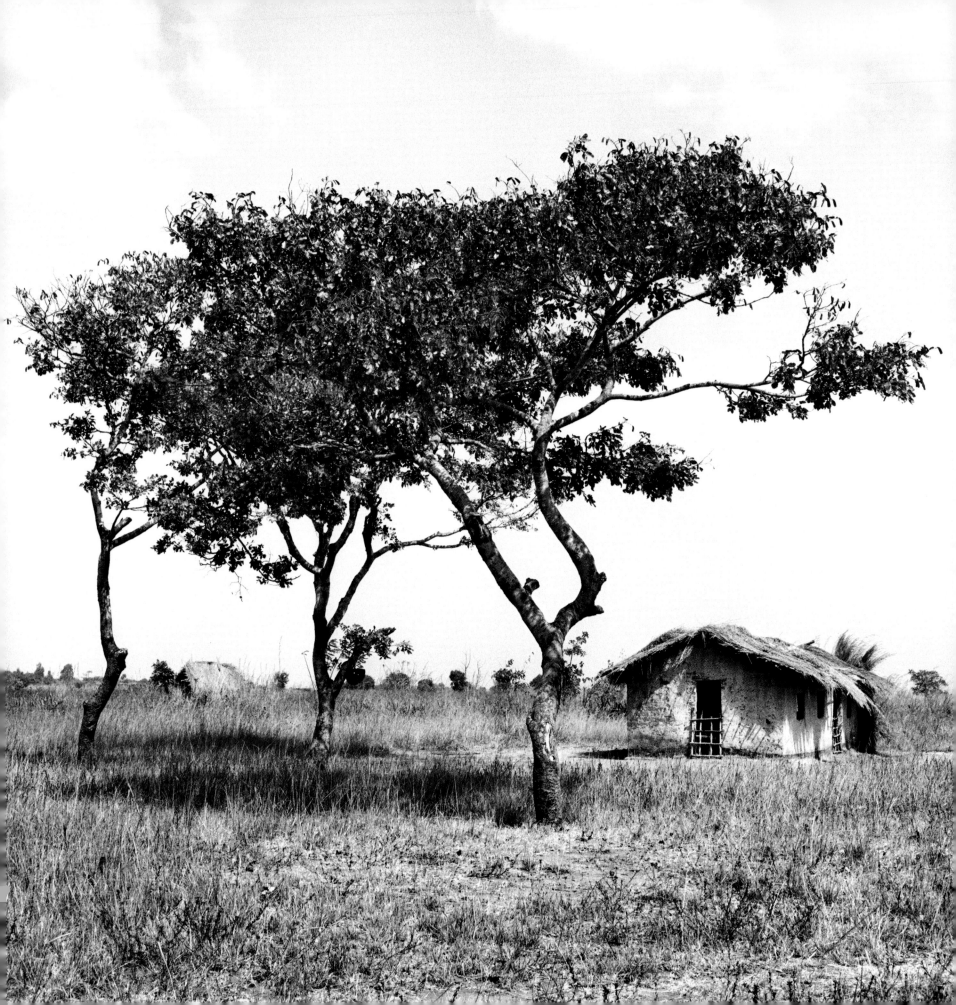

IN THE LAST TWENTY-FIVE YEARS, AIDS, A PREVENTABLE, TREATABLE DISEASE, has killed approximately 30 million people in Africa. This massive loss of mothers and fathers has created an entire generation of orphans.

More than 12 million children have experienced the death of a parent from AIDS. These children face incalculable odds. The fortunate find shelter with distant relatives or elderly grandparents. Others are left to fend for themselves.

Without a safety net, many orphans drop out of school to find work. The eldest are often forced to become parents to their younger siblings. All of these vulnerable children are trapped in a vicious cycle of poverty that exposes them to higher risks of contracting the virus themselves.

In 2007 alone, 1.6 million people died of AIDS in southern Africa. Only a quarter of those needing medical care actually received it. With the advent of anti-retroviral drugs over the last decade, AIDS is no longer a death sentence. However, for the overwhelming majority of the 22.5 million HIV-positive Africans and their children, these life-saving drugs remain out of reach.

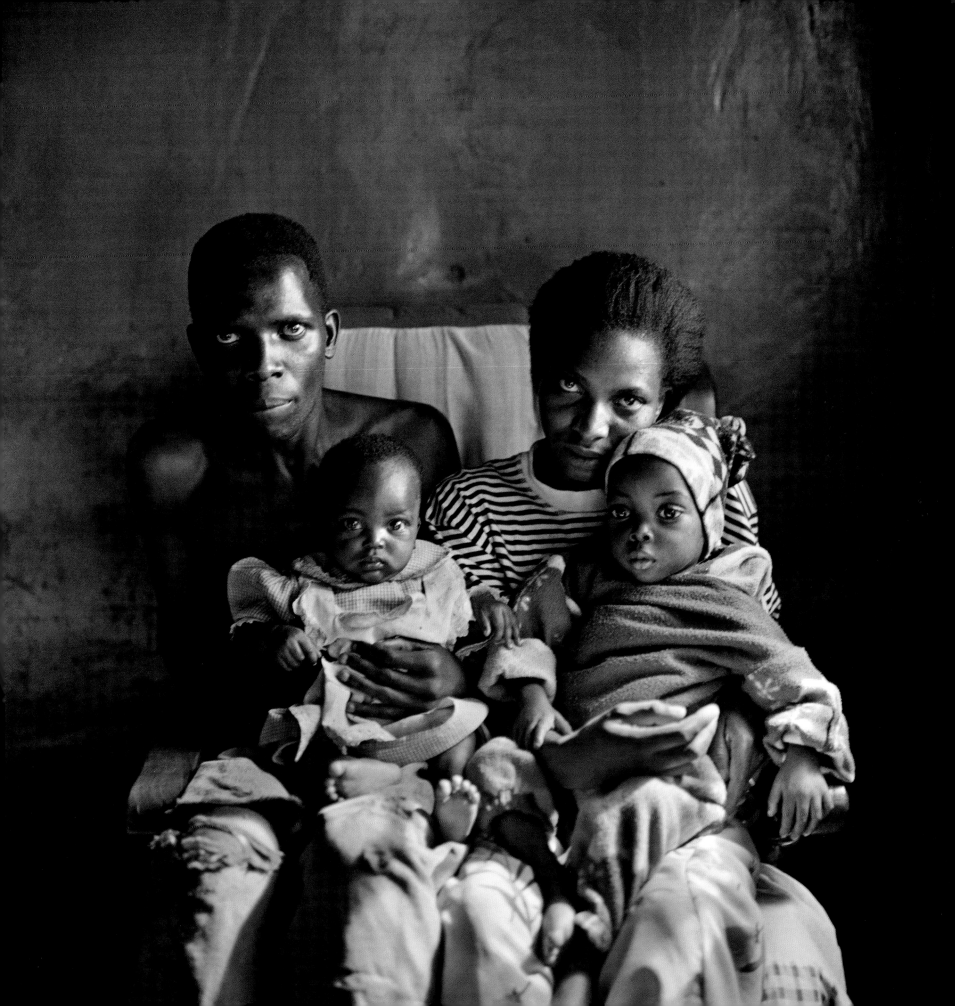

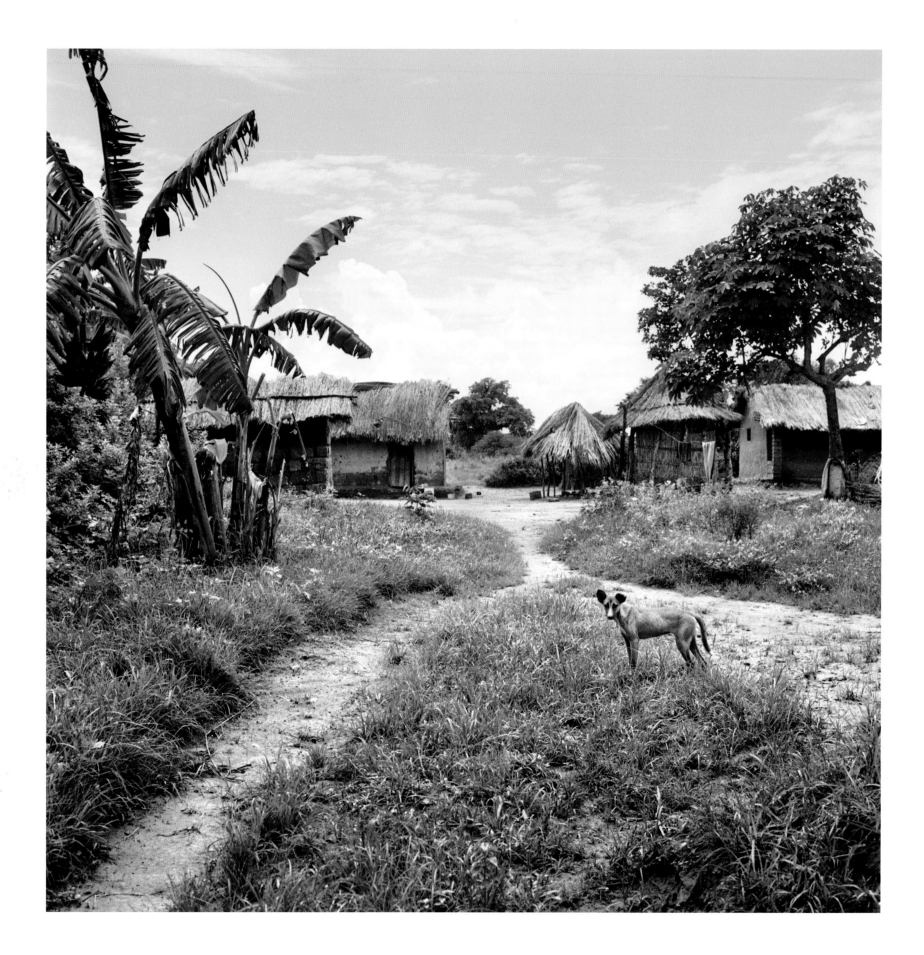

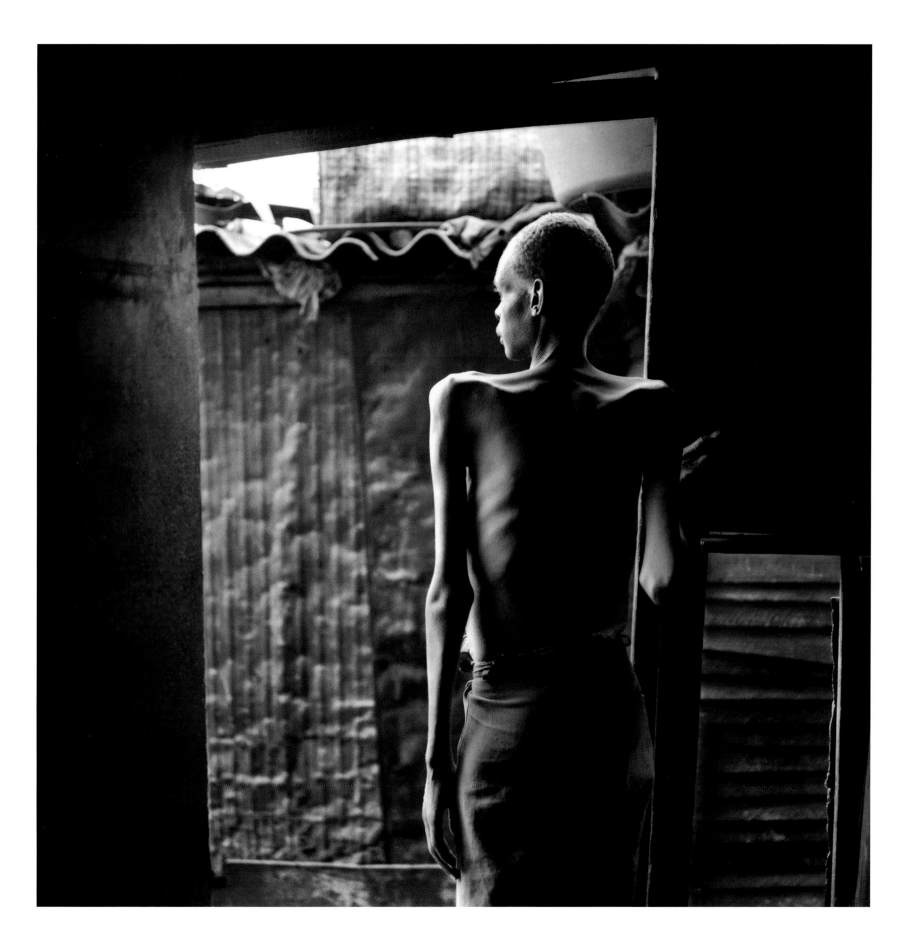

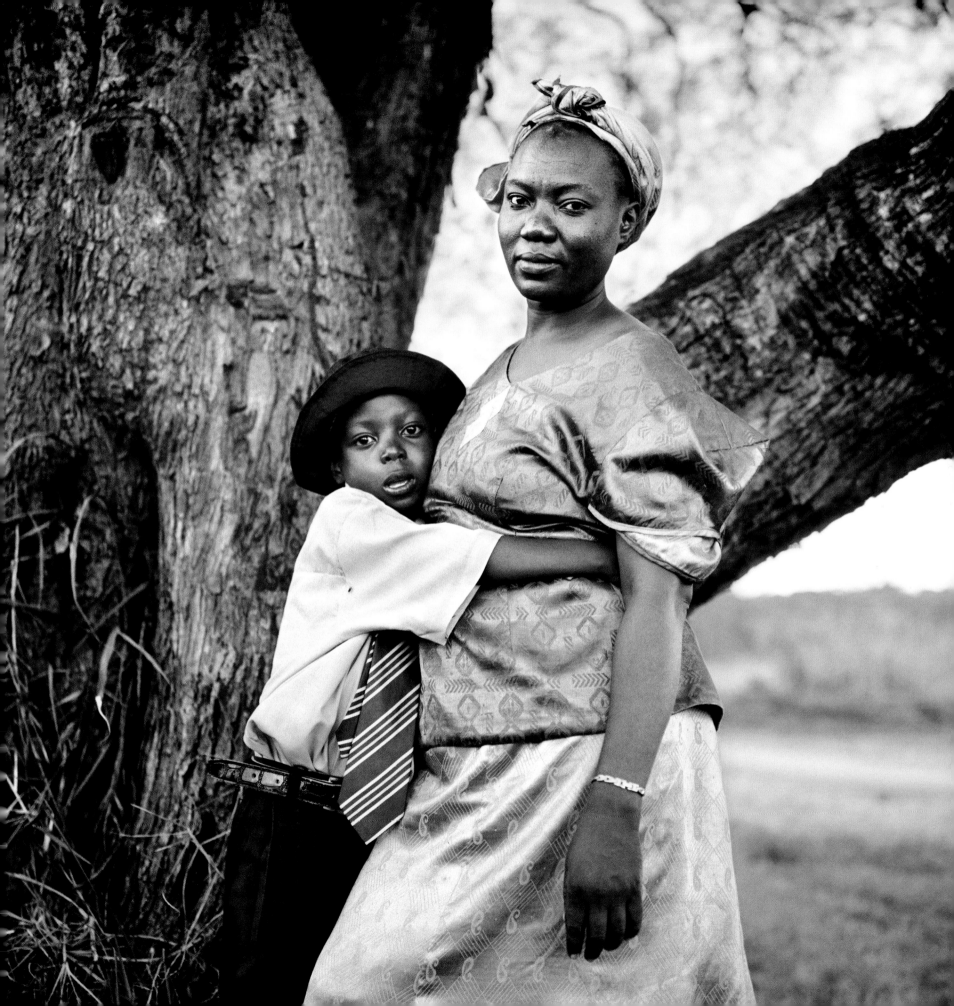

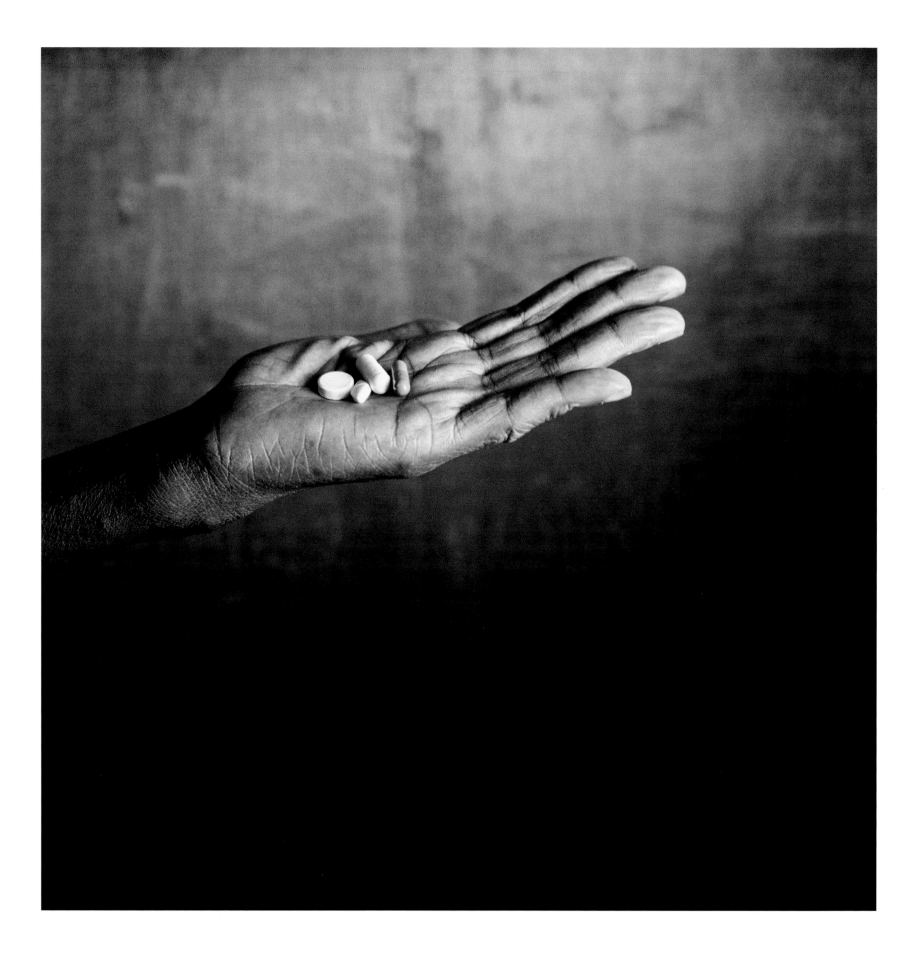

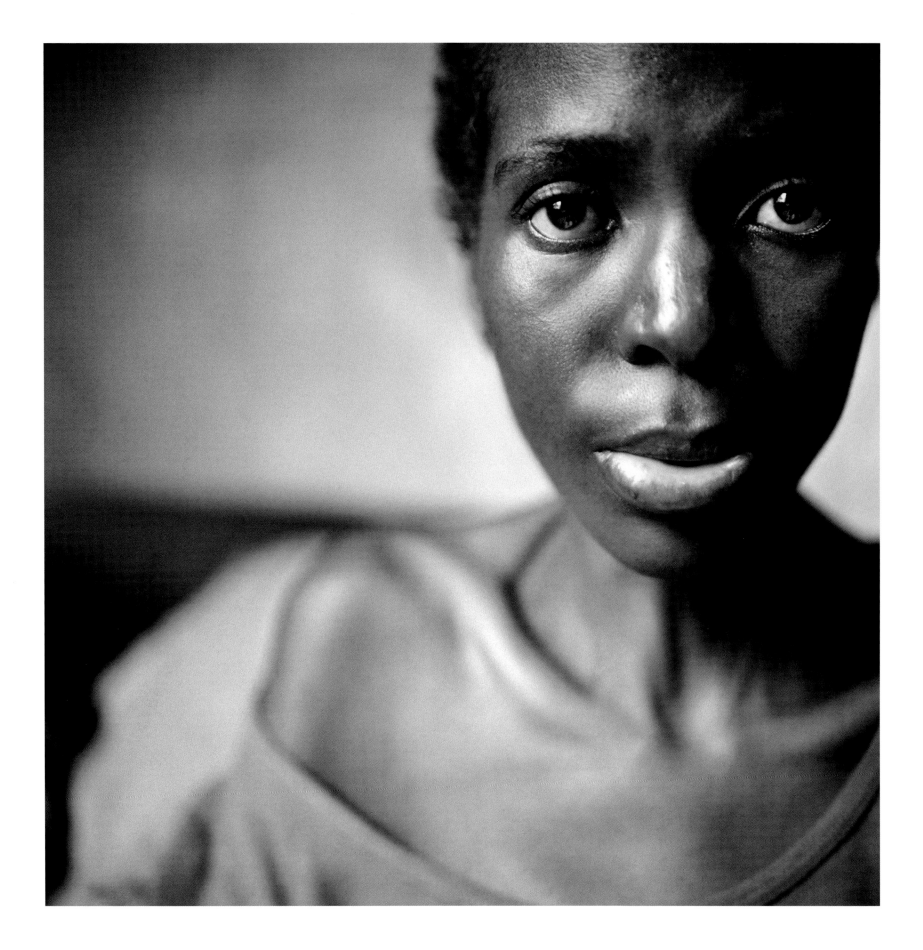

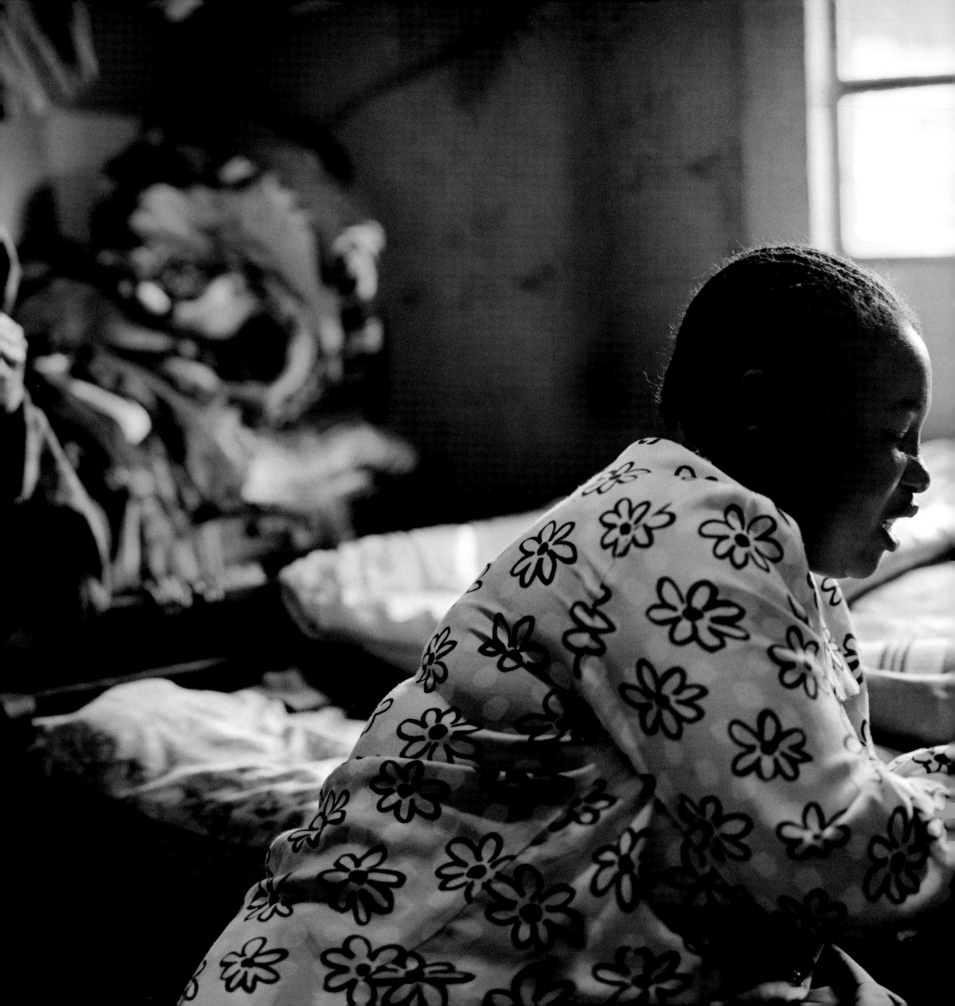

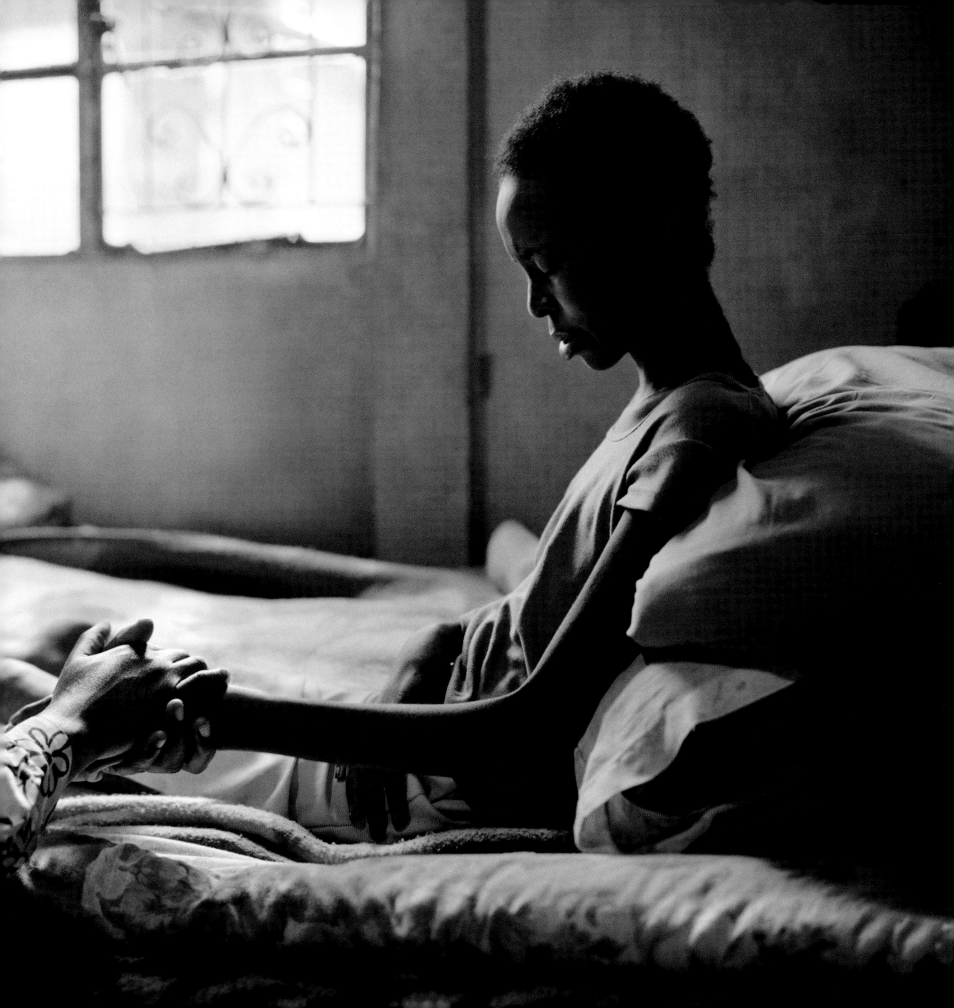

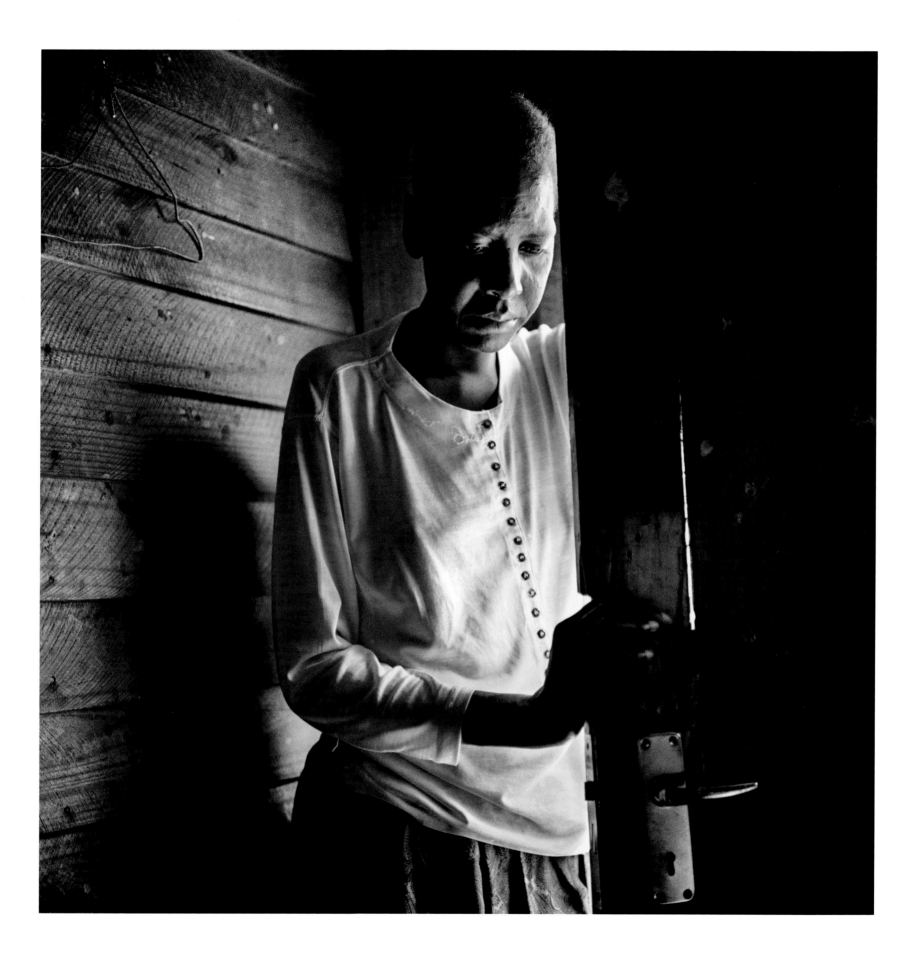

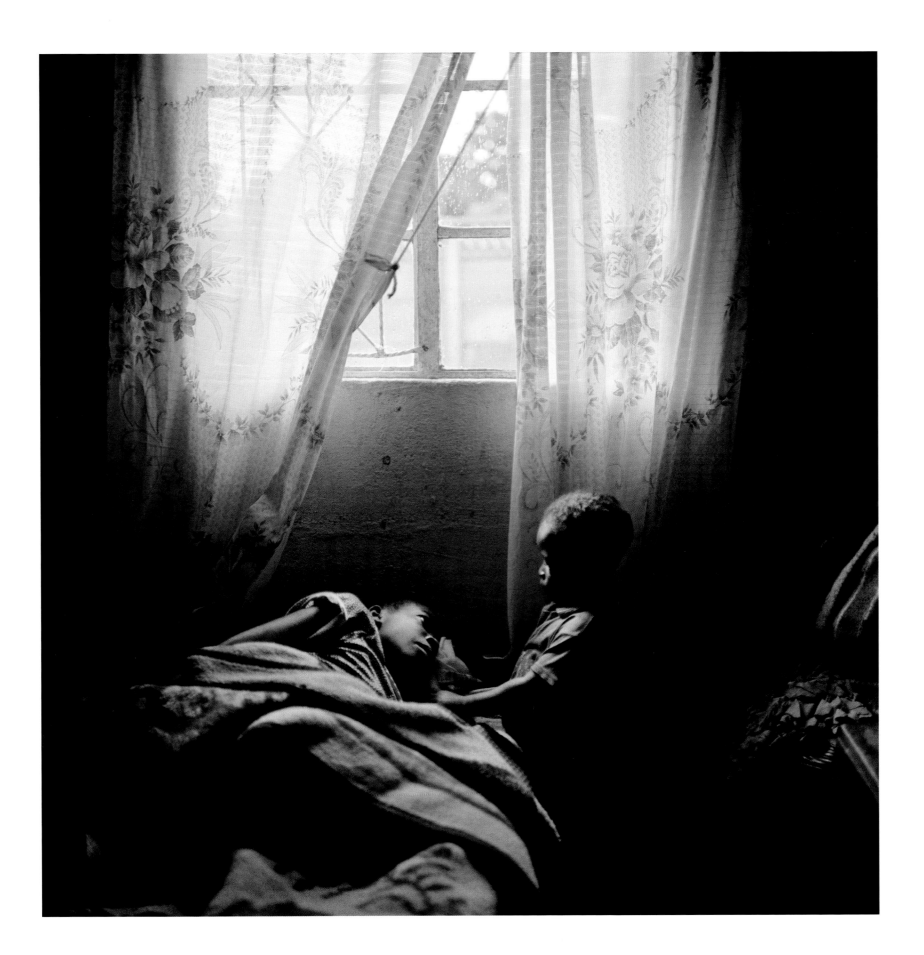

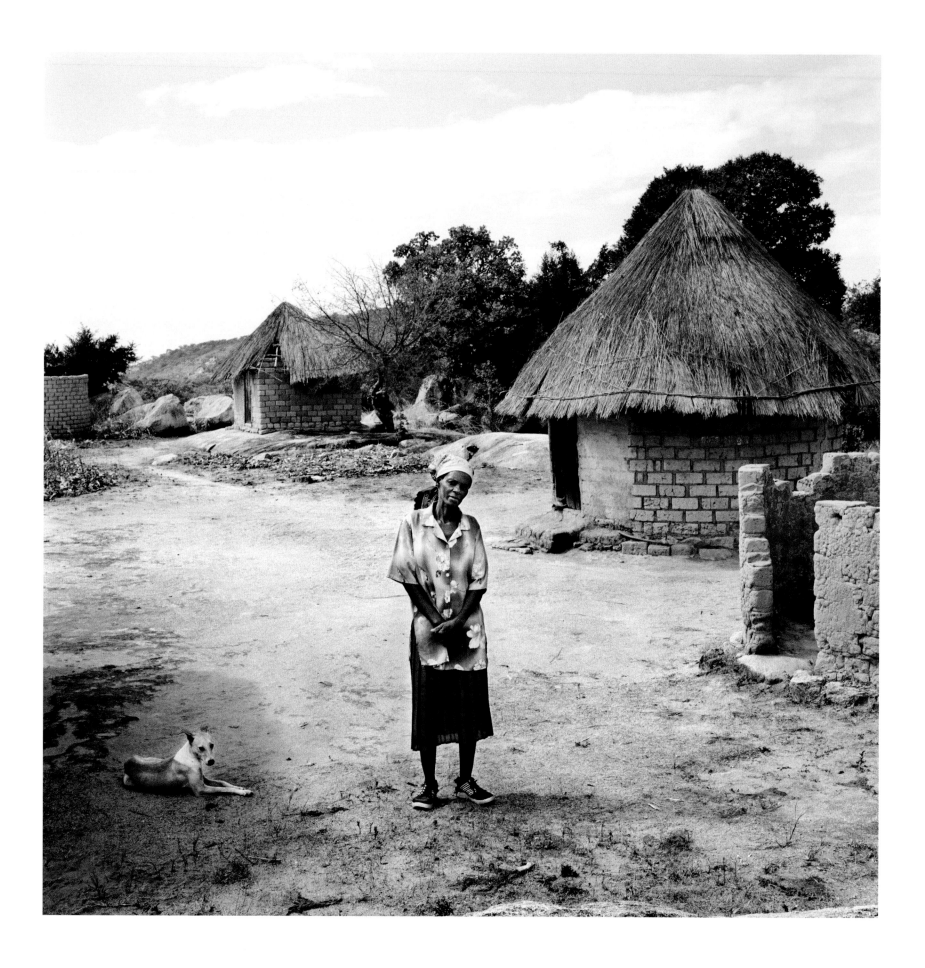

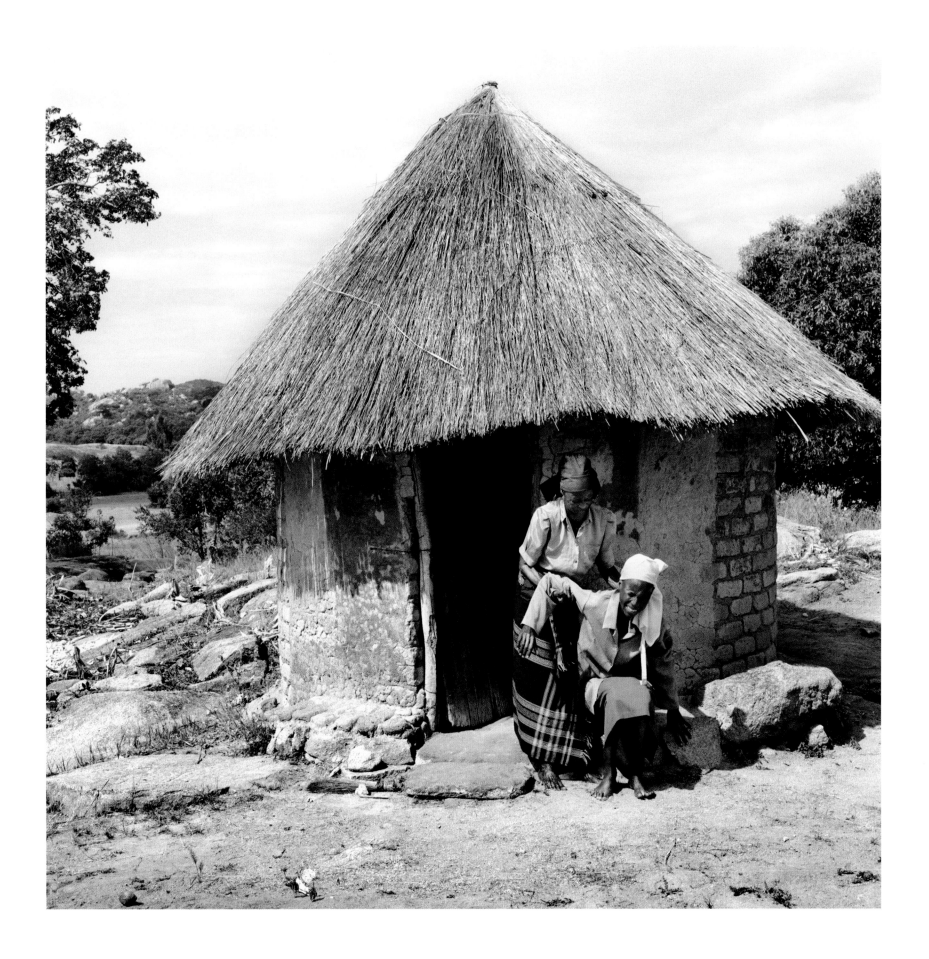

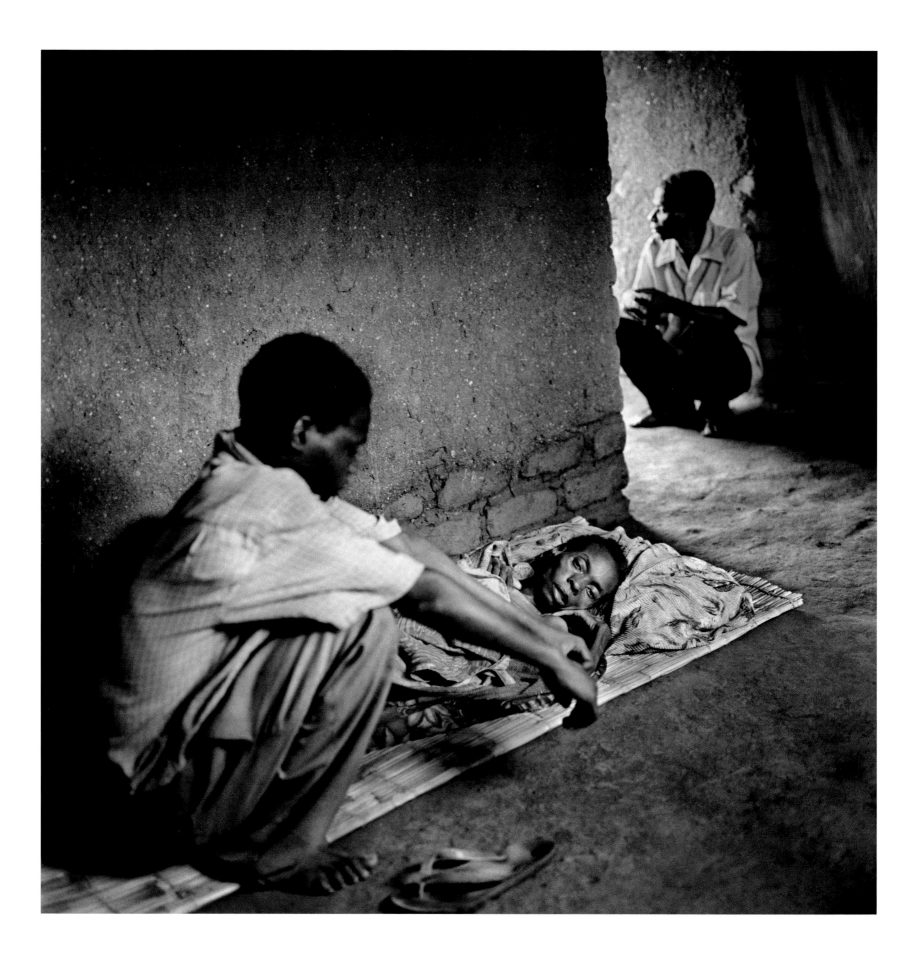

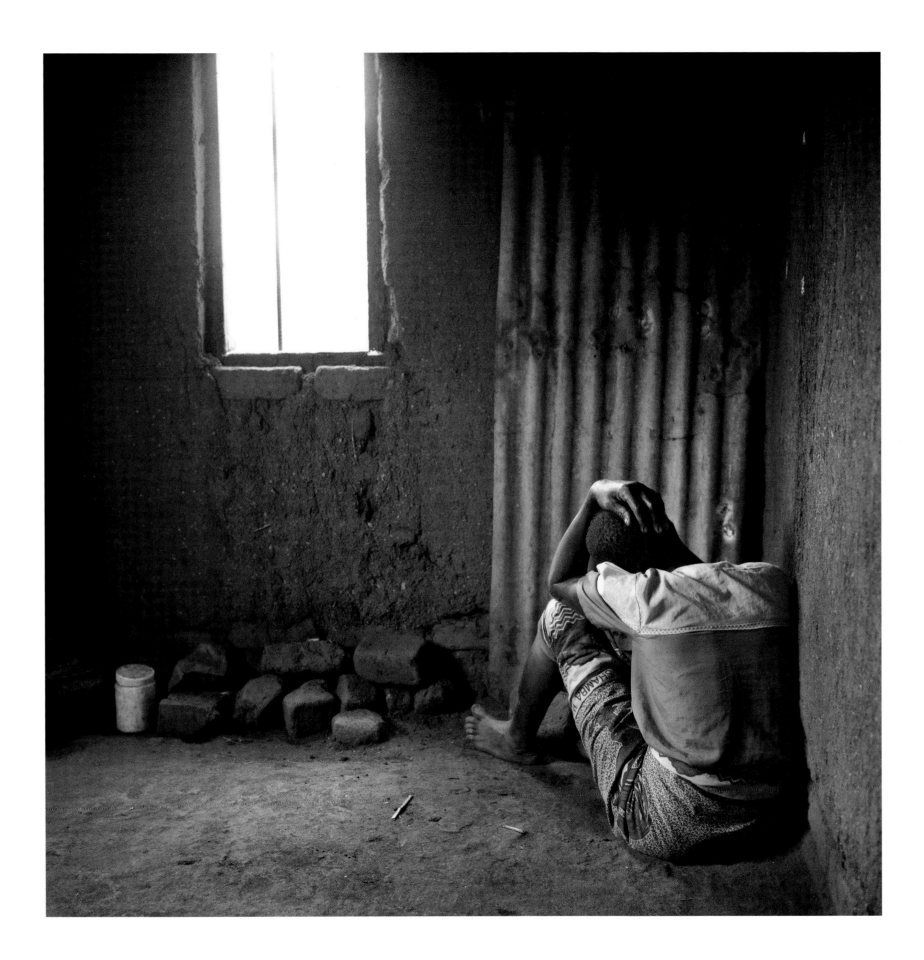

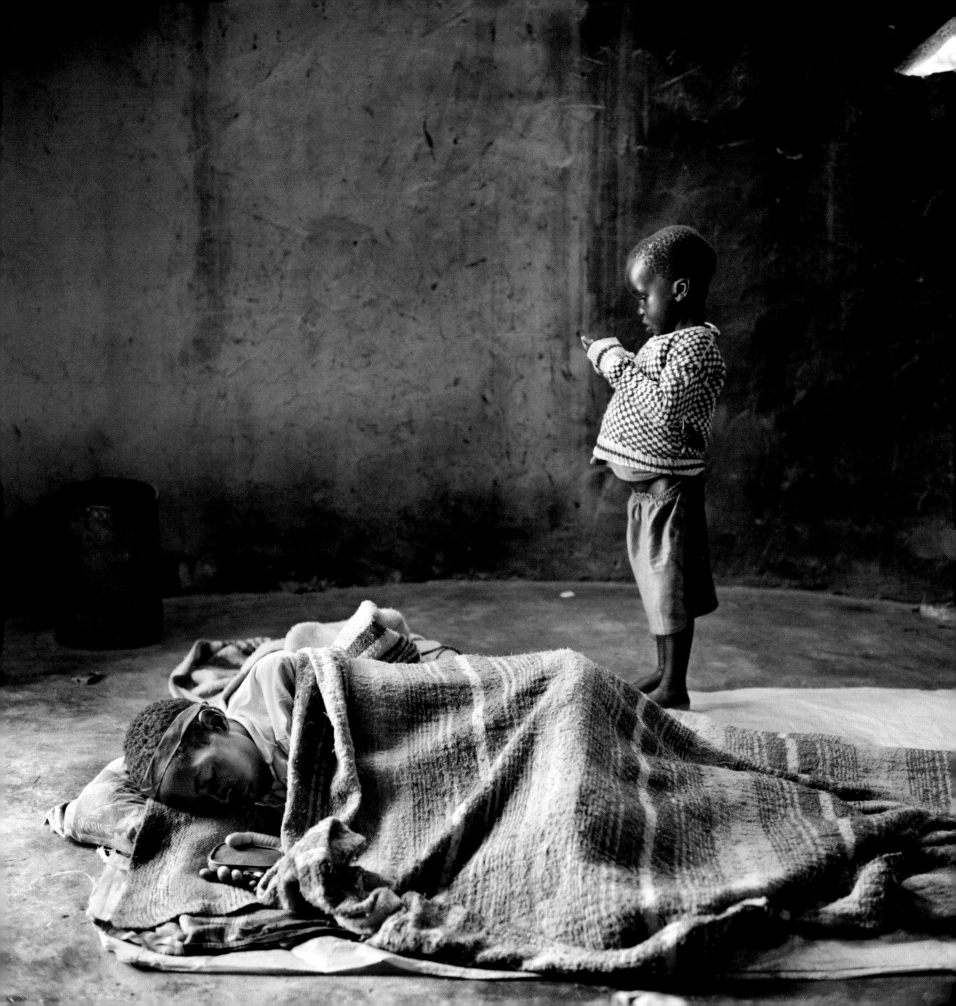

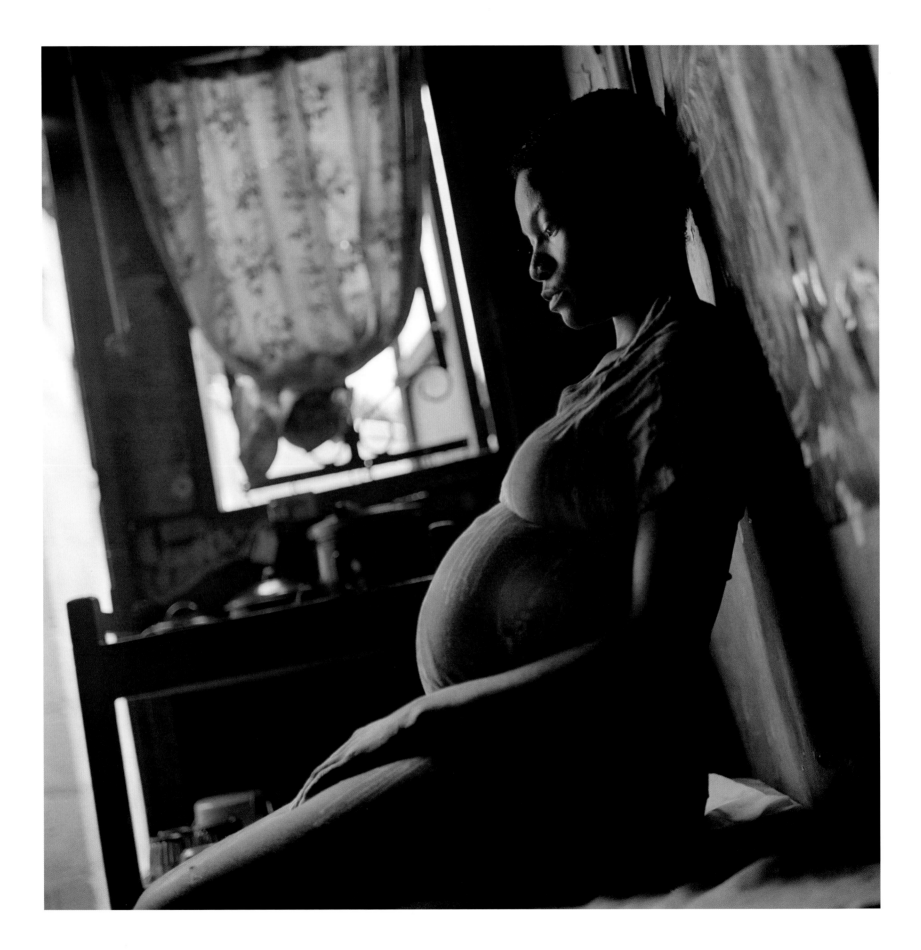

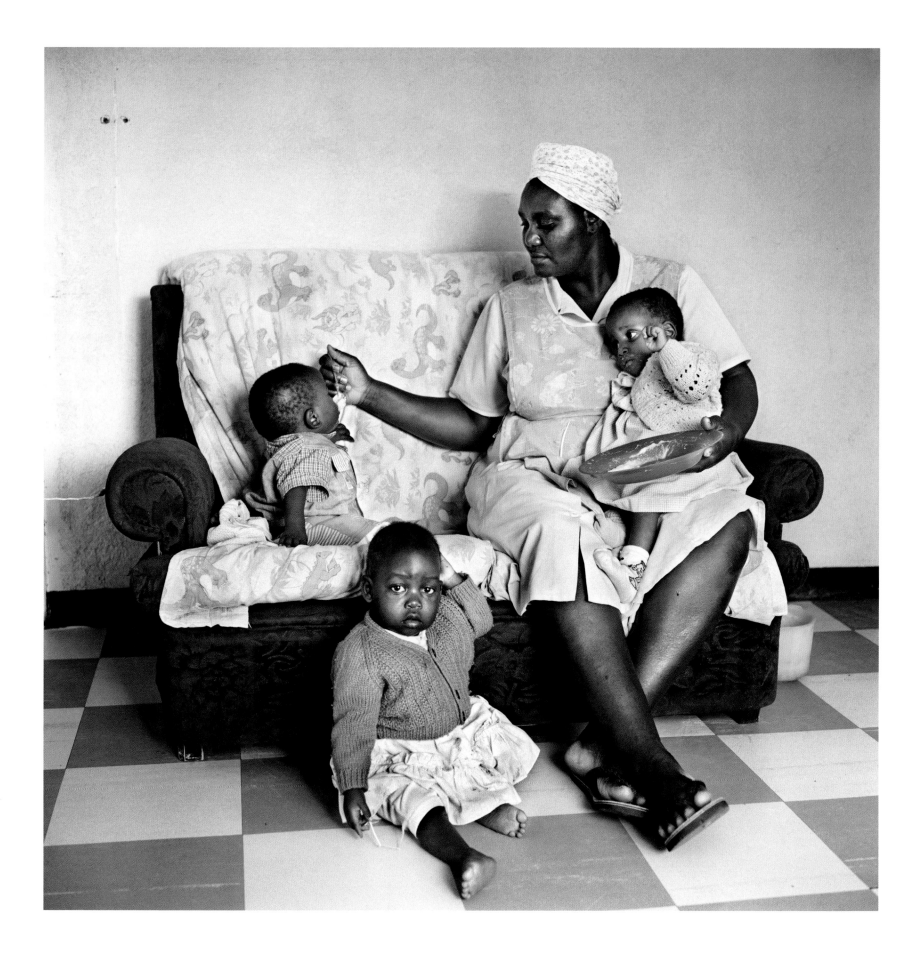

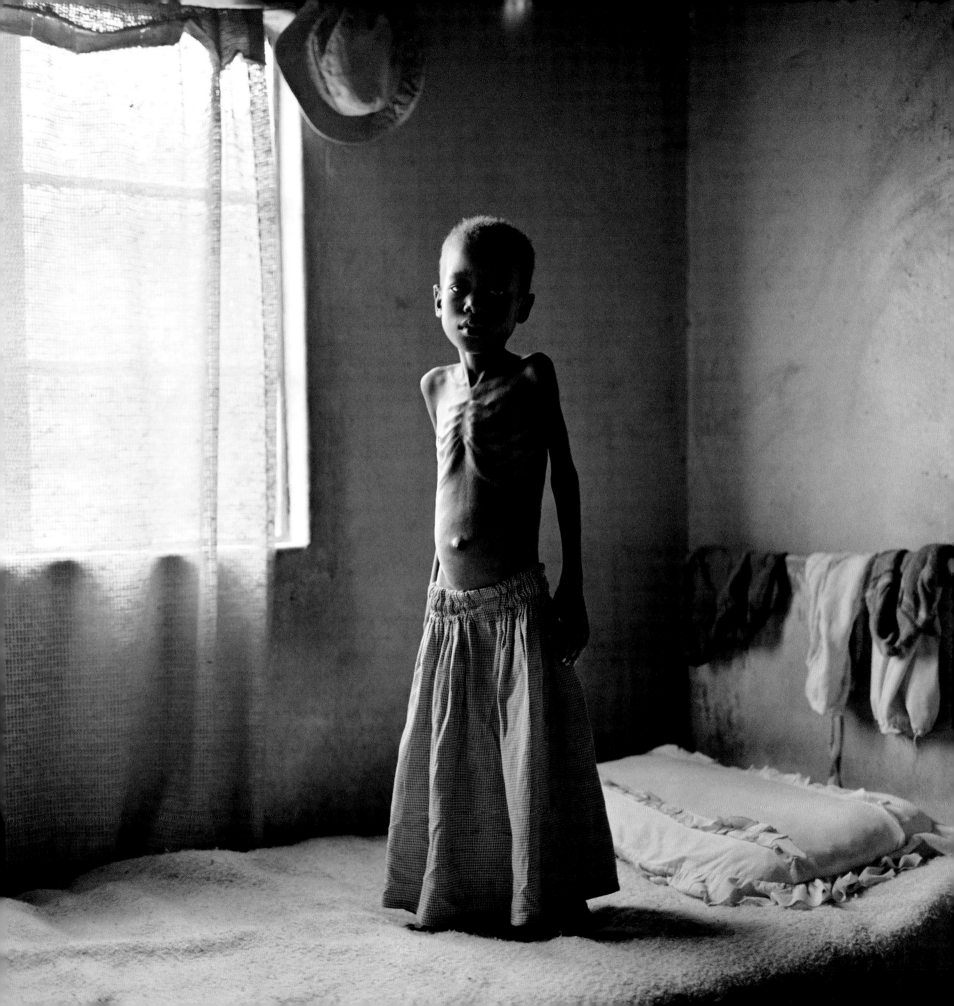

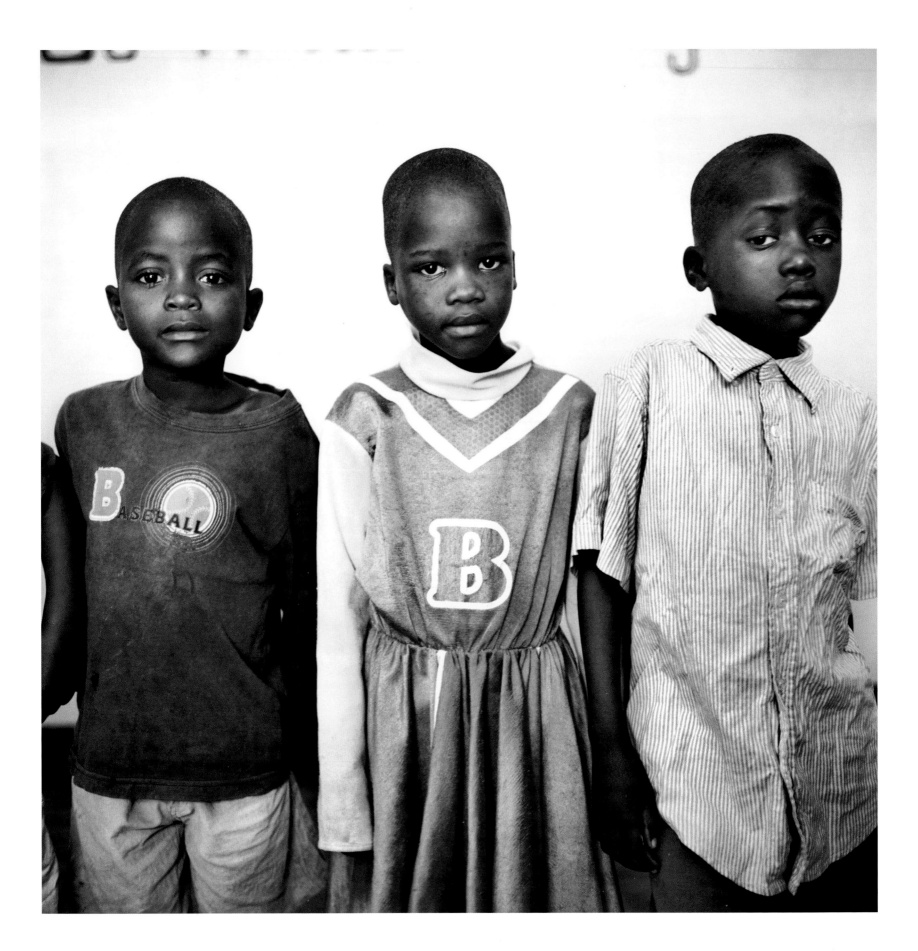

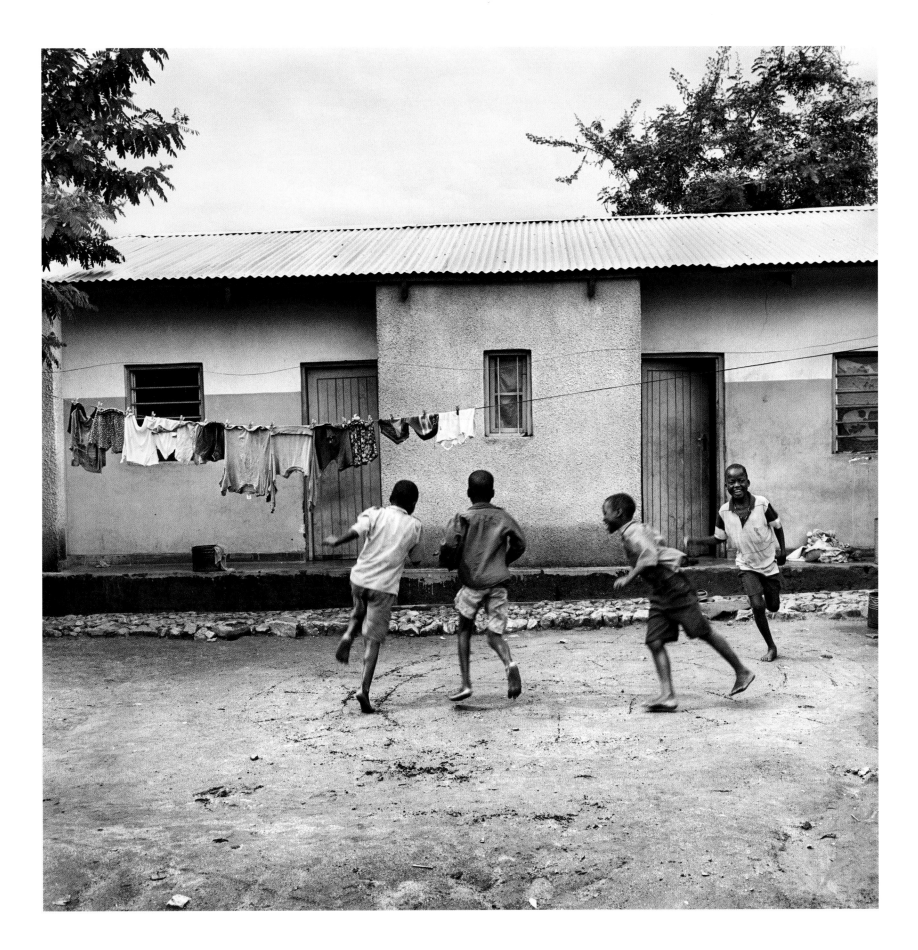

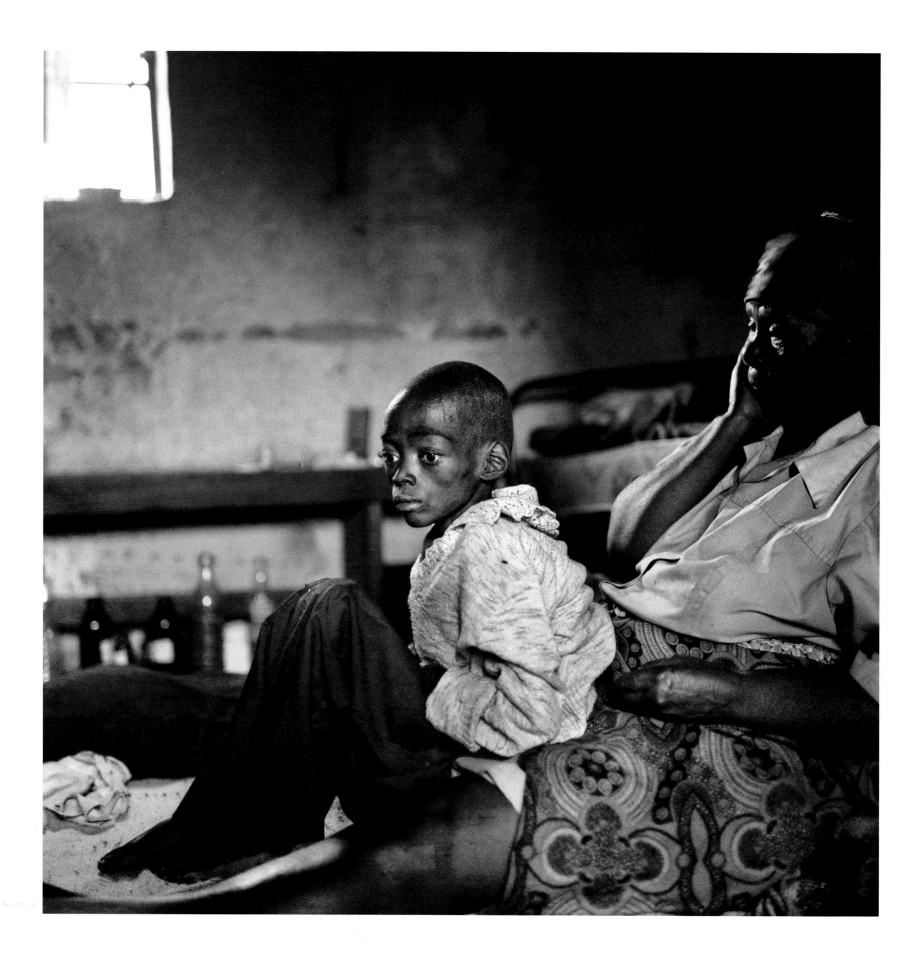

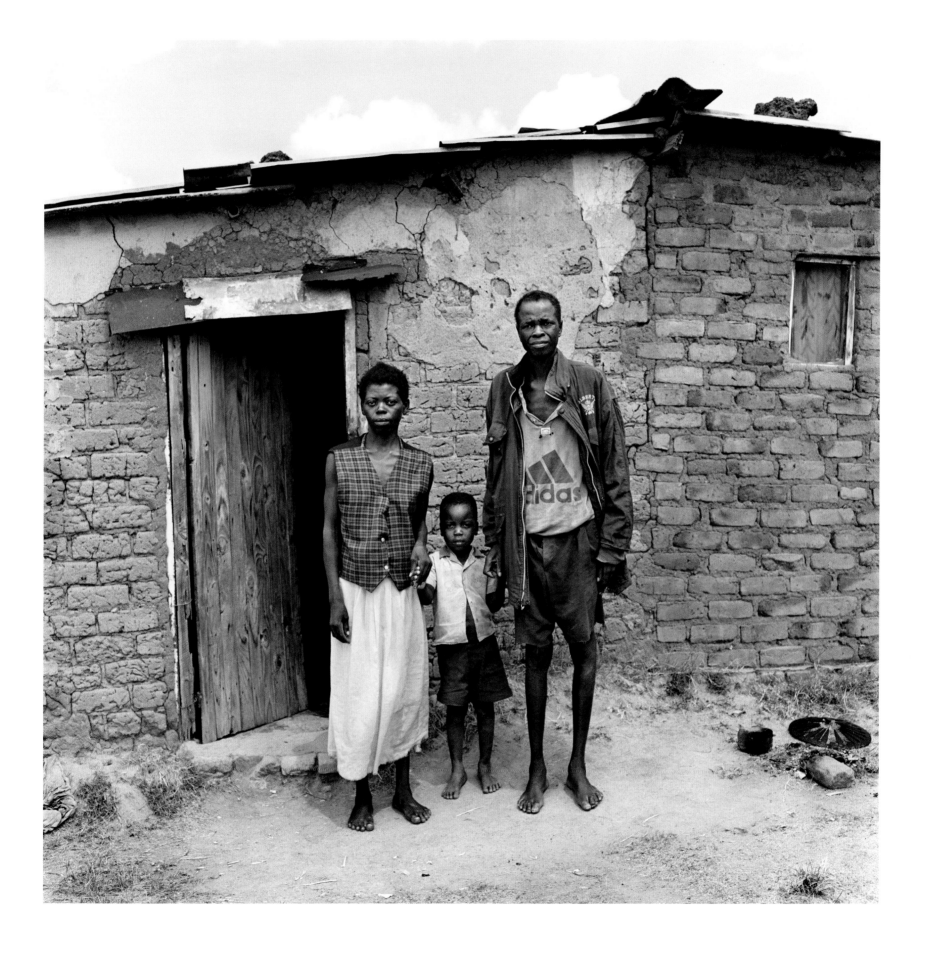

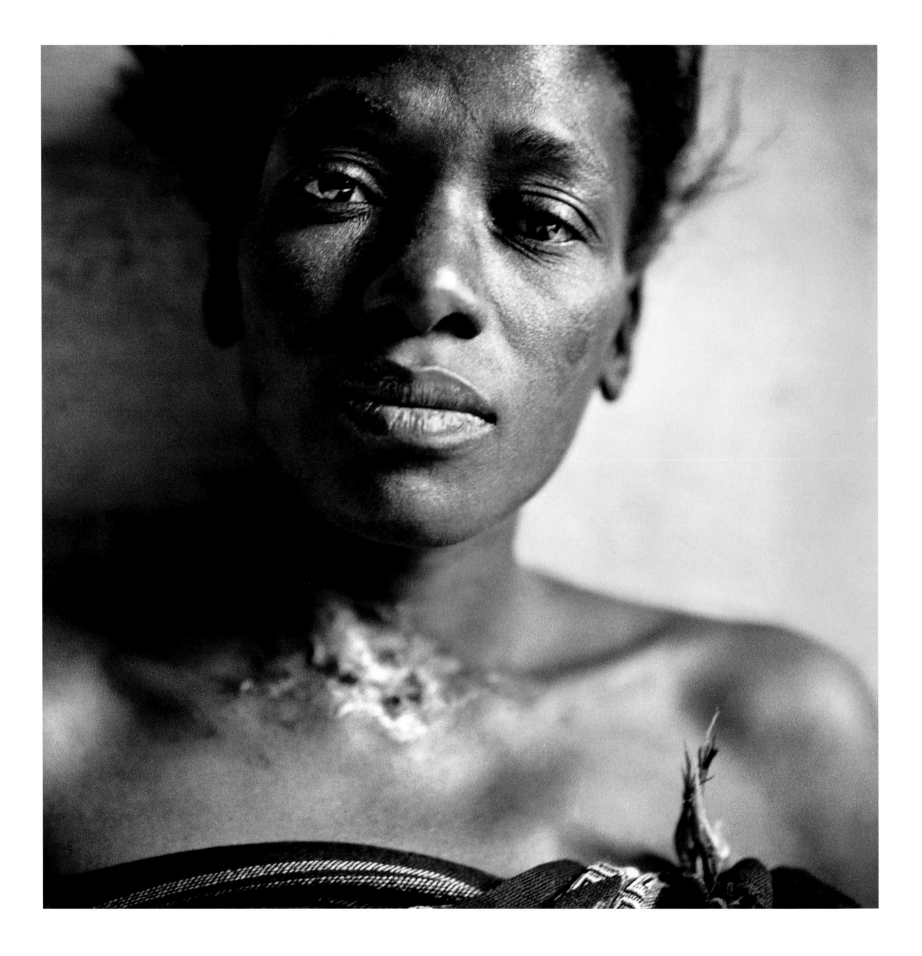

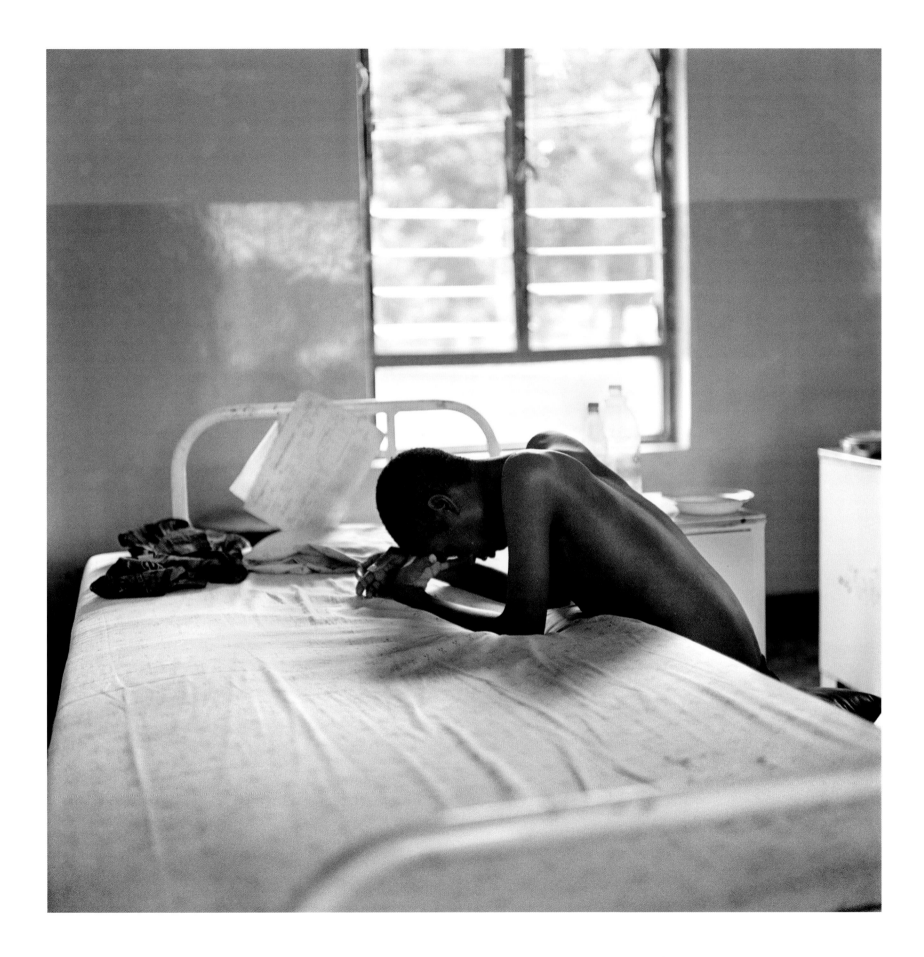

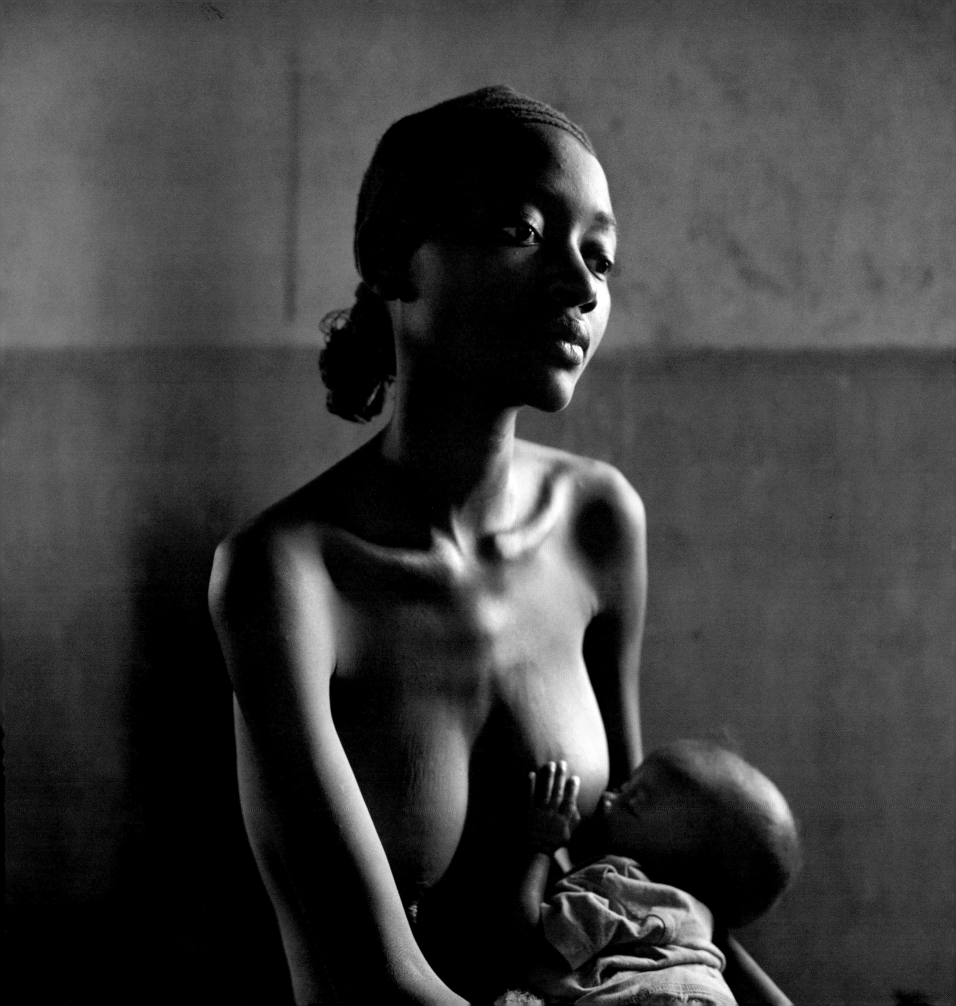

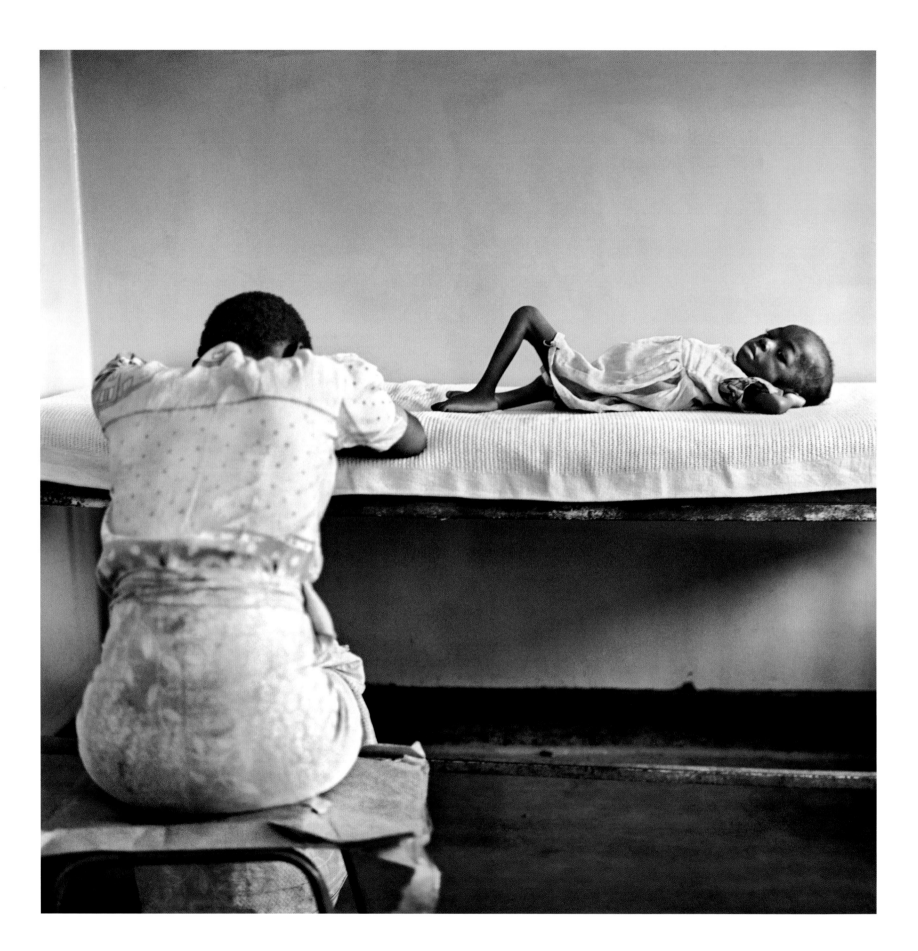

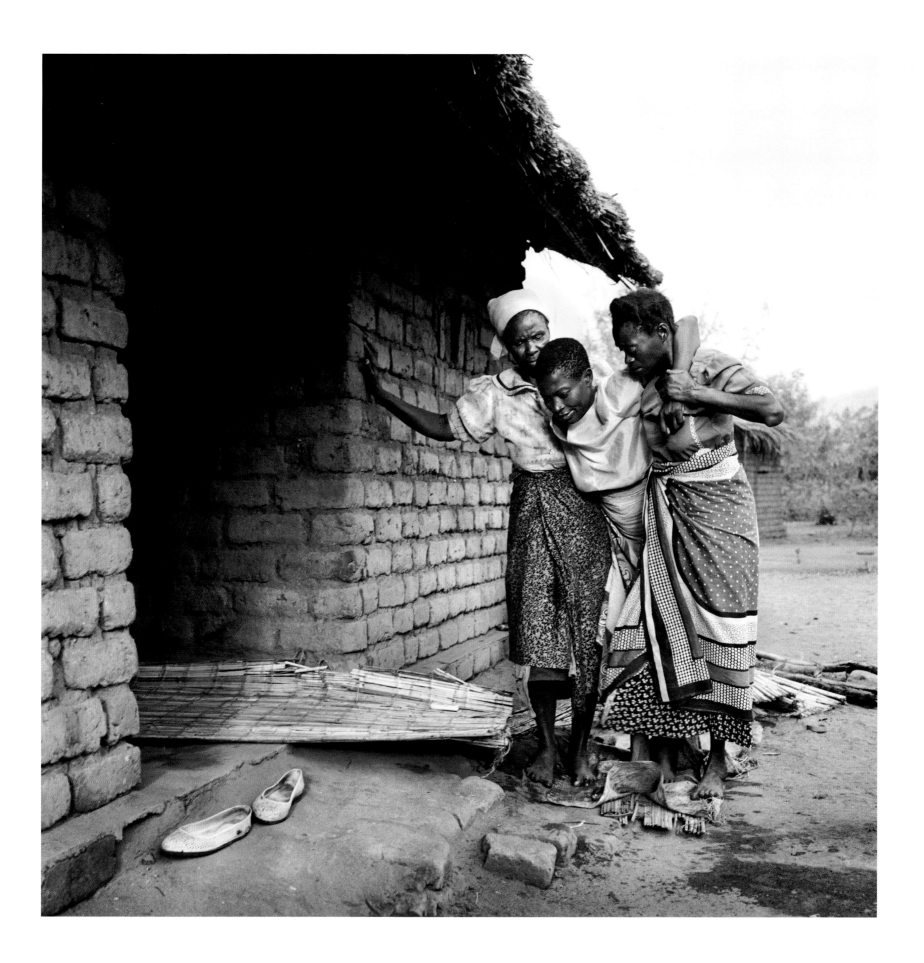

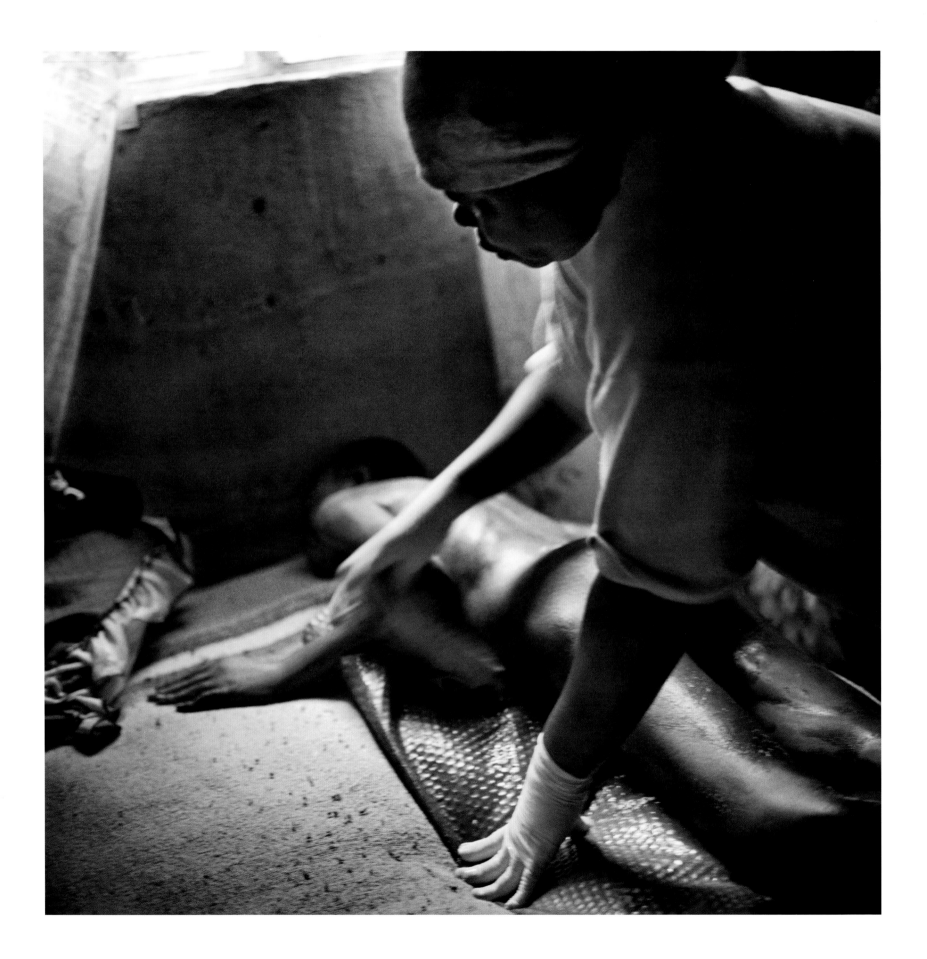

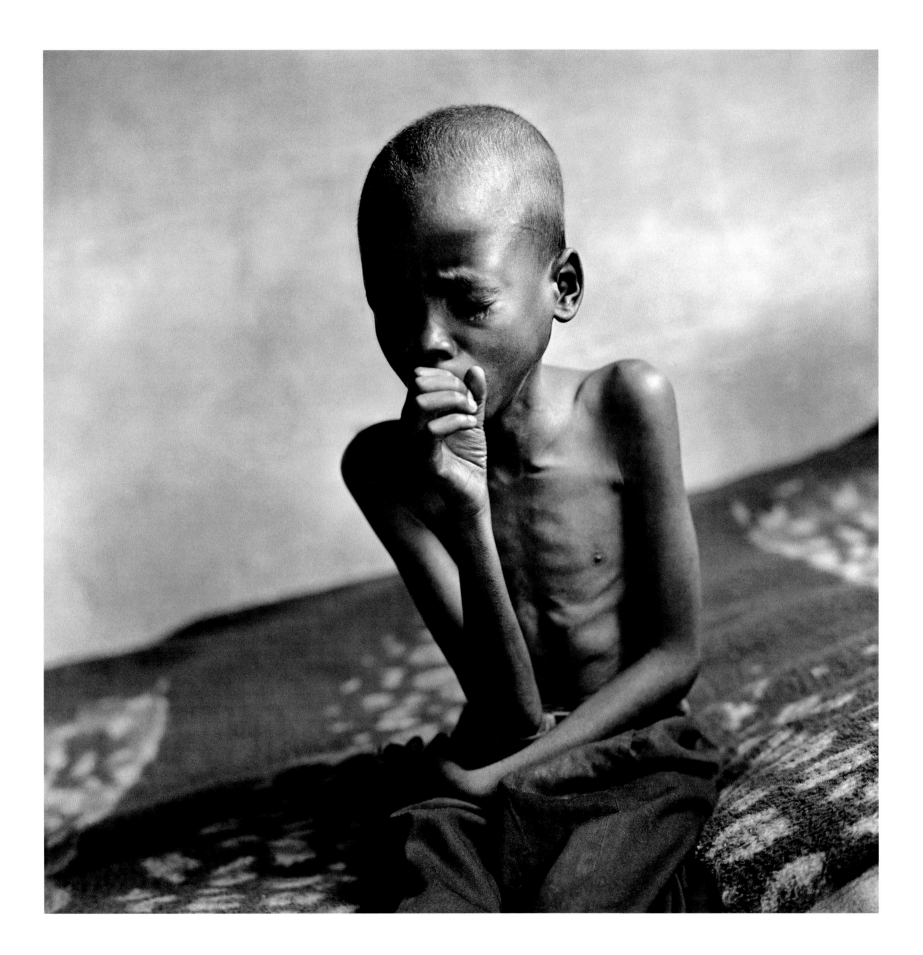

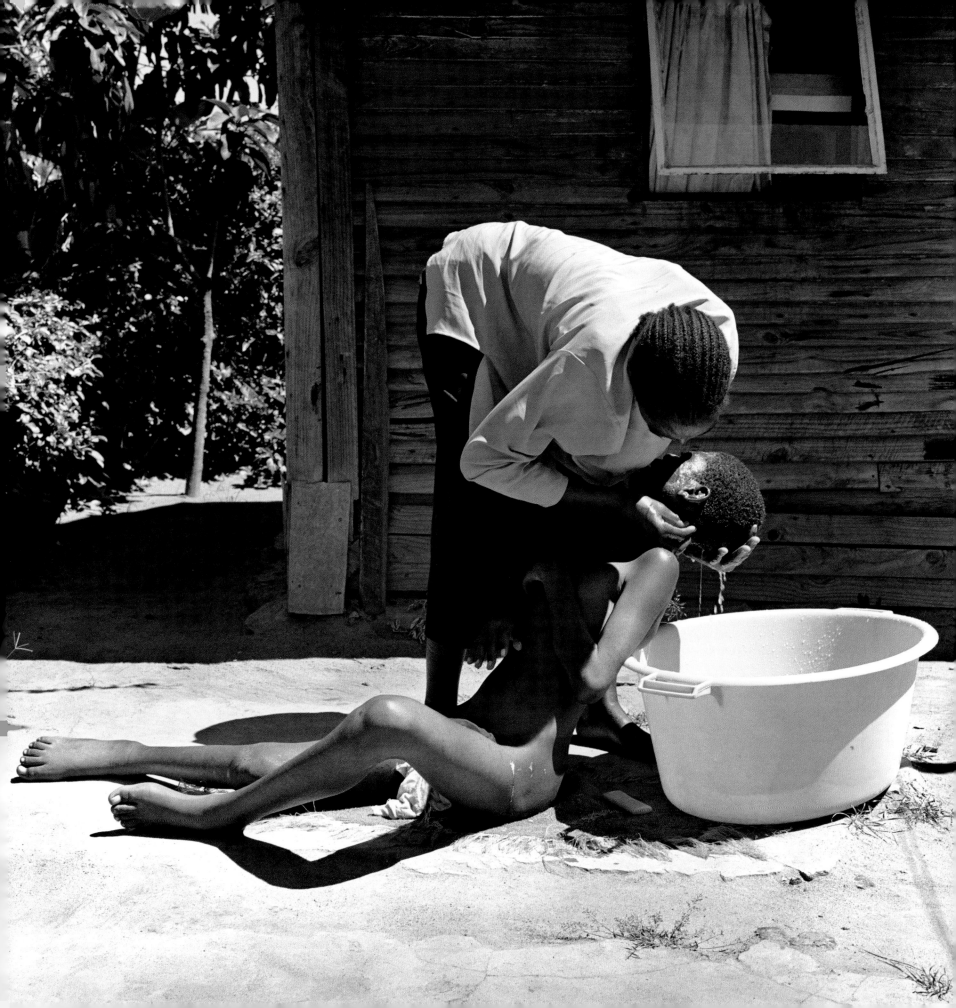

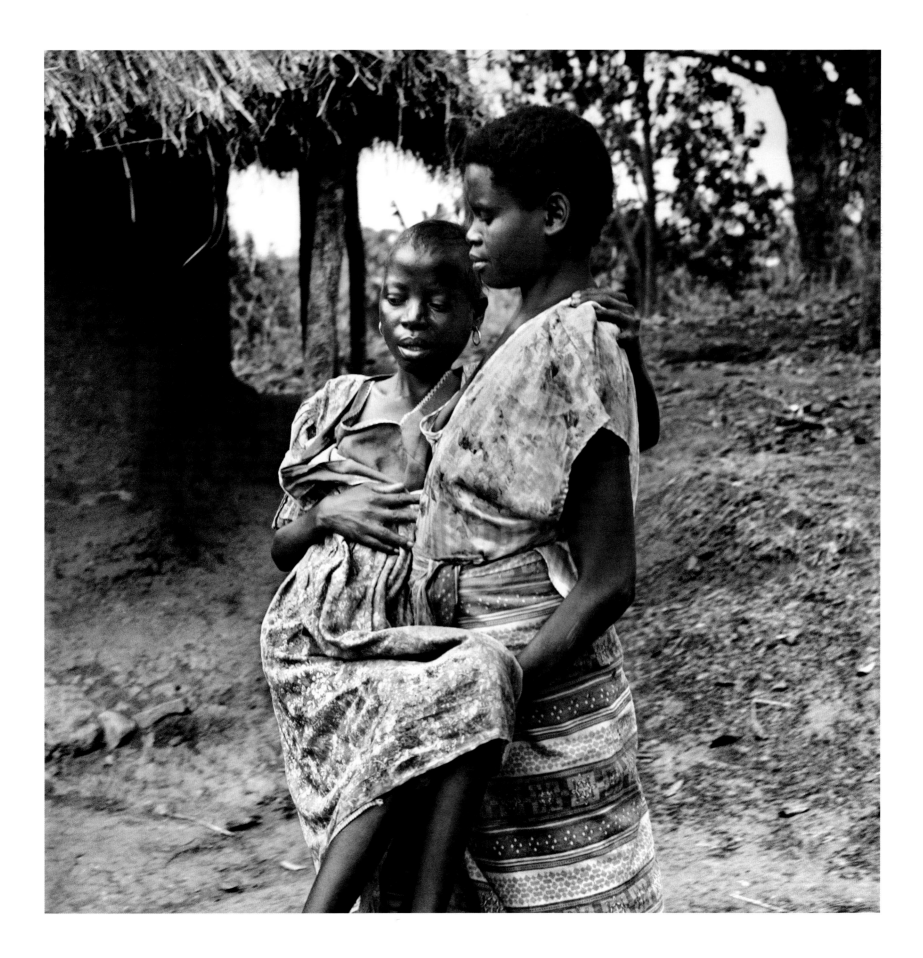

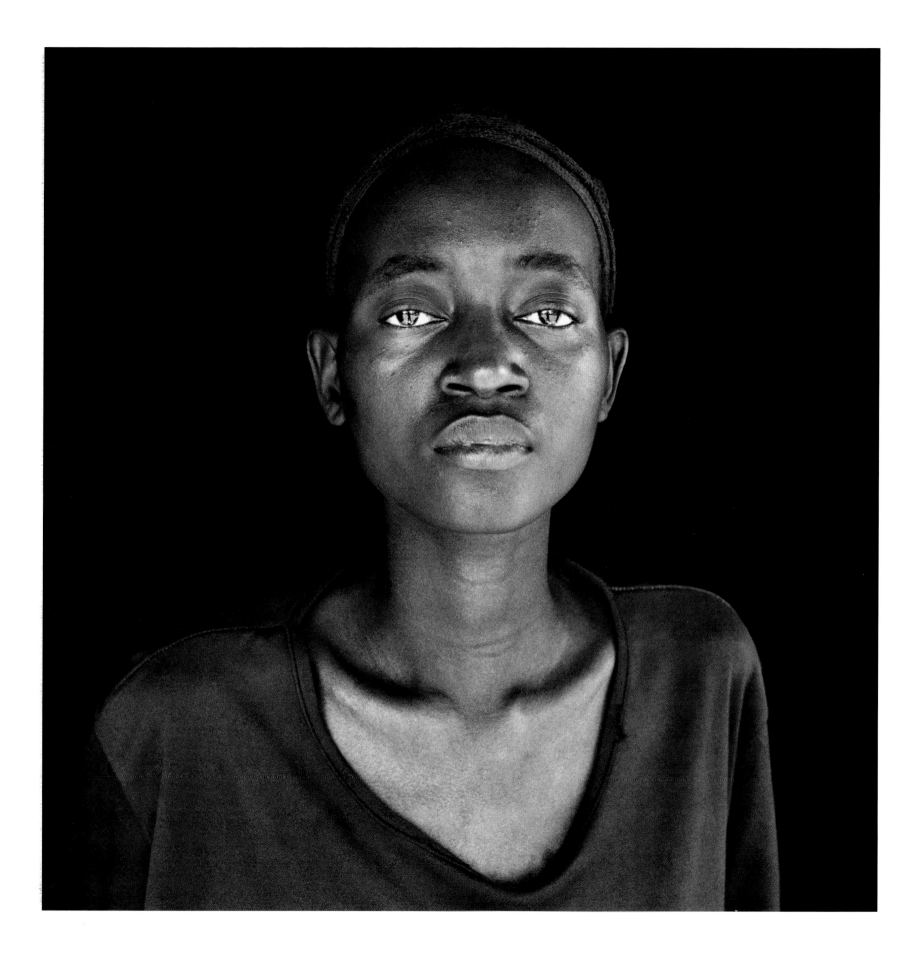

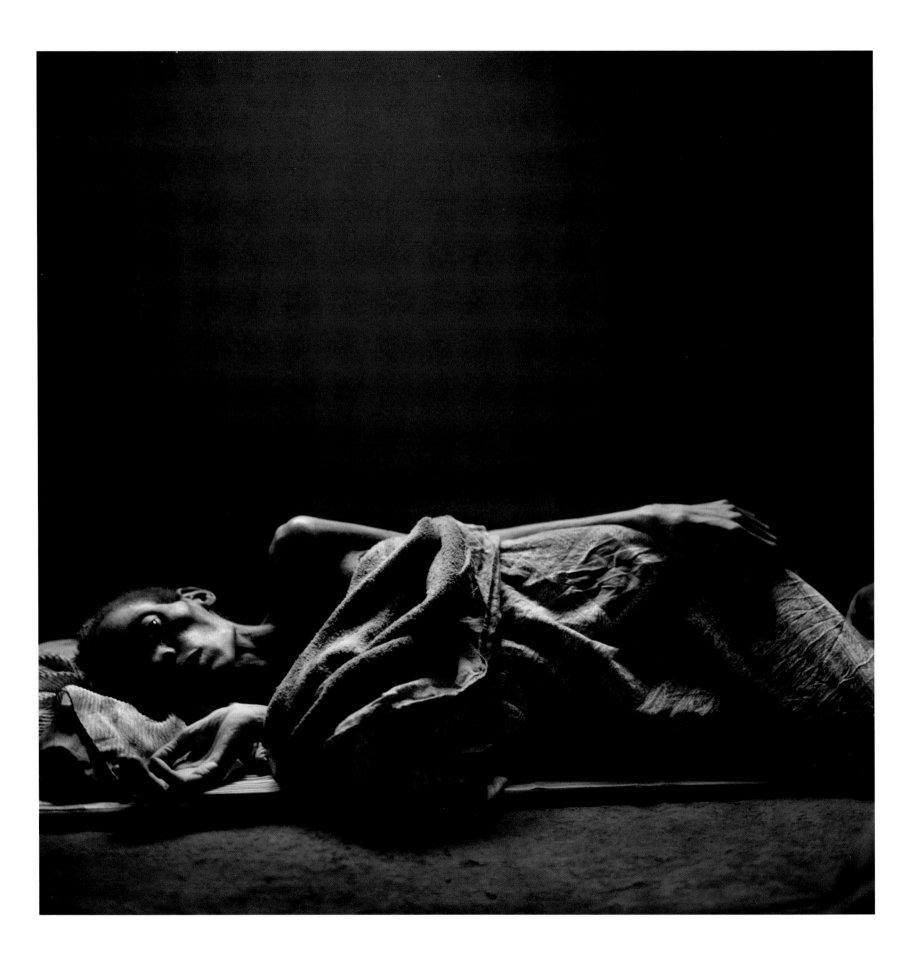

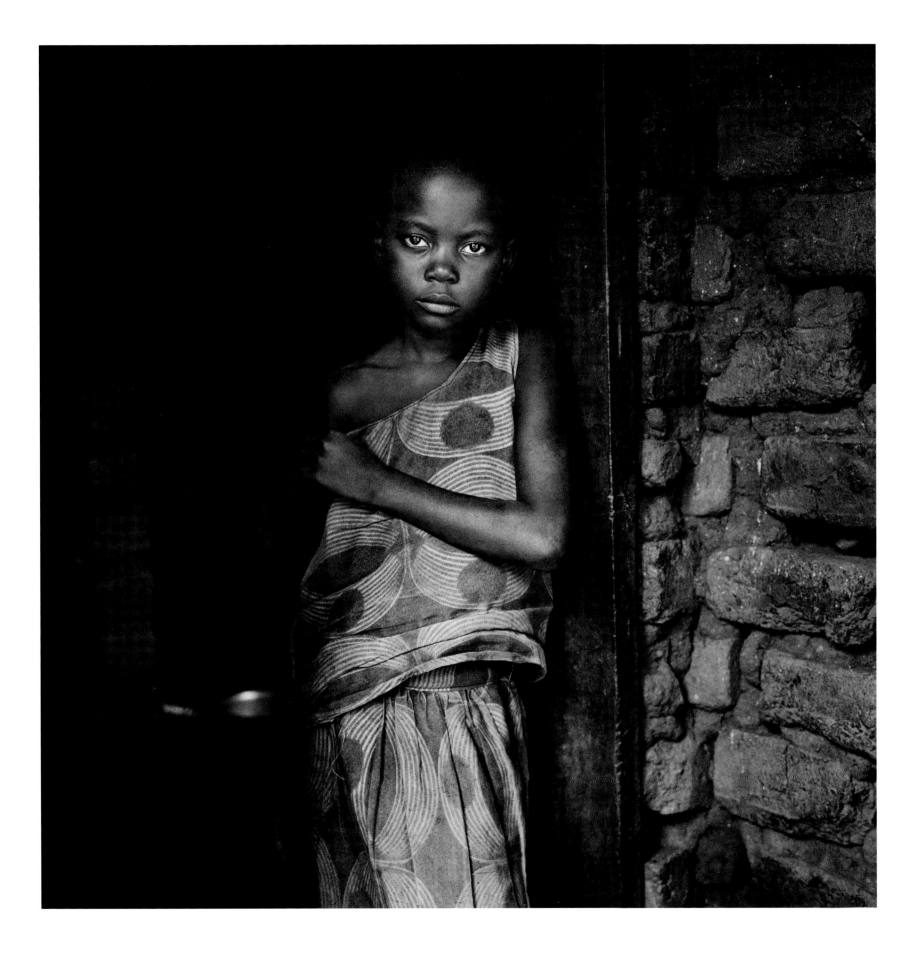

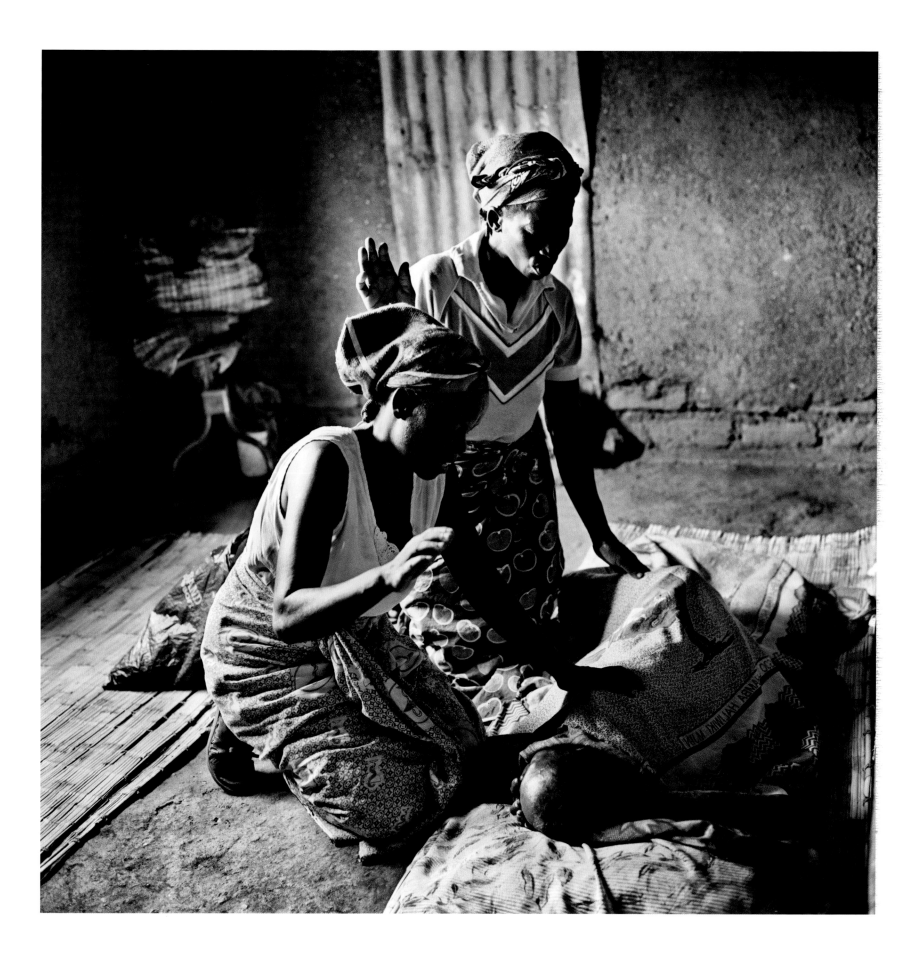

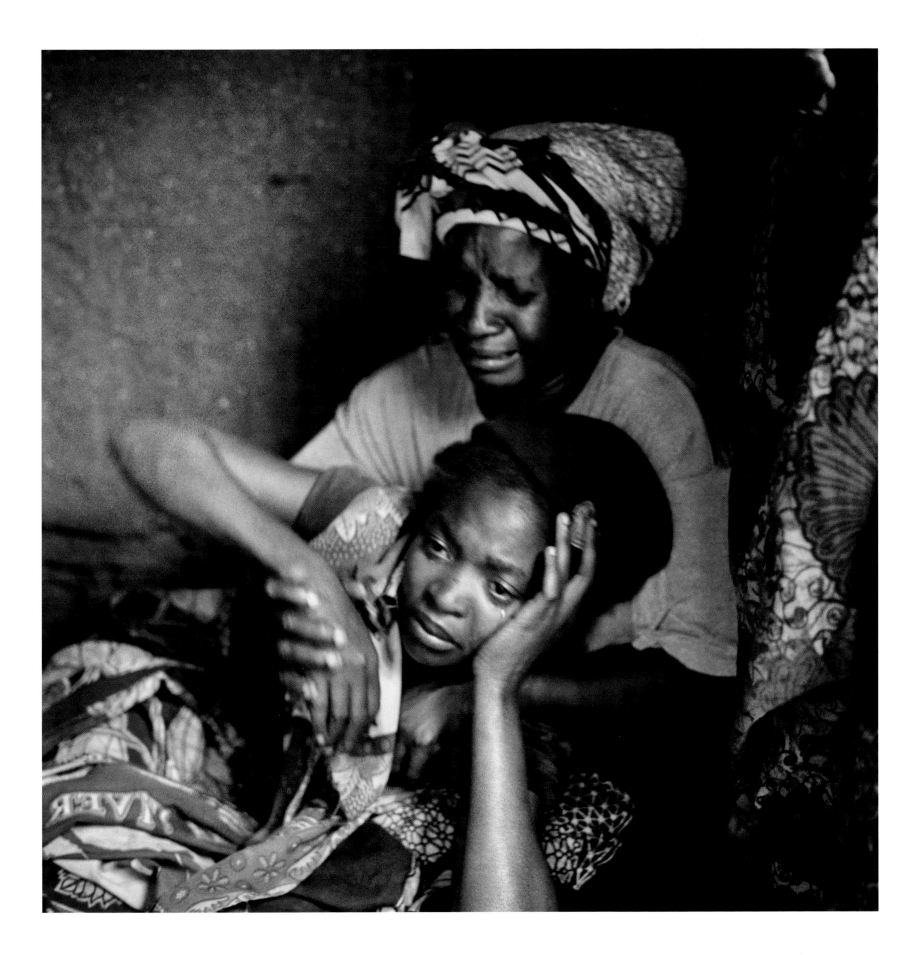

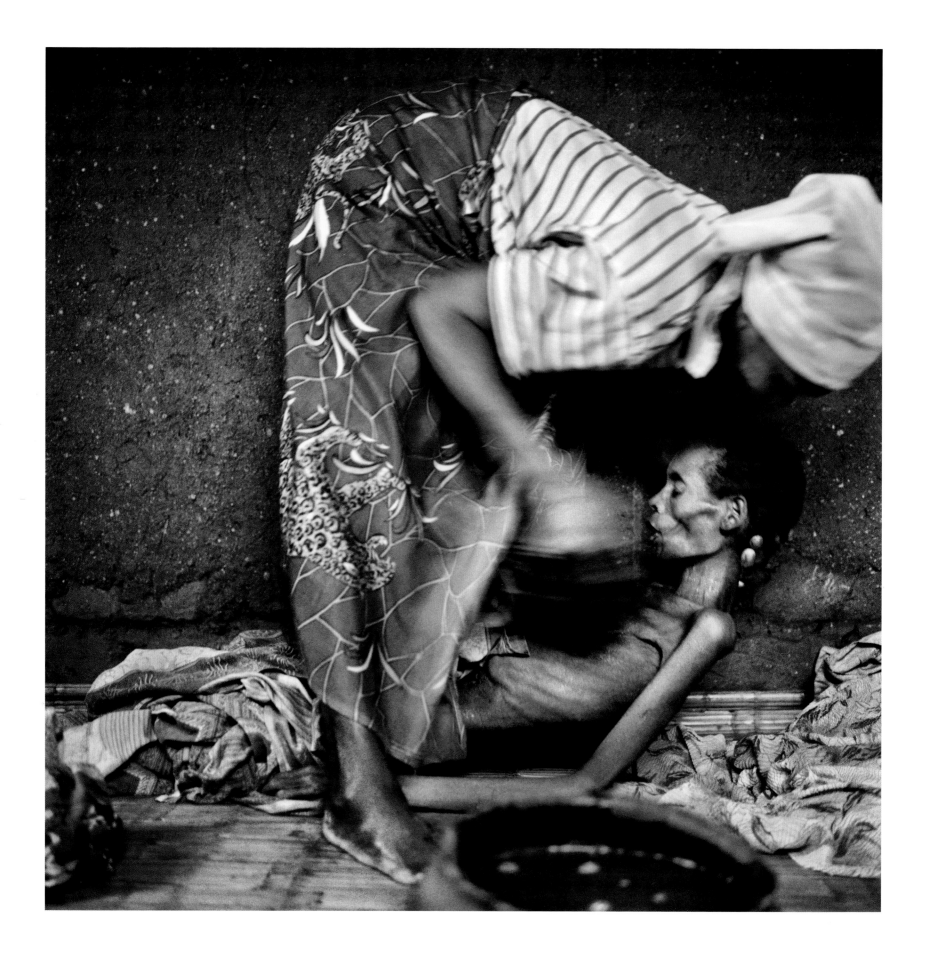

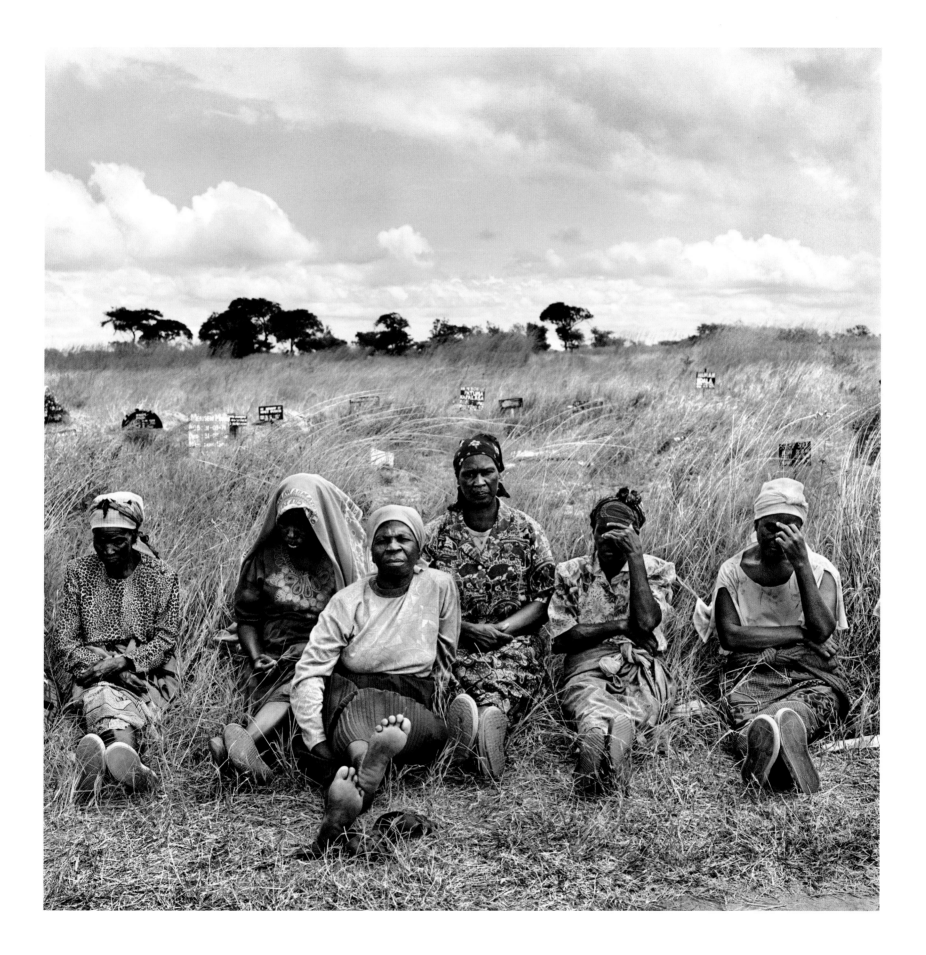

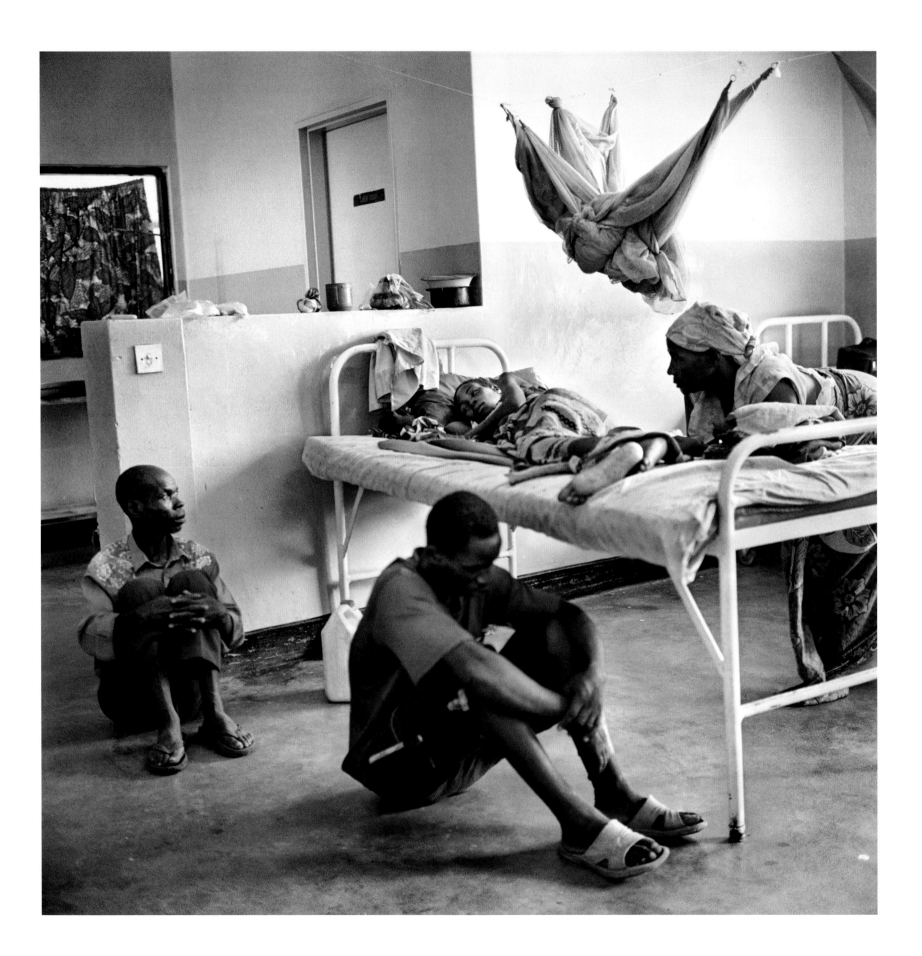

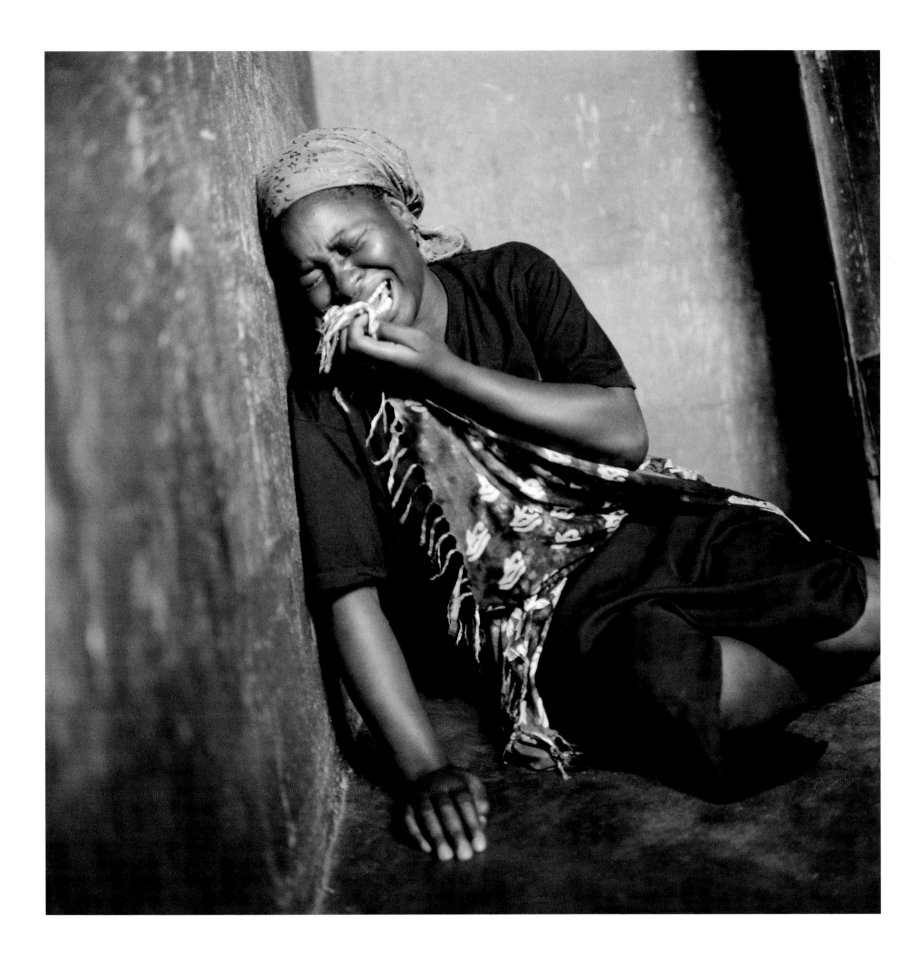

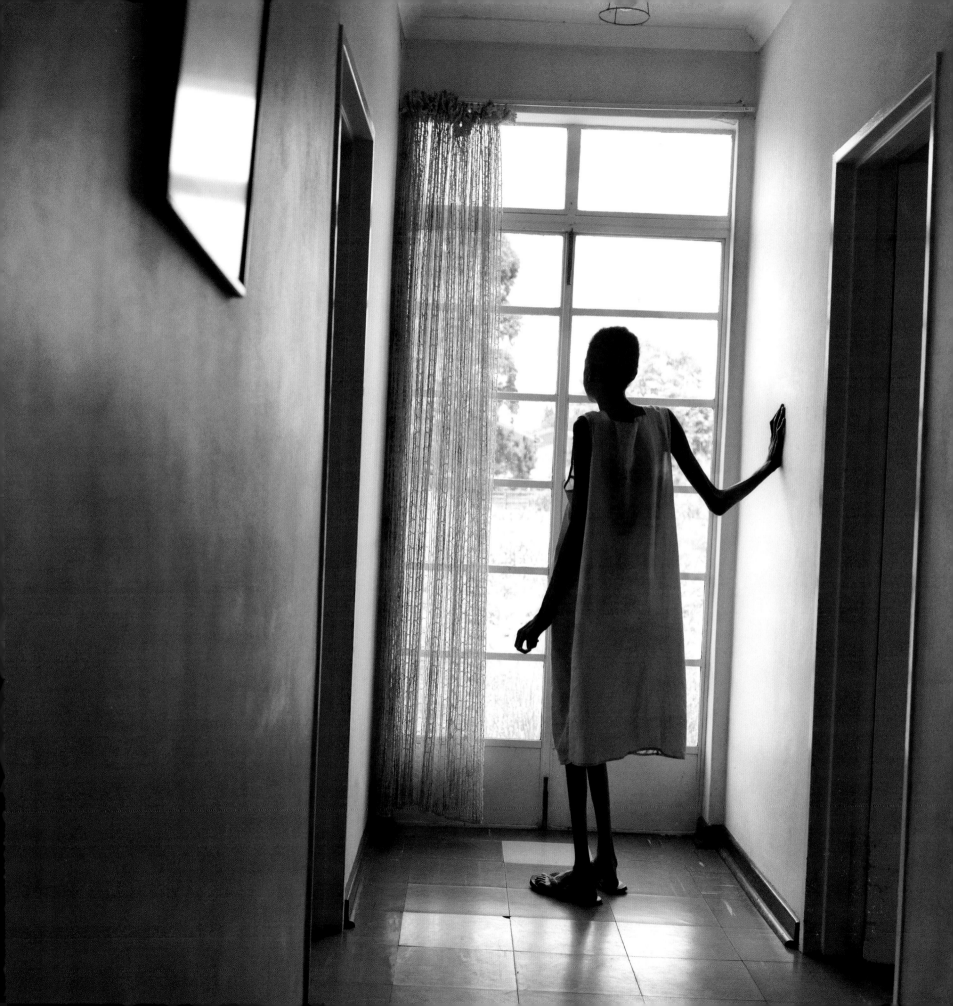

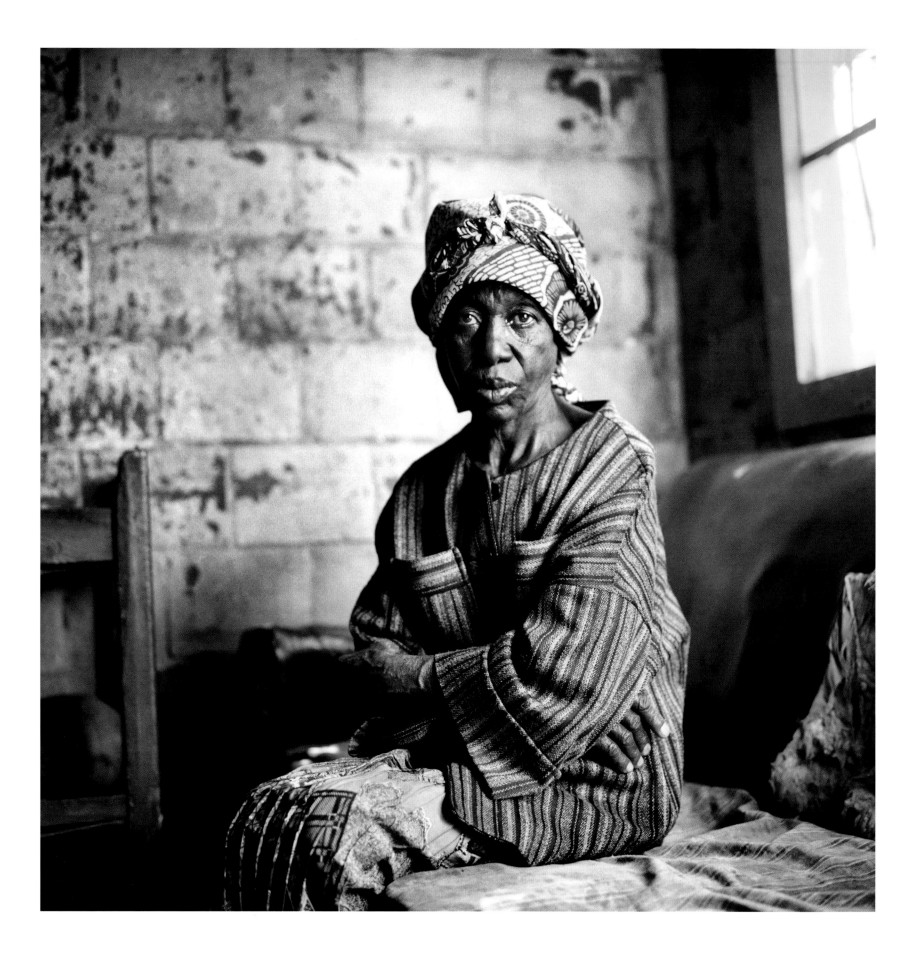

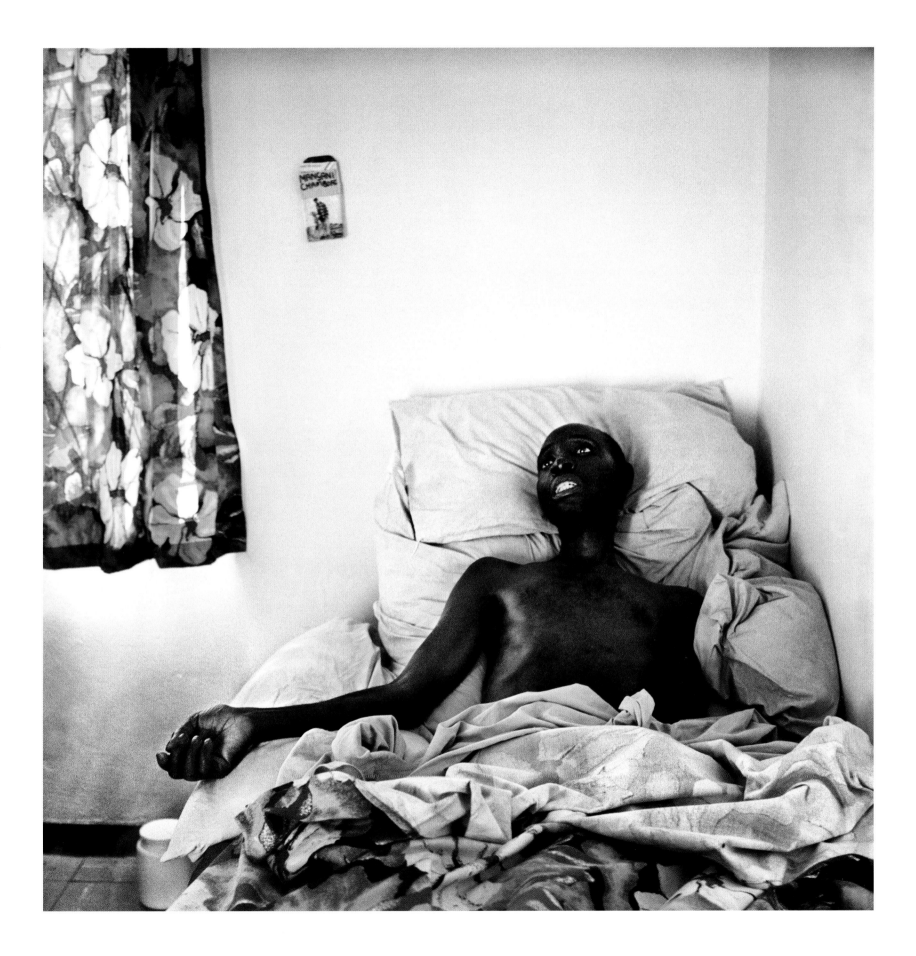

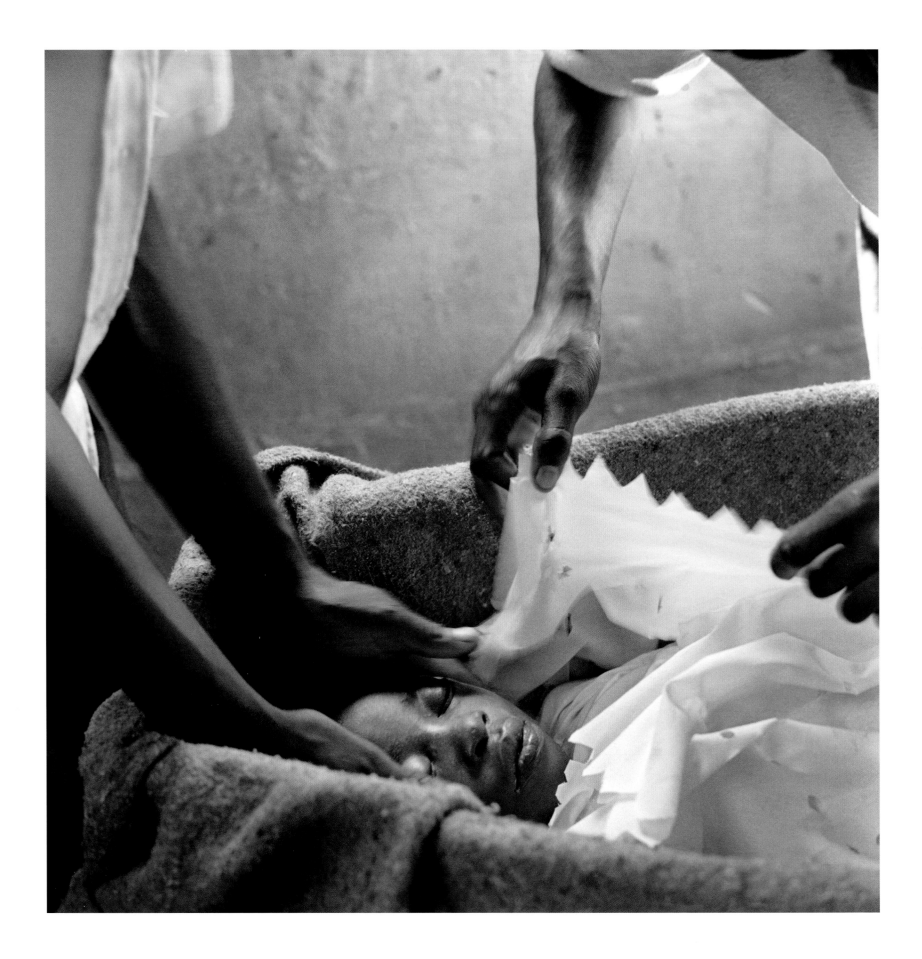

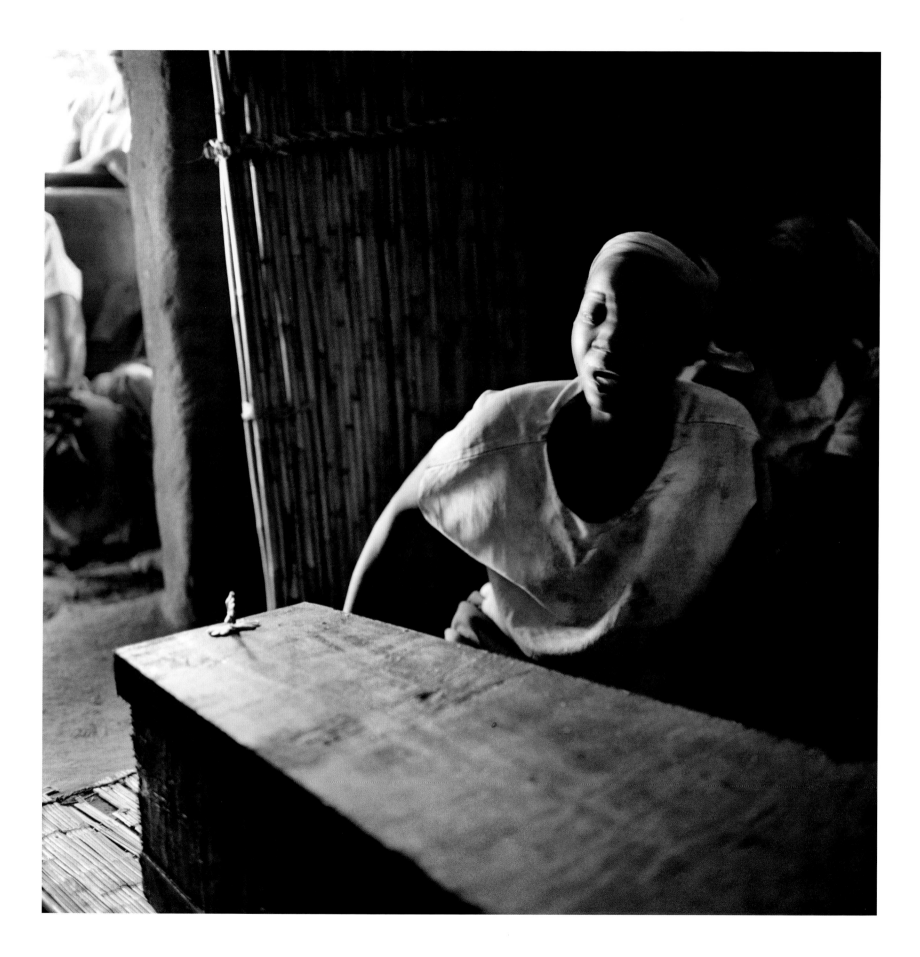

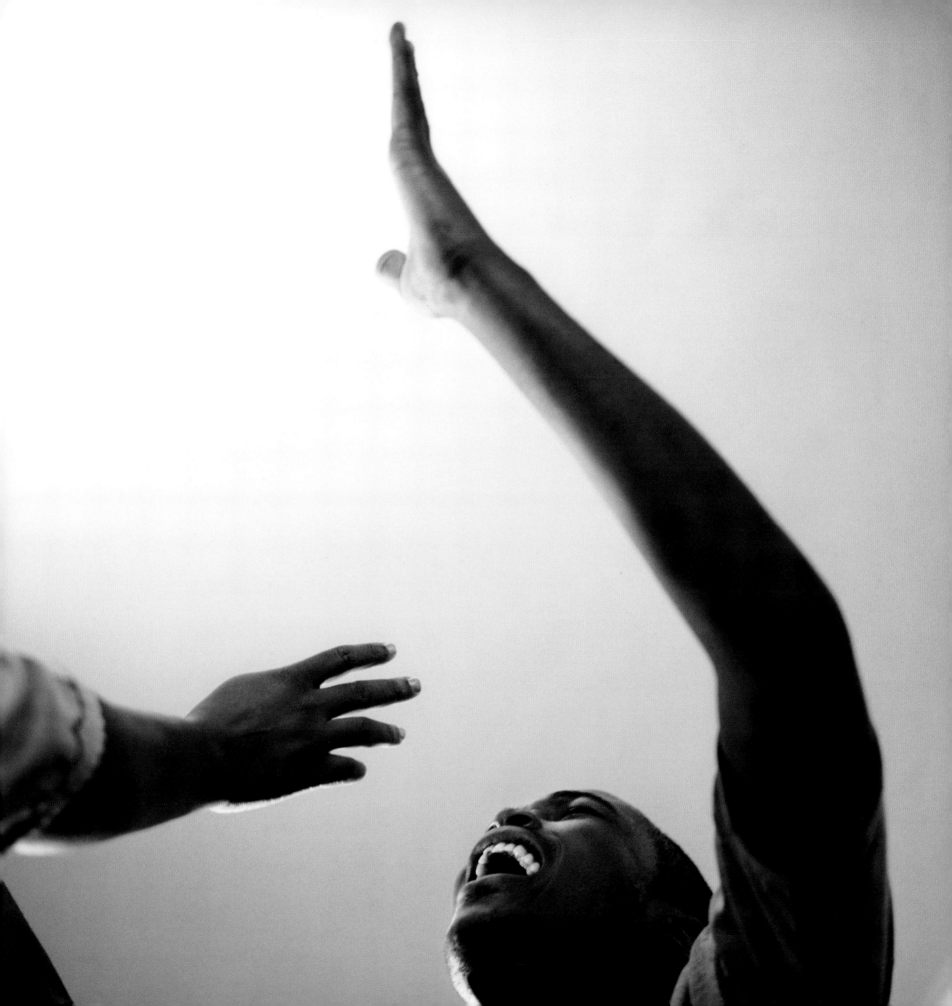

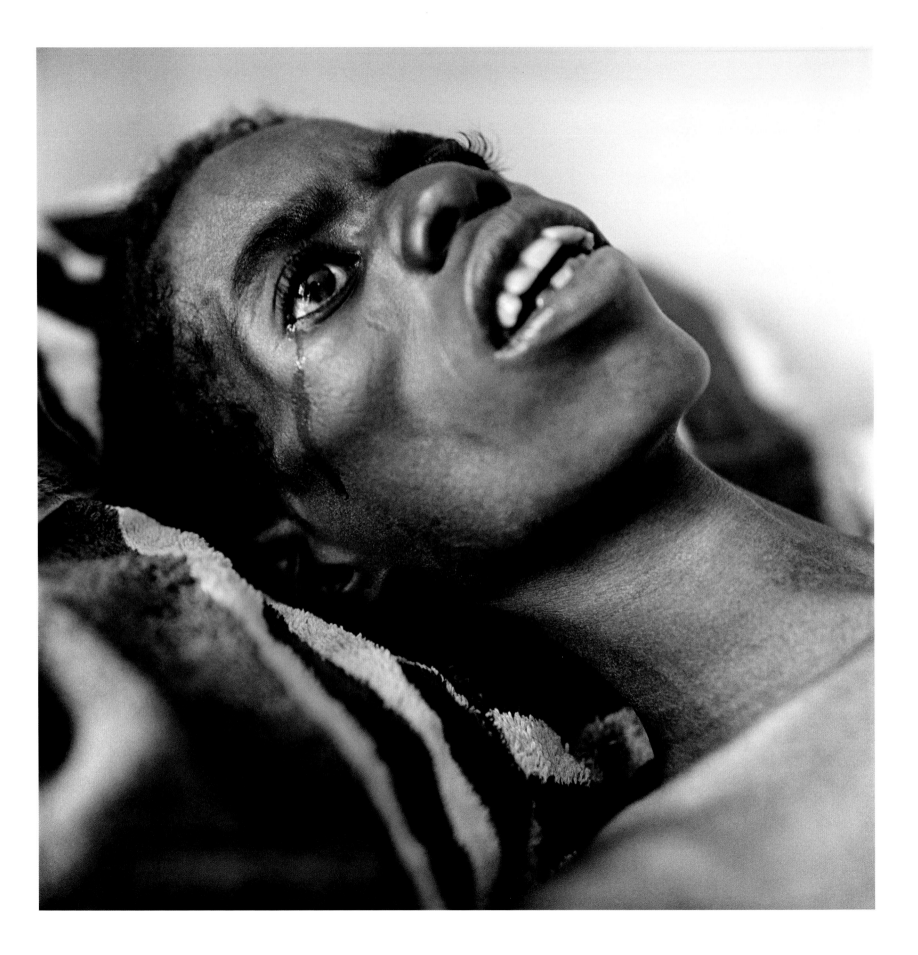

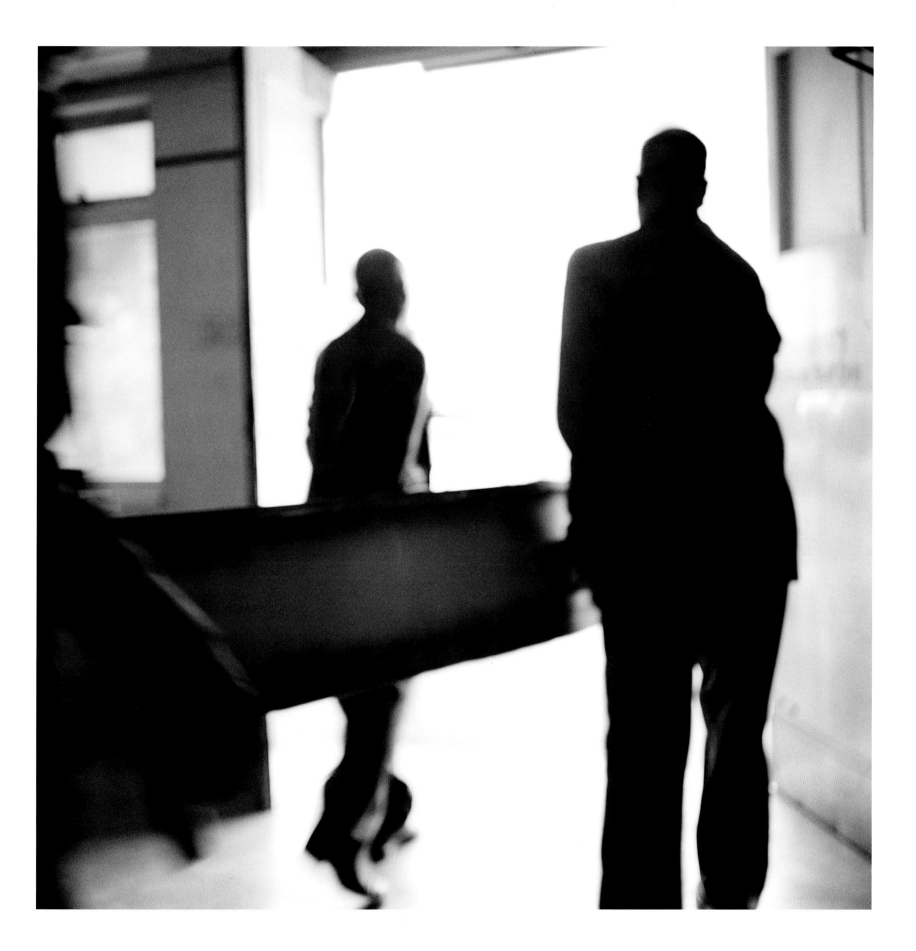

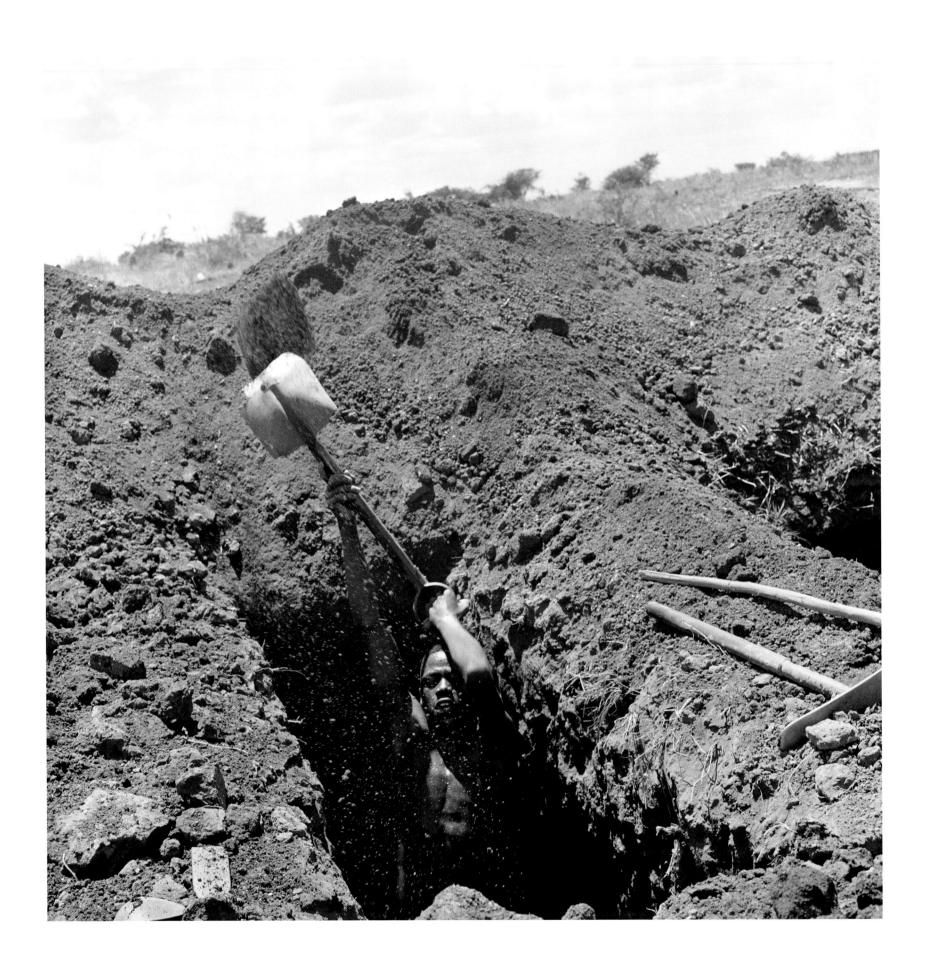

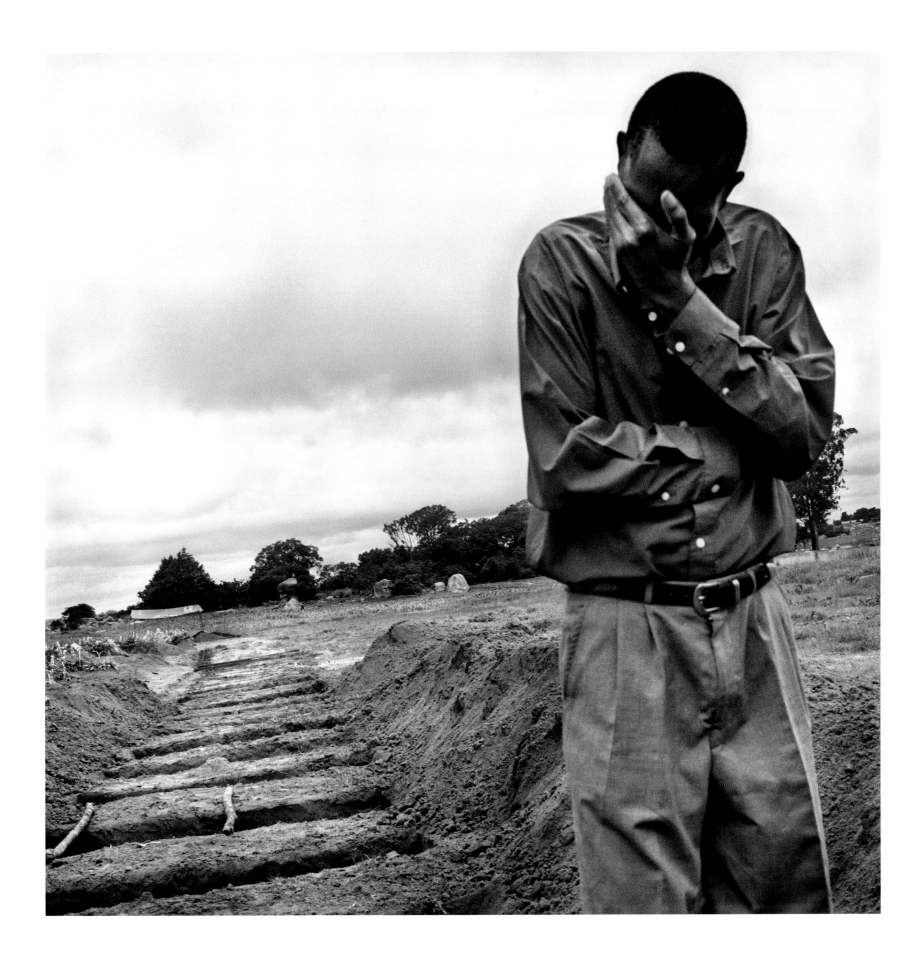

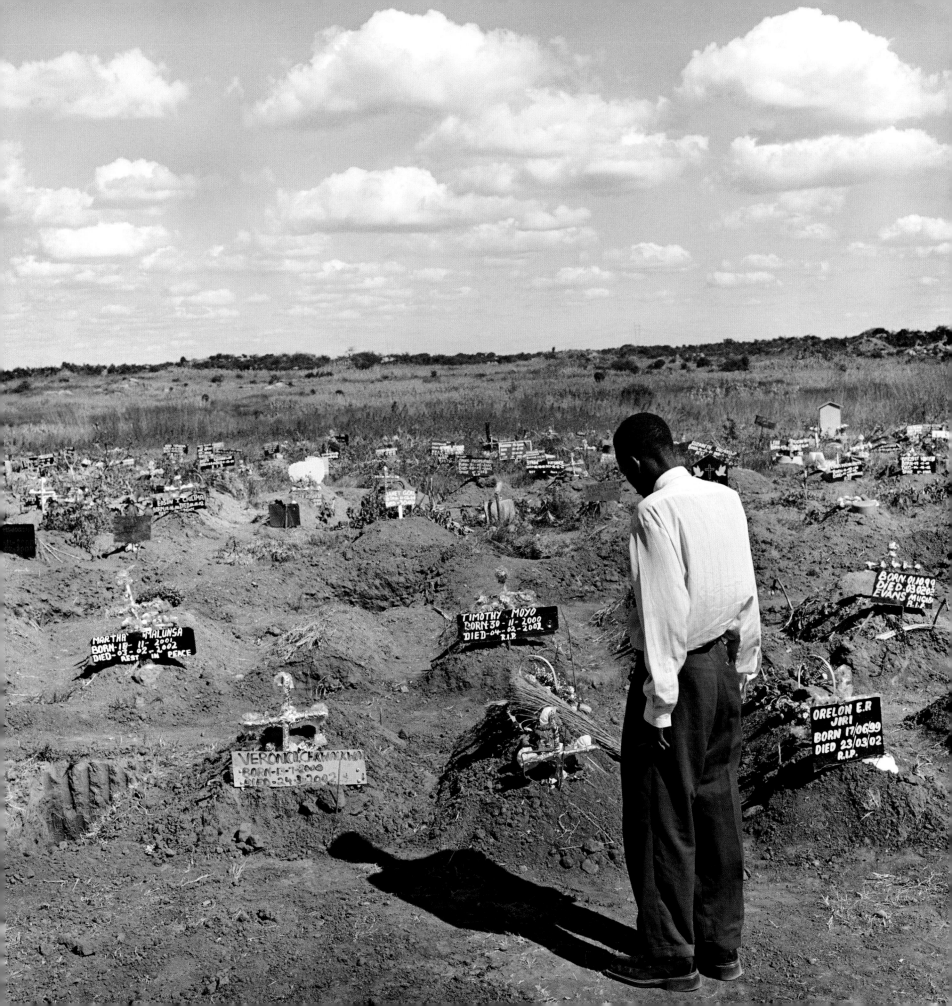

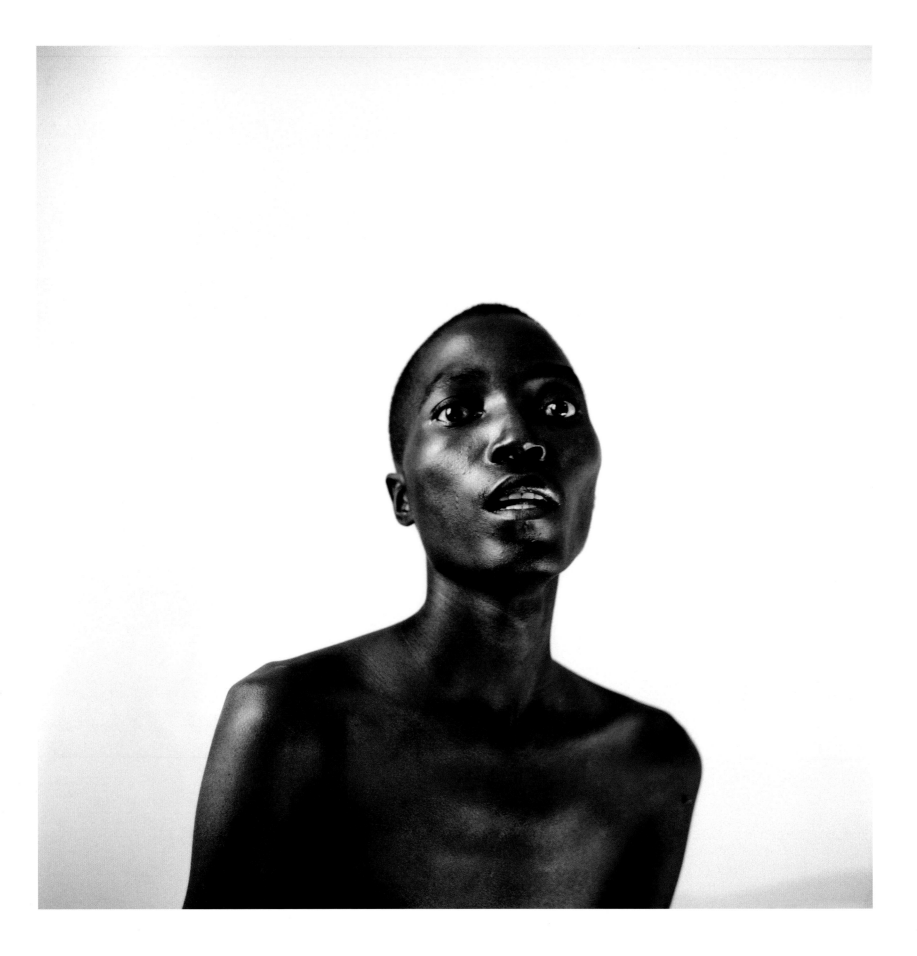

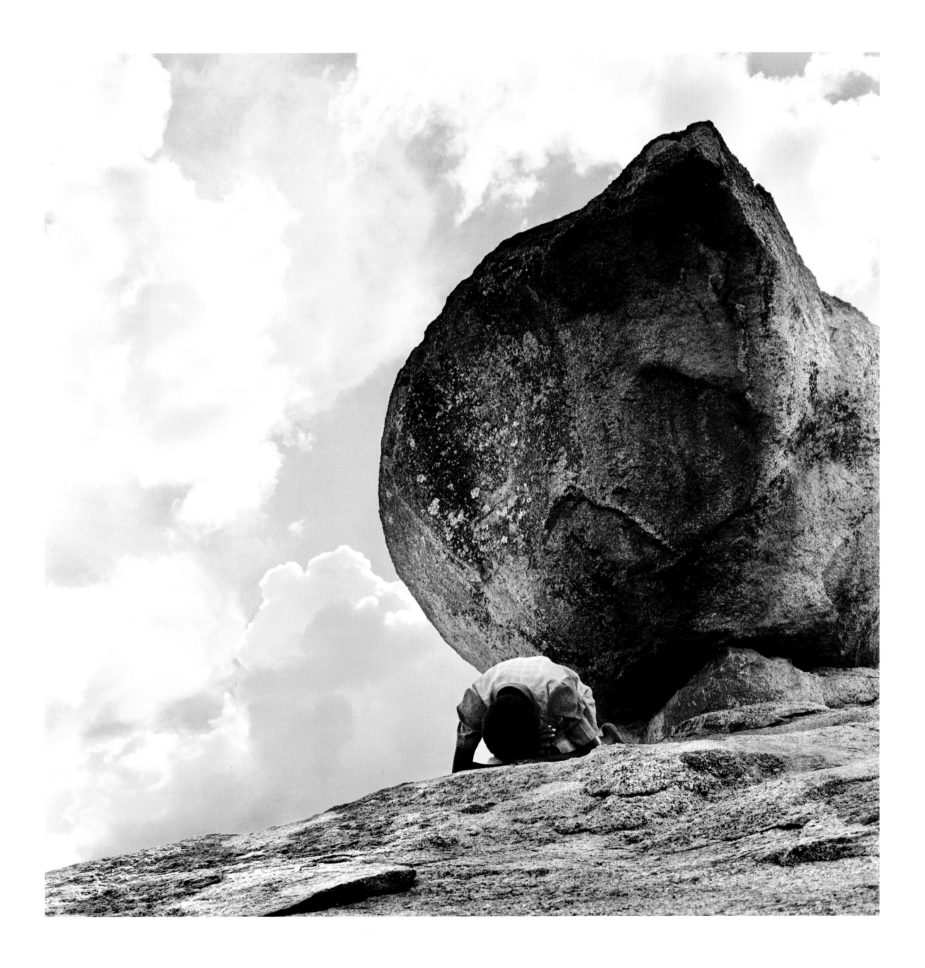

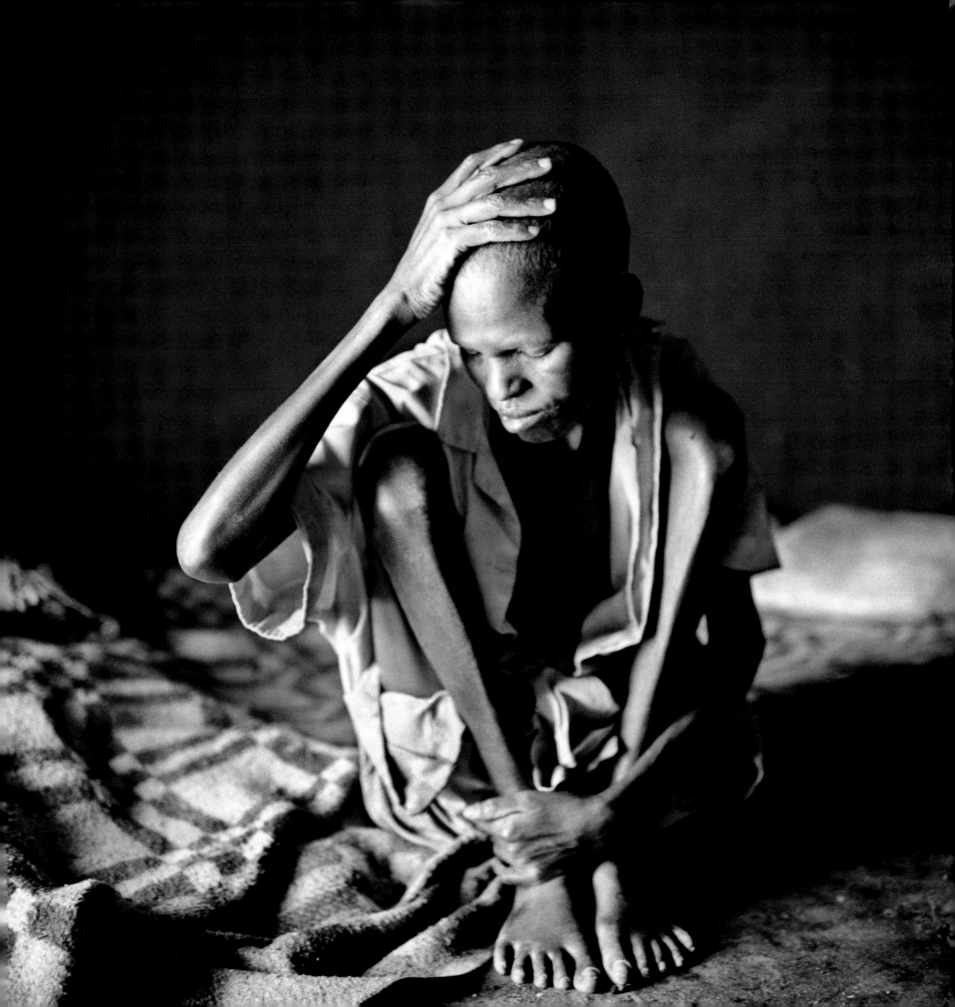

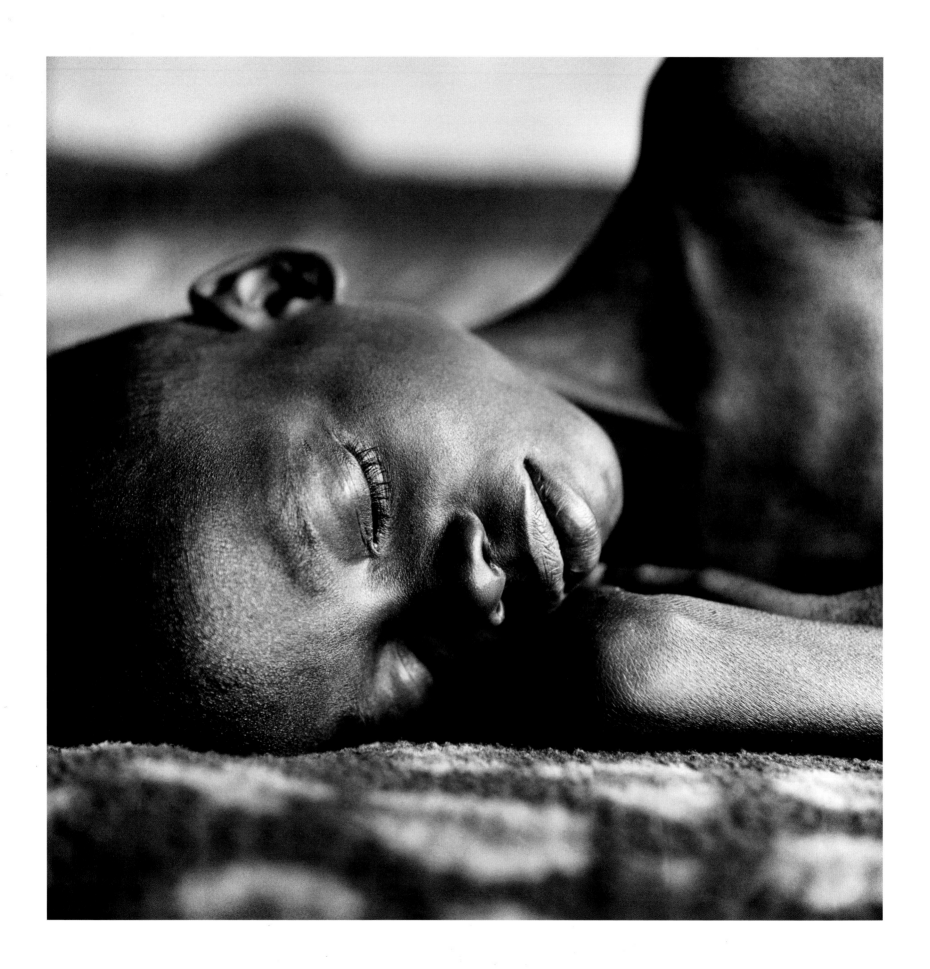

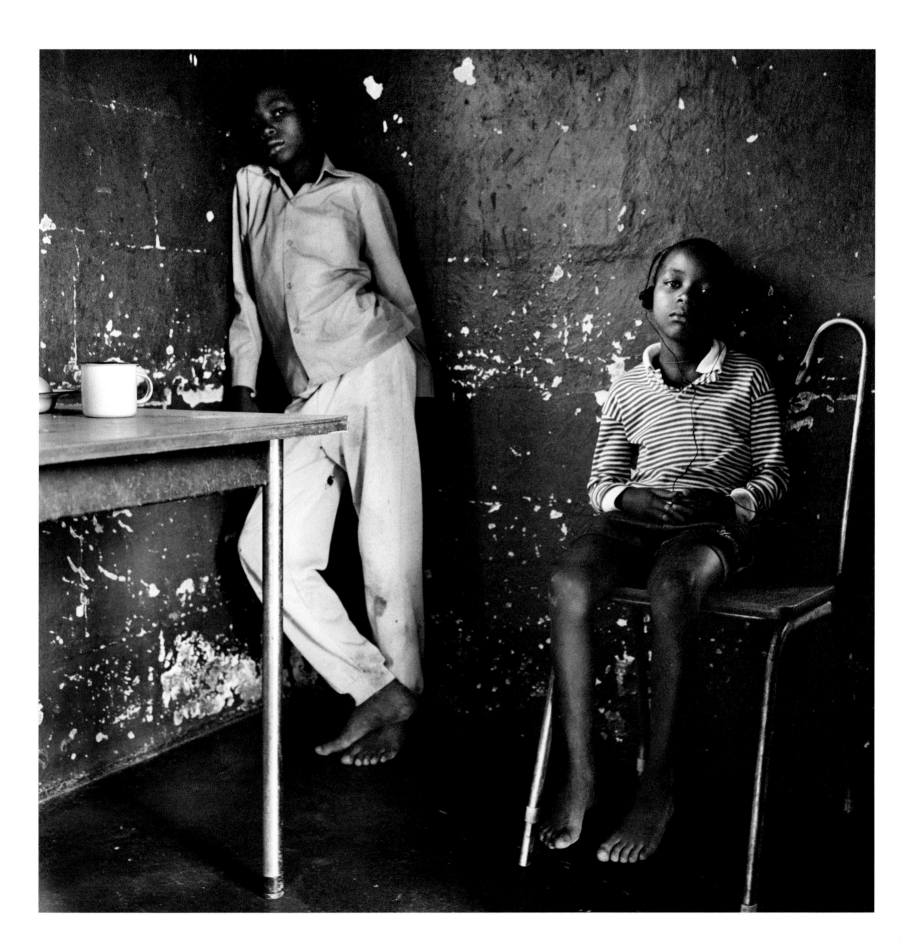

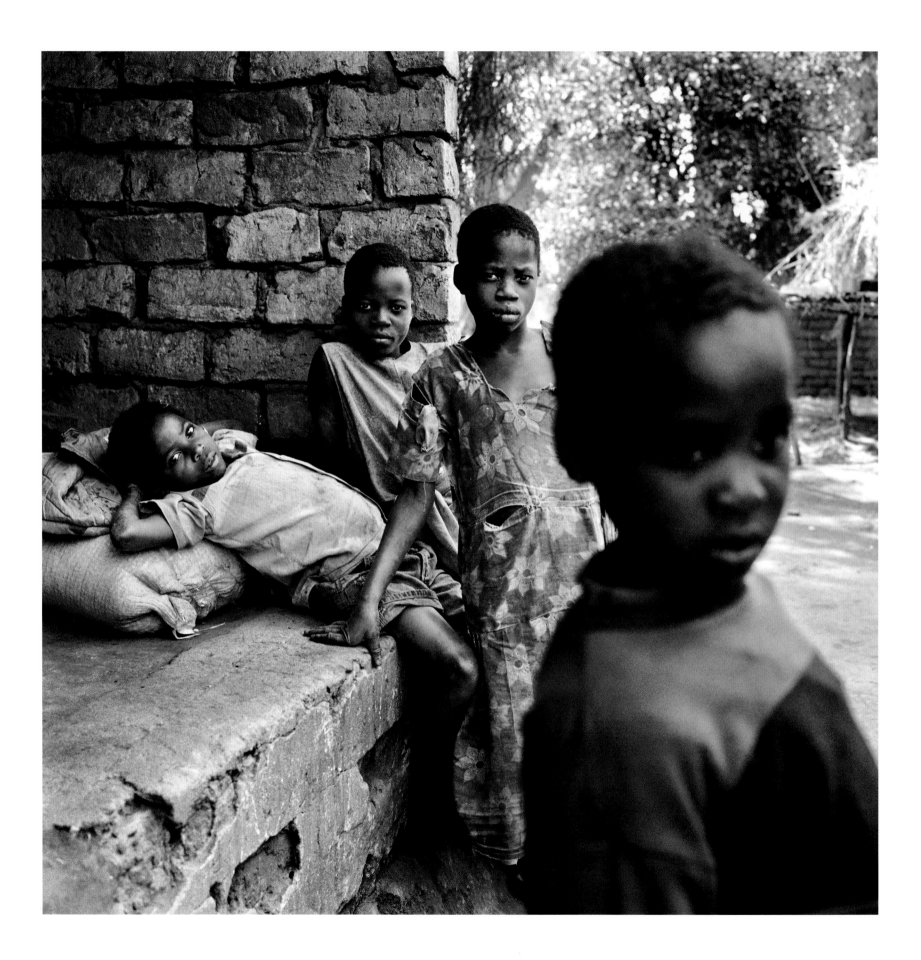

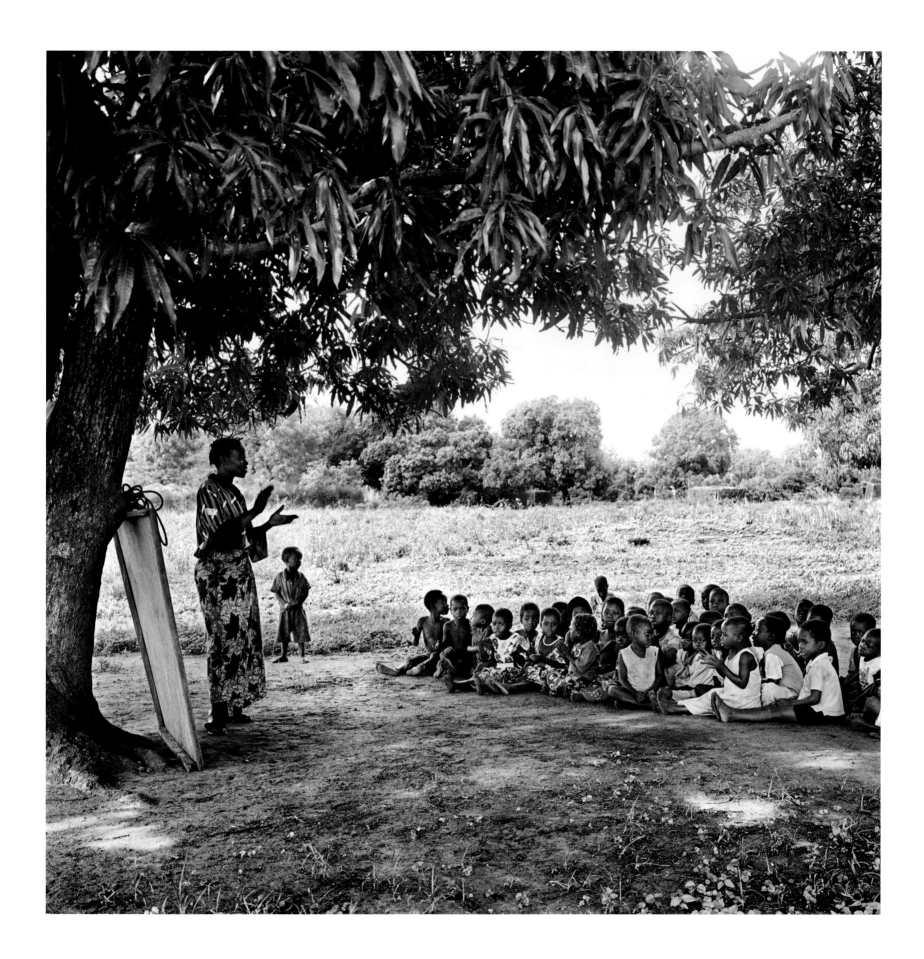

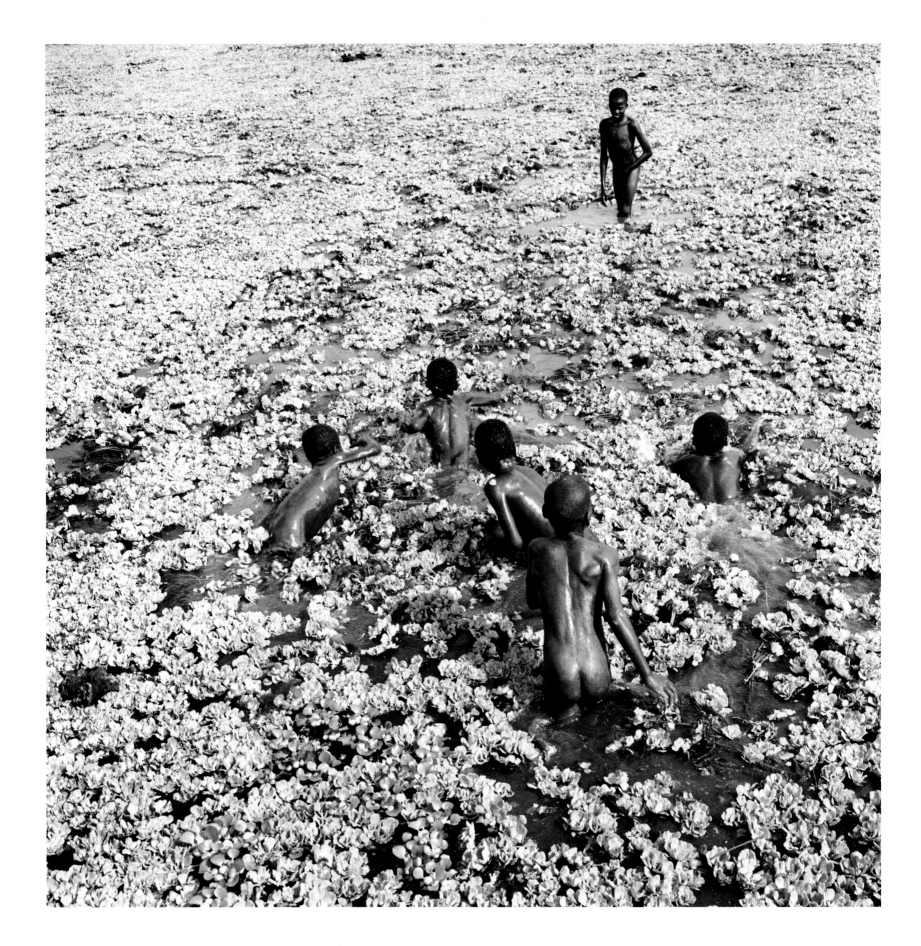

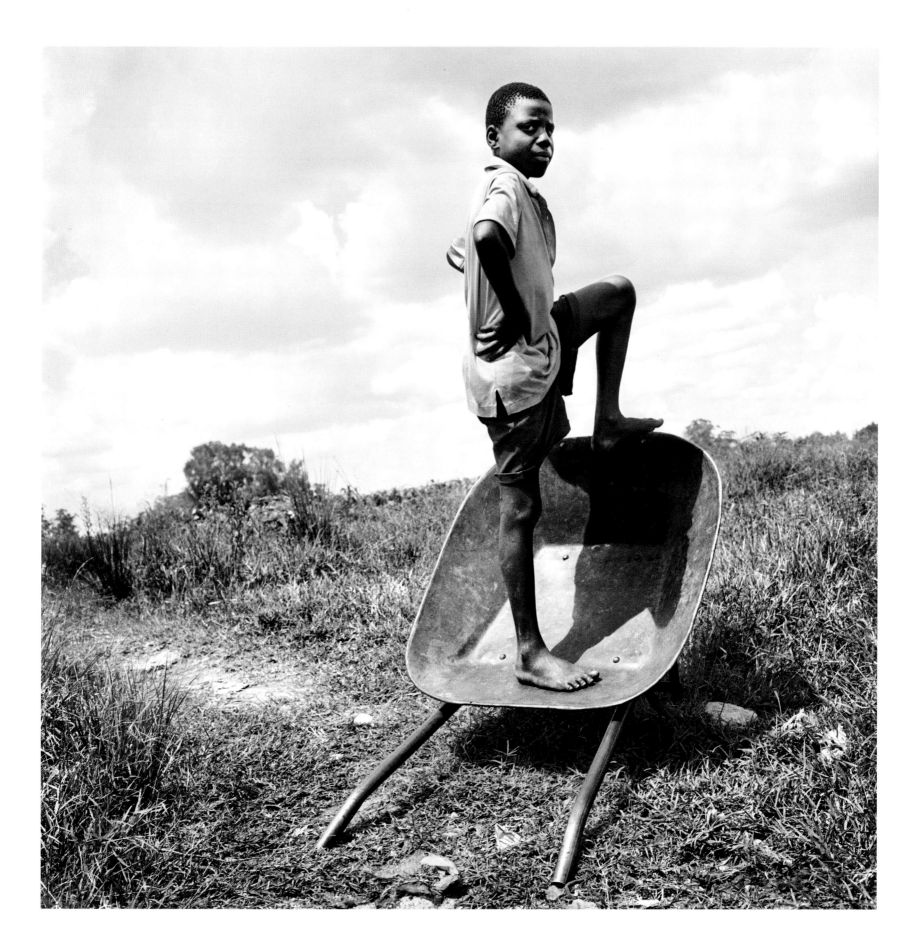

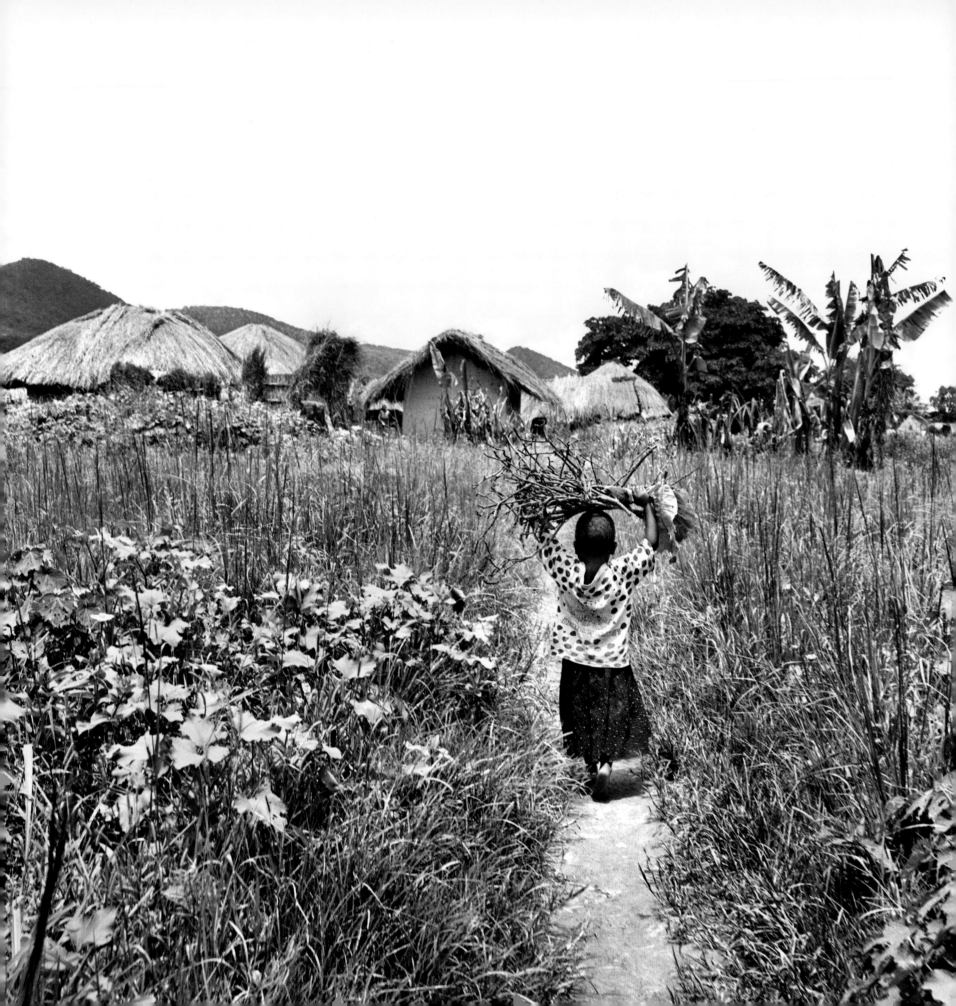

AFTERWORD

While preparing this book, I looked through thousands of images. Each brought back a memory.

I will never forget the first family I met who asked me if I could provide them with ARVs—the life-saving AIDS drugs. I was sitting in the living room of Wendy and her son, Valentine. They were both HIV positive.

Wendy looked me straight in the eye. As she talked, she labored to breathe: *"Is it true that in your country people no longer die of this HIV?"*

It was a question I would be asked over and over. People heard that the drugs existed and wanted to know how they could get them. With so many in need, I was completely overwhelmed. I convinced myself that I was only there as a journalist and that I could help the most by documenting the crisis. Now, looking back, I could have found a way to provide the drugs. And I should have. I could have helped to save one person. I could have saved Valentine.

Always eager to help, Valentine tagged along as I conducted interviews in the neighborhood. Once, trying to brighten his day and mine, we ate fast food and saw the movie *Teenage Mutant Ninja Turtles*. Afterwards he practiced his karate kicks and talked about what he would do when he got better.

Valentine died a year later. He was ten years old.

AIDS drugs are now cheaper and more accessible then ever. We've run out of excuses. Valentine's death was preventable, and so are the deaths of millions of HIV-positive people in sub-Saharan Africa. This is not just about medicine, though. It's about involvement. It's about elevating people out of poverty, and addressing the unjust distribution of resources.

These images span my journey through Botswana, Zimbabwe, South Africa, and Malawi—all countries heavily affected by the virus. Much of what I experienced I can never convey in words. Each person in this book allowed me into their lives and shared their most difficult times so that we could bear witness to their suffering. Their hope, and mine, is that their stories will help us understand the heartbreaking reality of the pandemic and just how much is at stake.

—Kristen Ashburn

The Kachepa family
—Joseph, 35, Viola, 34,
Emanuel, 2, Tabeth, 1—in their
home. Both parents and
Emanuel (right) are HIV positive.
Emanuel died the day after this
photograph was taken.

Chitungwiza, Zimbabwe.

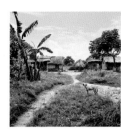

Mchinji Village, Malawi.

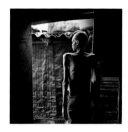

Godfrey, 32, too sick to work,
survives on donations from
friends and family.
His relatives are unable to
afford the anti-retroviral drugs
that could save him.

Mbare, Harare, Zimbabwe.

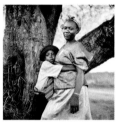

Otialia Tasikani, 38, and son
Nigel, 9, are both HIV positive.
They are unable to afford
anti-retroviral drugs.

Glenview, Harare, Zimbabwe.

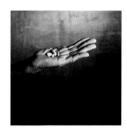

Anti-retroviral drugs in the hand
of Florence Alfonso.

Nsanje, Malawi.

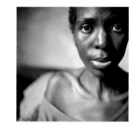

Maria Vindi, 32, worked as a
nurse in South Africa before
falling ill. Her family lacked the
resources to buy anti-retroviral
drugs, and she spent her
savings on treating
opportunistic infections.

Tafara, Harare, Zimbabwe.

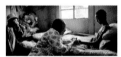

Maria Vindi prays with her
mother and home-based care
volunteer Forget Gutuza.

Tafara, Harare, Zimbabwe.

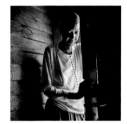

Rosemary Tavaziva, 28,
lost her husband to AIDS.
She was put on a waiting list for
anti-retroviral drugs from the
Zimbabwean government but
never received them.
She died in 2006, leaving
behind three children.

Mabvuku, Harare, Zimbabwe

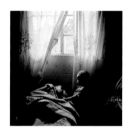

Chipo, 6, stands by the side
of her mother, Christina
Kamusere, 29, as she lies dying
of AIDS.

Mabvuku, Harare, Zimbabwe.

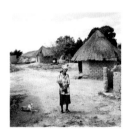

In this rural village many of the
men have died, leaving the
women to care for children left
behind and those suffering from
the virus.

Mutoko, Zimbabwe.

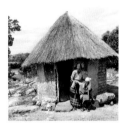

Mutoko, Zimbabwe.

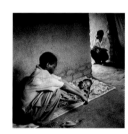

Stella Forty, 41, lies dying of AIDS
in her home beside her son
Frank, 15, and her husband,
Fred. She died in August 2006.

Nsanje, Malawi.

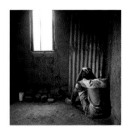

A relative of Stella Forty mourns
her death.

Nsanje, Malawi.

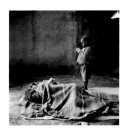

Grace Chiriponyanga,
abandoned by her husband
when she became ill, is cared
for by her five-year-old son.

Mutoko, Zimbabwe.

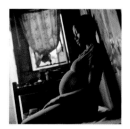

Joyce Maduviko, 21, learned of
her HIV-positive status during a
pre-natal check-up.
Her daughter was born HIV
negative due to participation in
a mother-to-child transmission
program. Joyce died a year after
giving birth.

Chitungwiza, Zimbabwe.

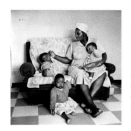

Orphans cared for at the Mother Of Peace Community. The extended family system, which typically looked after orphaned children, is no longer effective because of the catastrophic extent of the AIDS pandemic.

Mutoko, Zimbabwe.

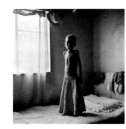

Caroline Mudzvit, 10, is an HIV-positive orphan. She suffered for years from opportunistic infections such as tuberculosis.

Chivu, Zimbabwe.

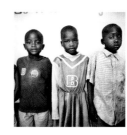

Orphans cared for at the Mother Of Peace Community.

Mutoko, Zimbabwe.

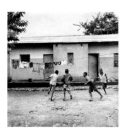

Children play outside their home in a high-density suburb.

Lilongwe, Malawi.

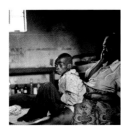

Esnath Chinaka sits with her grandson Herbert, who died at age 12, soon after this photo was taken. Esnath also fell sick and died shortly after.

Chivu, Zimbabwe.

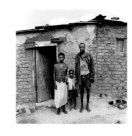

HIV-positive parents too ill to care for their son.

Epworth, Zimbabwe.

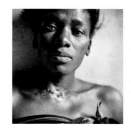

Wendy Miriam Simbaneuta, 33, is HIV positive. She died in 2001, leaving behind her son Valentine Mulaudzi, 10. Valentine died of AIDS in August 2002.

Mabvuku, Zimbabwe.

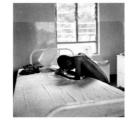

TB ward of the main district hospital of Nsanji. Tuberculosis is one of the main opportunistic diseases that kill HIV-positive patients.

Nsanje, Malawi.

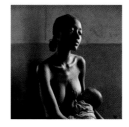

Florence Alfonso, 24, with her son Moses. Florence died in November 2006. Her son died three weeks later.

Nsanje, Malawi.

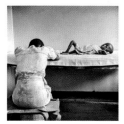

HIV-positive mother and child at the Nsanje District Hospital.

Nsanje, Malawi..

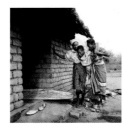

Beatrice Gutu, 36, being helped into her house by volunteers from ACCOCAPO, a community-based organization helping HIV-positive people in the district.

Nsanje, Malawi.

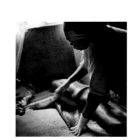

Christina Kamusere, 29, is bathed by her mother a few weeks before she died from AIDS.

Mabvuku, Harare, Zimbabwe.

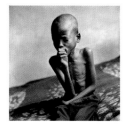

Valentine Mulaudzi, 10, battles pneumonia. He died of AIDS in August 2002.

Mabvuku, Zimbabwe.

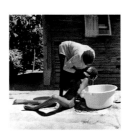

Simba Piri, 19, is washed by his mother Susan. Simba is HIV positive.

Old Mabvuku, Zimbabwe.

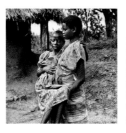

Linesi Chinga, 20, is carried by her sister Ellen, 25. Linesi's three children are also under Ellen's care. Ellen's husband has to work three jobs to make enough money to feed the entire family.

Sitima Village, Malawi.

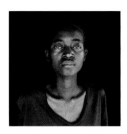

Florence Alfonso, 24, lives 30 km from the hospital and must walk or take a three-hour bicycle ride to reach medical care. Her husband died of AIDS while she was pregnant. Florence died in November 2006. Her six-month-old son, Moses, died three weeks later.

Nsanje, Malawi.

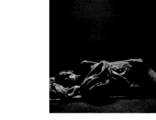

Stella Forty, 42, lies dying of AIDS on the floor of her home. When she died in 2006, her husband was left to care for their five children.

Nsanje, Malawi.

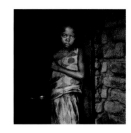

Mary Forty, 7, stands in the doorway of her home after the death of her mother.

Nsanje, Malawi.

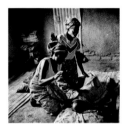

Stella Forty, 42, is visited by home-based care volunteers from ACCOCAPO, a community-based organization helping HIV-positive people in the district.

Nsanje, Malawi.

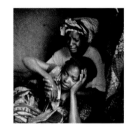

Stella Forty's eldest daughter Judi, 25, collapses at her mother's funeral.

Nsanje, Malawi.

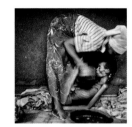

Stella Forty's body is washed by a relative in preparation for burial.

Nsanje, Malawi.

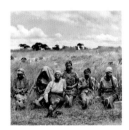

Women at a funeral.

Harare, Zimbabwe.

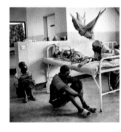

Edith Kandielo lies in a hospital bed surrounded by her family.

Nsanje, Malawi.

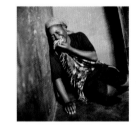

Gracious Mapondera breaks down at the funeral of her sister's son, Alan Andrew Kabichi, 12, who died of AIDS.

New Mabvuku, Zimbabwe.

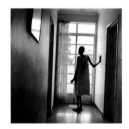

Patient in the female ward of Mashambanzou Care Trust Hospice.

Waterfalls, Zimbabwe.

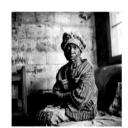

Home-based care patient sits in her living room awaiting instructions on how to take her medicine.

Zimbabwe.

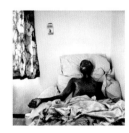

A former police officer dying of AIDS at the Mashambanzou Care Trust Hospice.

Waterfalls, Zimbabwe.

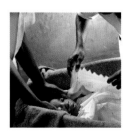

Alan Andrew Kabichi, 12, being laid in his coffin.

New Mabvuku, Zimbabwe

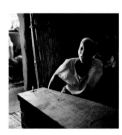

Joyce Banda mourns the death of her son, Aaron, who died of AIDS.

Nsanje, Malawi

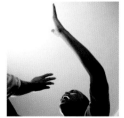

A charismatic Christian prays for the sick and needy.

Harare, Zimbabwe.

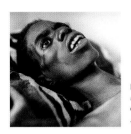

Funji, a patient at Mashambanzou Hospice, dying of AIDS.

Waterfalls, Zimbabwe.

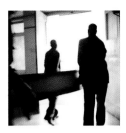

Christina Kamusere's coffin is carried through the doors of the mortuary. She died at age 29, leaving her daughter in the care of her mother.

Mabvuku, Zimbabwe.

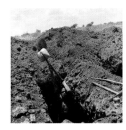

Graves are prepared eight at a time to keep up with the vast number of deaths.

Mabvuku, Zimbabwe.

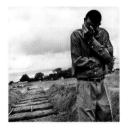

Mourner at the funeral of a loved one who died of AIDS.

Harare, Zimbabwe.

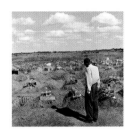

Joseph Kachepa, 35, at the grave of his son Emanuel, 2, who died of AIDS. Both Joseph and his wife are HIV positive.

Chitungwiza, Zimbabwe.

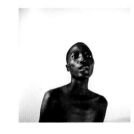

Kudzanayi Maekera, 30, a patient at Mashambanzou Care Trust, dying of multiple opportunistic diseases.

Waterfalls, Zimbabwe.

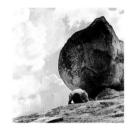

A child prays under the balancing rocks in the fields surrounding her home.

Old Mabvuku, Zimbabwe.

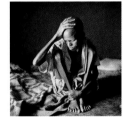

Emily Viriri. 36, sits dying of AIDS in her family's home. With her death, her three children were orphaned.

Buhera, Zimbabwe.

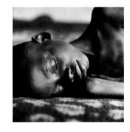

Valentine Mulaudzi, 10, battles pneumonia. He died of AIDS in August 2002.

Mabvuku, Zimbabwe.

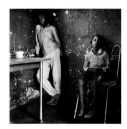

Orphaned brothers under the care of their grandmother.

Gaborone, Botswana.

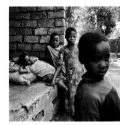

Children outside a house where a man is dying of AIDS.

Malawi.

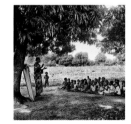

Volunteers with ACCOCAPO conduct school under a tree. The community does not have funding to afford a permanent structure. Many of the children in the group are orphans.

Nsanje, Malawi

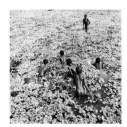

Children cool off from the heat in a pond filled with lily pads.

Nsanje, Malawi.

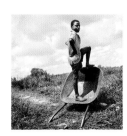

A young boy rests from his work in the fields.

Waterfalls, Zimbabwe.

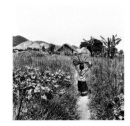

A young girl hauls firewood home to her family.

Mchinji Village, Malawi.

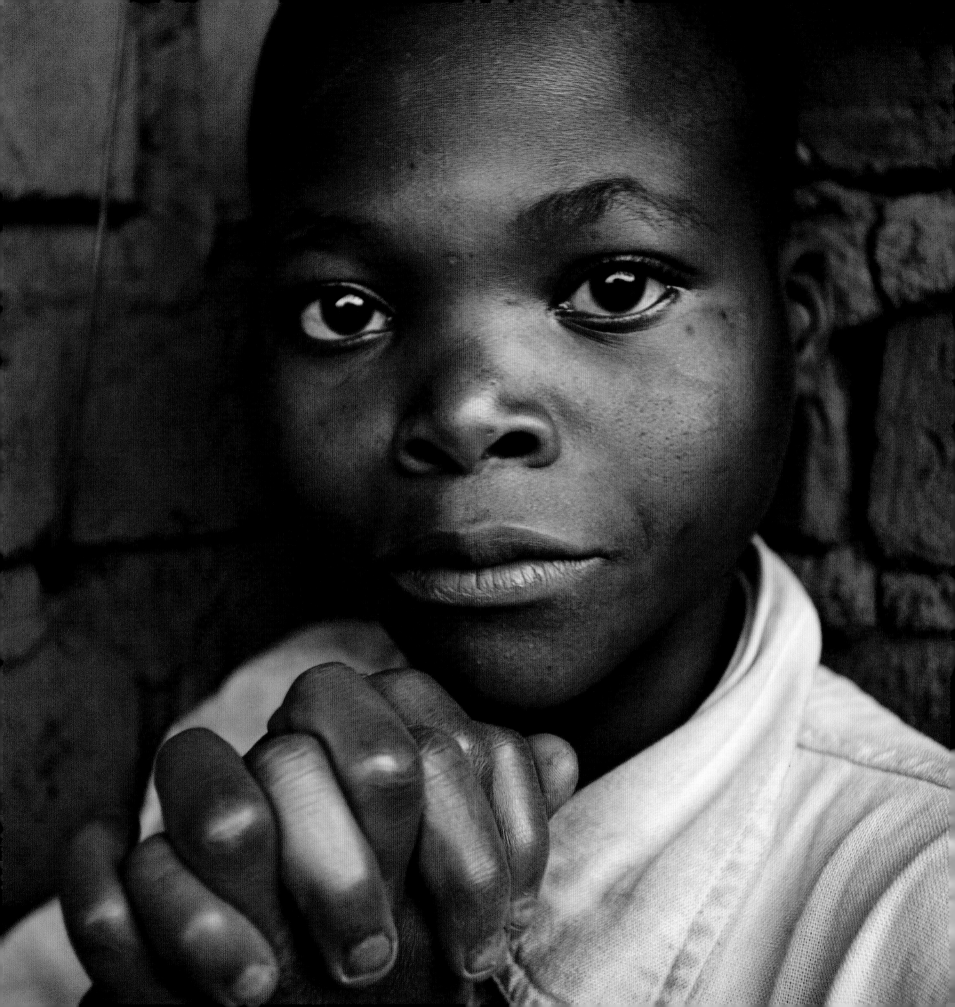

RAISING MALAWI

Raising Malawi is dedicated to bringing an end to the extreme poverty and hardship endured by Malawi's 1 million orphans. Cofounded by Madonna and Michael Berg, the organization uses a community-based approach to provide immediate direct physical assistance, creating long-term sustainability. It supports education and social programs, and builds public awareness through multimedia and worldwide volunteer efforts.

As part of its activities, Raising Malawi distributes financial support to grassroots organizations, and has already provided tens of thousands of vulnerable children with nutritious food, proper clothing, secure shelter, formal education, targeted medical care, and emotional support. It does not create or manage its own programs in Malawi; rather, it supports dedicated organizations on the ground.

By choosing to work at a community level, rather than imposing Western beliefs and methodologies on Malawian culture, Raising Malawi is bringing sustainable change to the lives of children who need it most.

For more information about Rasing Malawi, or to support their work, visit www. raisingmalawi.org

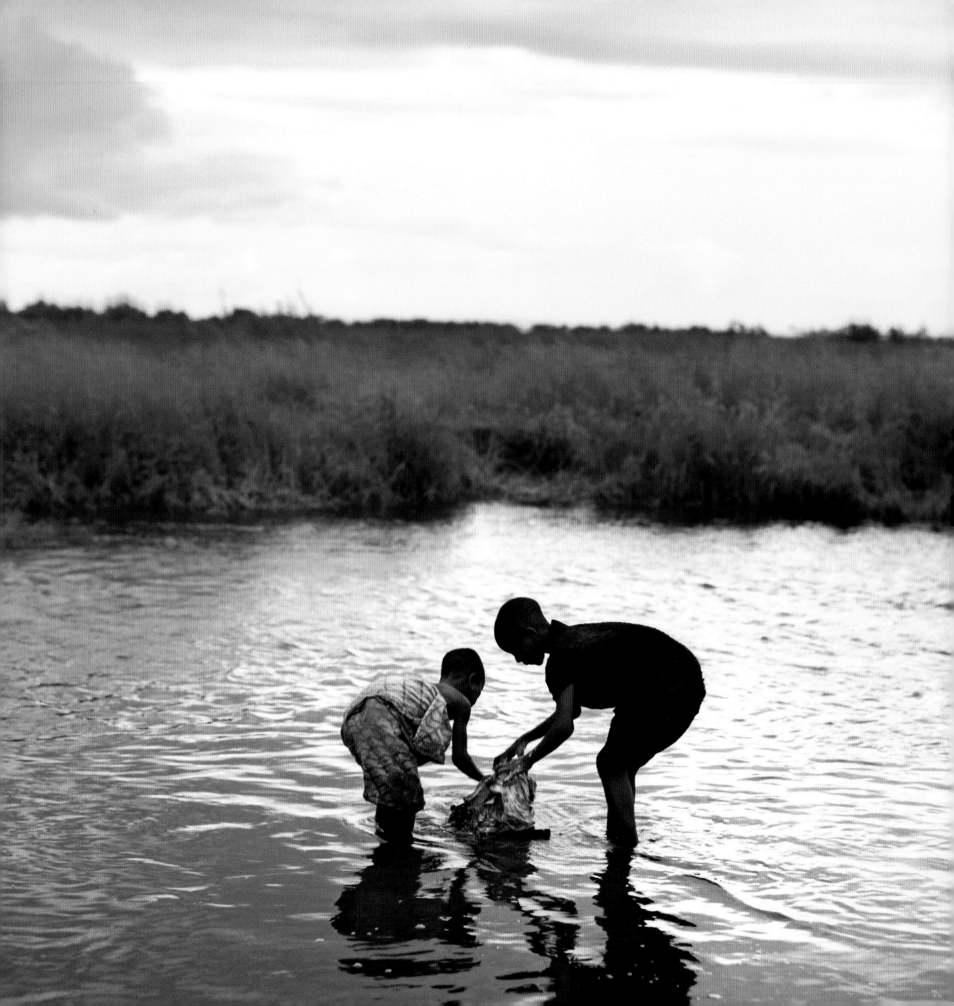

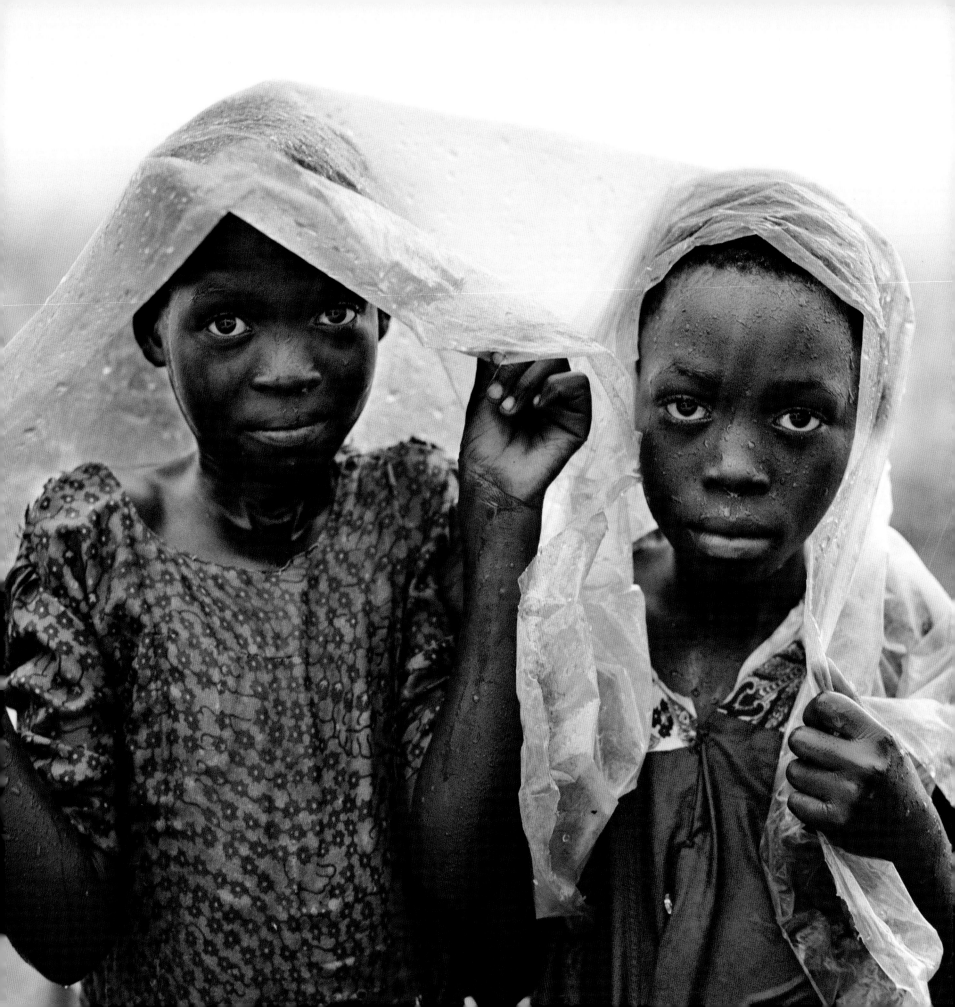

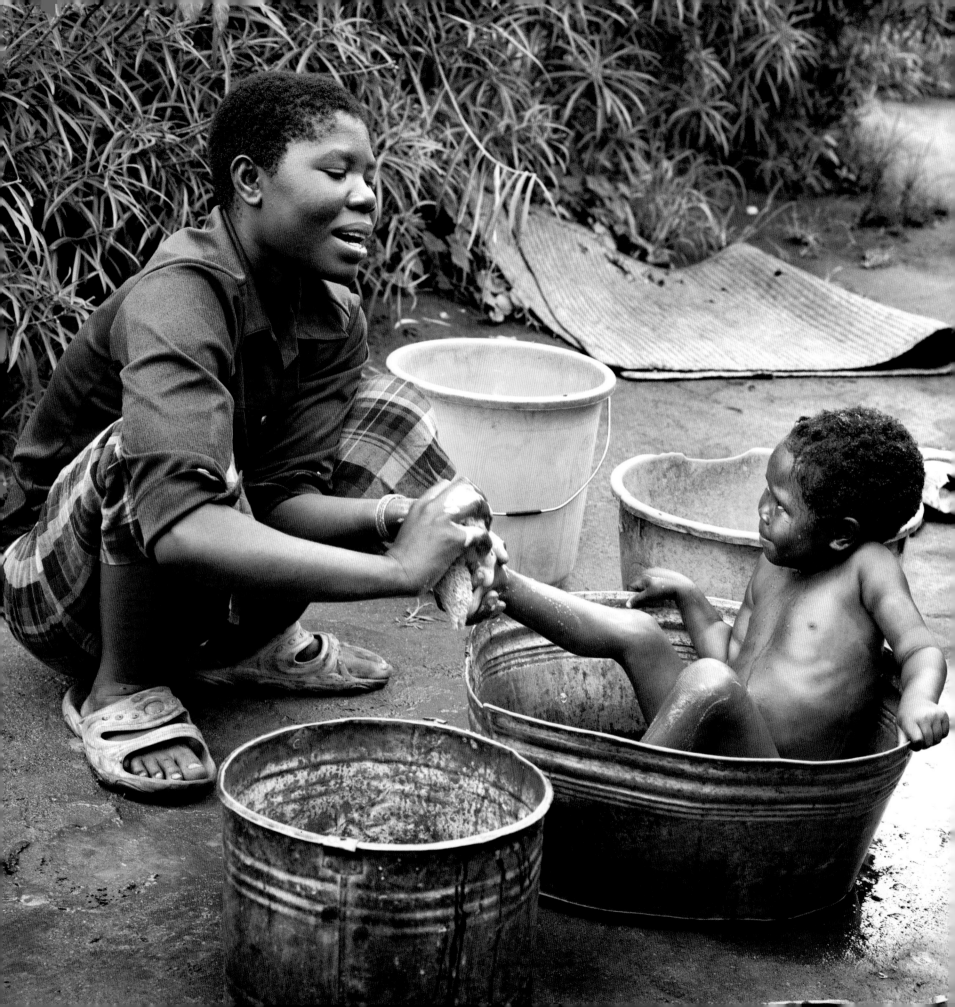

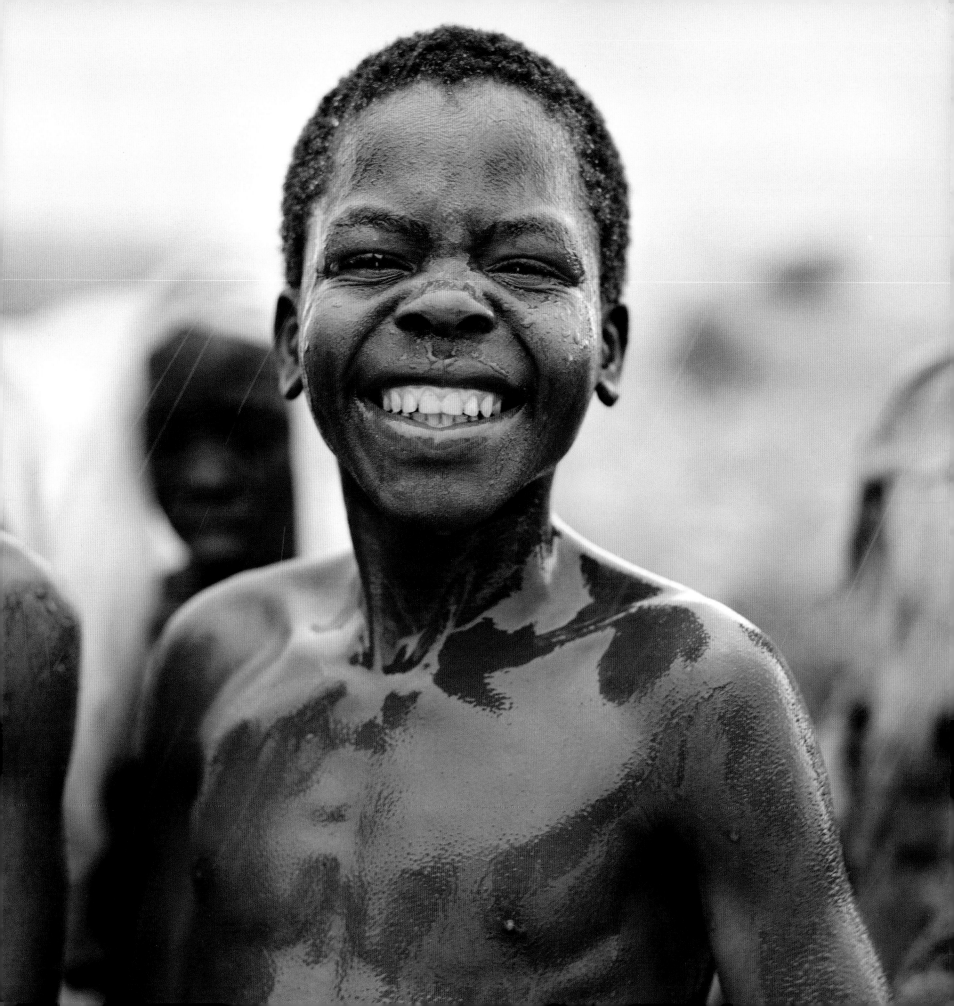

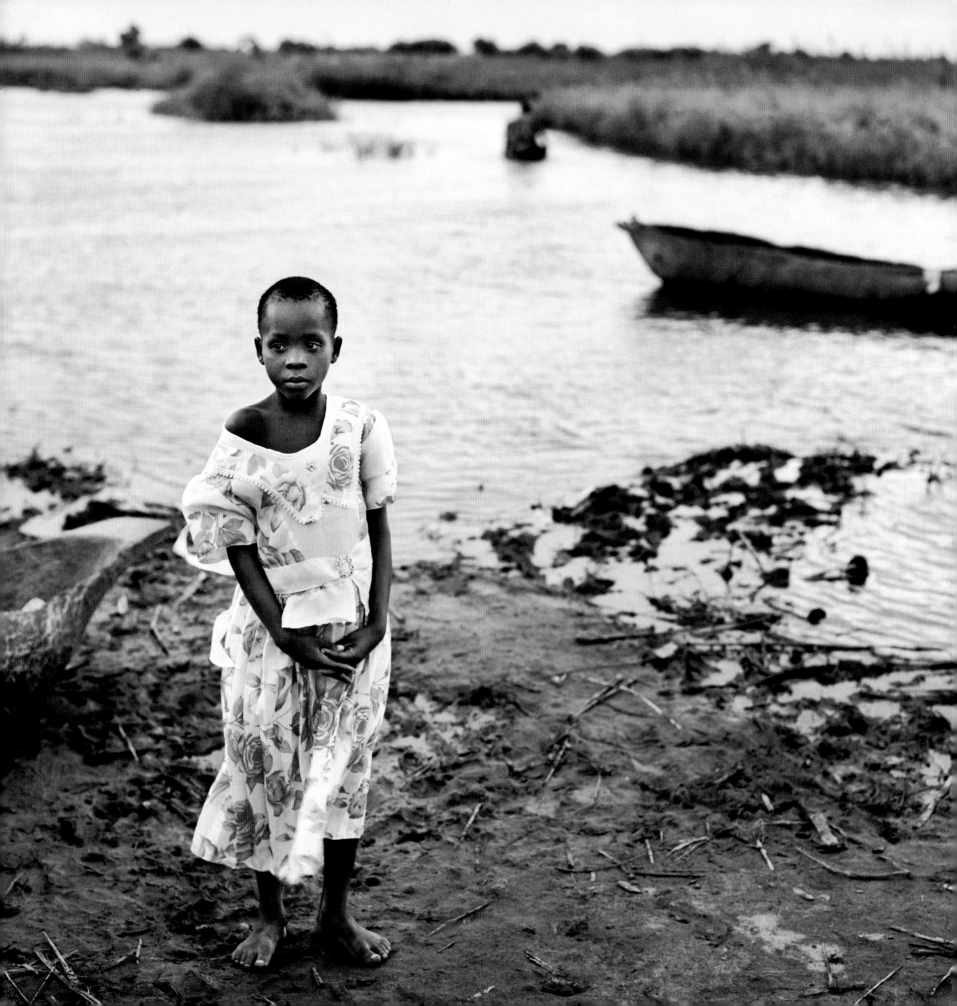

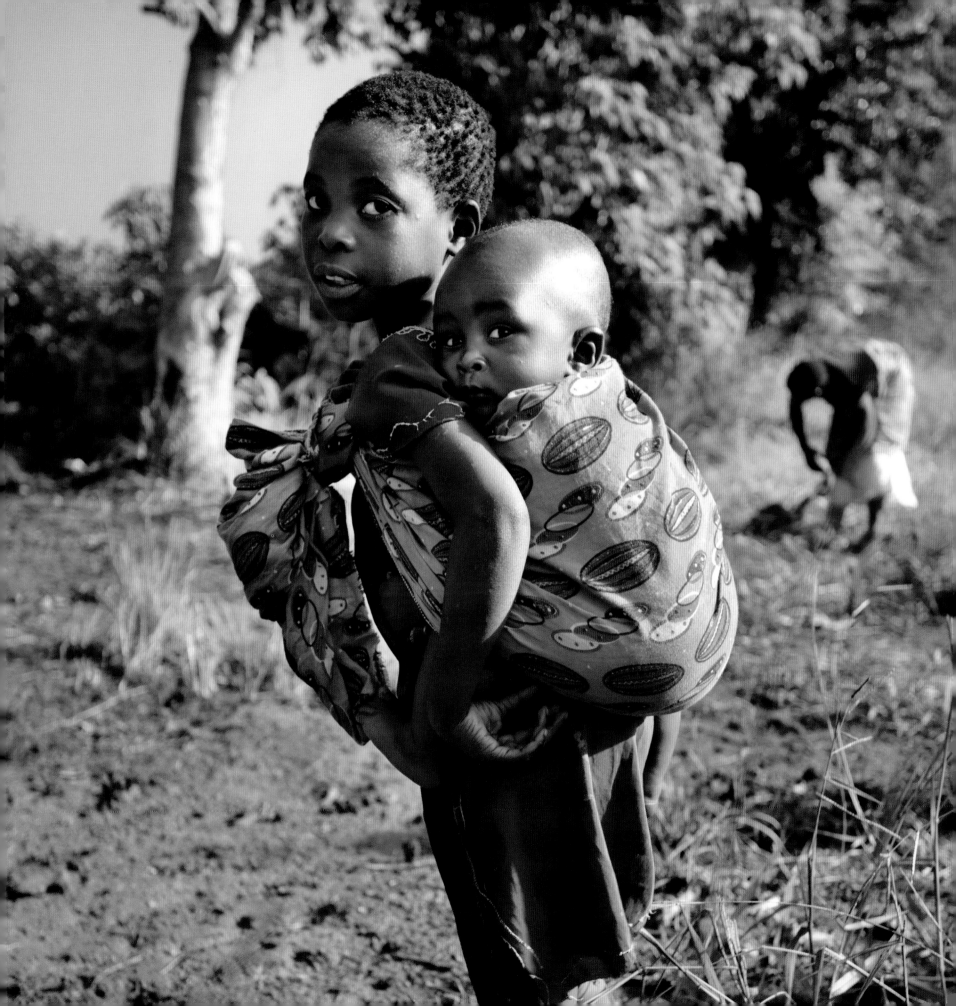

THE MAKERS OF I AM BECAUSE WE ARE

I Am Because We Are was filmed between April 2006 and September 2007. Post-production took place in London and the film was completed in March 2008. The premiere was held at the Tribeca Film Festival on April 24, 2008 and the European debut was at the Cannes Film Festival on May 21, 2008. The documentary has been distributed worldwide.

Director:
Nathan Rissman

Producer:
Angela Becker

Consulting Producers:
Kristen Ashburn
Kevin Lee Brown
Philippe Van Denbossche

Producer & Writer:
Madonna

Associate Producer:
Grant James

Camera:
Nathan Rissman
Kevin Lee Brown
John-Martin White
Grant James

Editor:
Danny Tull

Assistant Editor:
Hamish Lyons

Still Photographer:
Kristen Ashburn

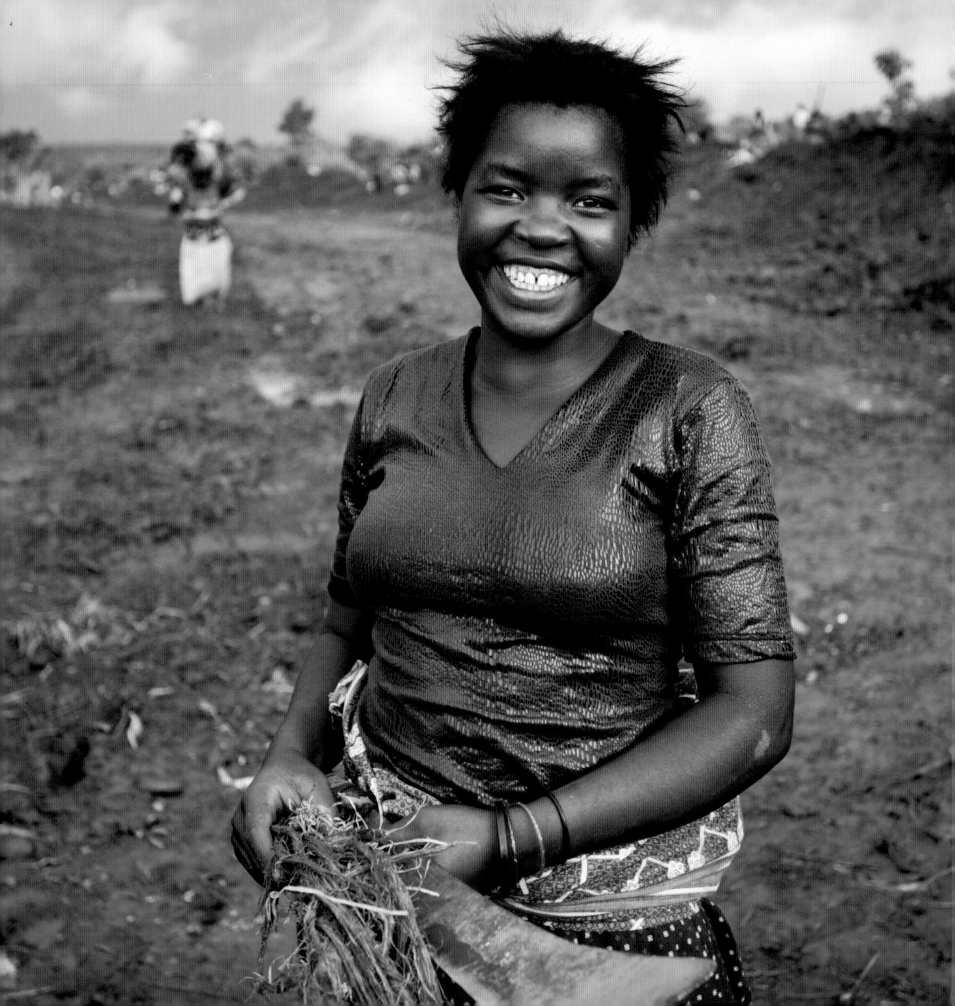

ACKNOWLEDGEMENTS

Heartfelt gratitude to all those who opened their lives to me: Otilia Taskani, Joseph and Viola Kachepa, Florence Alfonso, Maria Vindi, Forget Gutuza, Rosemary Tavaziva, Christina Kamusere and her family, the Forty family, Joyce Maduviko, Caroline Mudzvit, Esnath Chinaka, Herbert Chipoya, Wendy Miriam Simbaneuta, Valentine Mulaudzi, Beatrice Gutu, Simba Piri, Susan Piri, Emily Viriri, Edith Kandielo, Gracious Mapondera, Alan Andrew Kabichi, Joyce Banda, Kudzanayi Maekera, Joyce June, Grace Chiriponyanga, Fanizo Machipista, Wezi Nyirenda, Luka Samuel and his family, Fred Forty, Mabvuto Mbeleko, Mercy Mwale, Sinode Kandielo, as well as many others.

If it weren't for the generosity of many friends throughout Africa, this project would not have been possible: Mashambanzou Care Trust, Sister Margaret Allen, Sostain Moyo, Otilia Tasikani, Peter Phiso, Jacquie Gulliver, Louise Gubb, Andrew Gilbert, Sophie Dilmitis, Anne and John Rigby, Colin and Peta Beattie, K.S. Mkandawire, Cleopas, Jocob Lief, Jabulani, Jeffrey George, Prisca Mhlolo, Lydia, Zeph Kajevu.

Special thanks to Madonna for believing in the importance of this project and for moving mountains, Steven Klein for taking the time to make things happen, Robert Pledge for years of guidance, Jacques Menasche for helping me every step of the way and for always finding the right words, Jeffrey Smith for never failing to come through, Nathan Rissman for his sensitive documentary, Guy Oseary for his patience and perseverance, Kiki Bauer for her elegant design, Steve Yadzinski at Big Swing for helping to prepare each and every image in this book and for his generosity, Chris Anderson for his continual belief in my work, Elisabeth Biondi for her expert eye and for always taking the time, Ina Howard for spreading the word with wit and charm, Brian Storm for bringing sound, video, and soul together, Kevin Lee Brown for the tunes, Giovanni Jubert for helping with "the look," Jason Baumann, David Jiranek, the entire powerHouse team: Daniel Power, Craig Cohen, Sara Rosen, Ariana Barry, Adeline Besse, and Daoud Tyler-Ameen, Raising Malawi, Philippe Van Denbossche, Johanna Edholm, Rachel Strickland, Luis Viner, Grant James, Sara Zambreno, William Morris, Andy McNicol, Eric Zohn, Jennifer Rudolph Walsh, Peter Grant, Angela Becker, Liz Rosenberg, Represent Inc., Joseph Huff-Hannon, Sonal Bains, Cynthia Lowen, Box, Pascal Daugin, Marion Liang, Malcolm Gladwell, Paul Farmer, MD, Amber Palson, Tamara Porres, Natalie Brasington, Eric Thayer, Mark Seliger, George Ueushi, Brett Langden, Iman, Lenny Kravitz, Zoë Kravitz, Leigh Blake, Geoff Renaud, DKNY Jeans, Keith Greco, Alice Walker, John Legend, Elodie Mailliet, Shaul Schwarz, Eric Maierson, Pamela Chen, Jennifer Kilberg, Paul Martinez, Vic Marks, Nina Berman, Seth Berkley, Maryanne Golan, Laurie Garret, Kim Sevcik, Michael Bronner, Susanna Space, GHP-West Haven, CT especially Francisco Nogueira, Aric Laventhal, Allen Murabayashi, Kevin Gilbert at Blue Pixel, Tim Mapp, Ronald Pledge, Jamie Wellford, Emmanuella Chiche, James Nachtwey, Paolo Pellegrin, Per-Anders Pettersson, Tomas Muscianico, Rick Smolan, David Cohen, David Johnson, David Lang, John Gettings, Natasha Lunn, Naomi Ben-Shahar, Jim Megargee, Olivier Picard, Scott Thode, David Griffen, Aidan Sullivan, Scott Hagendorf, Susan Chokachi, Getty Images, Association des Femmes Journalistes (AFJ), Marty Forscher Grant, Olympus, Kodak, Lowepro and the entire staff at Contact Press Images.

And most importantly, I thank my family who helped me when no one else would, Theresa and Antoine Ashburn, Jordan, Nicole, Kate, and Nicholas. And to Michael, my Hunty, for all his understanding and love.

I AM BECAUSE WE ARE

Published in the United States by powerHouse Books,
a division of powerHouse Cultural Entertainment, Inc.
37 Main Street, Brooklyn, NY 11201-1021
telephone 212 604 9074, fax 212 366 5247
e-mail: iabwa@powerHouseBooks.com
website: www.powerHouseBooks.com

First edition, 2009

Library of Congress Control Number: 2008939784

Hardcover ISBN 978-1-57687-482-0
Separations, printing, and binding by Pimlico Book International, Hong Kong

Book design by Kristen Ashburn and Kiki Bauer

All author's proceeds from the sale of the book will be donated to Raising Malawi for their
extensive work with orphans throughout Malawi.

For more information about Kristen Ashburn, please visit
www.kristenashburn.com

A complete catalog of powerHouse Books and Limited Editions is available upon request;
please call, write, or visit our website.

10 9 8 7 6 5 4 3 2 1

Printed and bound in China